Battle Art

BATTLE ART

Images of War

106 reproductions
selected & introduced
by Denis Thomas

Phaidon

The author and publishers are grateful to all museum authorities
and private owners who have given permission for works in their
possession to be reproduced. Plate 76 is © by A.D.A.G.P., Plate 77
is © by S.P.A.D.E.M.

Phaidon Press Limited, Littlegate House, St Ebbe's Street, Oxford

Published in the United States of America
by E. P. Dutton, New York

First published 1977
© 1977 Phaidon Press Limited
All rights reserved

ISBN 0 7148 1773 2
Library of Congress Catalog Card Number: 77–75 317

Printed in Great Britain by Severn Valley Press, Caerphilly,
Glamorgan.

Arms and the Artist

War and art do not live easily together. Art is essentially one of the benefits of peace, when men's minds and spirits turn to the civilizing pleasures of reflection. Mankind tends to be sententious about war. In the state archive at Siena there is a tax register of 1468; one side of the wooden cover depicts a group of well-to-do citizens receiving money at a counter; on the other side an assortment of mercenaries are being paid their dues. Above the citizens' heads a girlish figure bears the legend (in Latin): 'Peace enriches the people'. Above the mercenaries there soars a ferocious-looking female, bearing a naked sword and the message: 'War enriches foreigners'.

In Europe during the Renaissance, war and bloodshed were inseparable from politics, and so, arguably, contributed in an indirect way to the practice of art. For one of the manifestations of grandeur among Renaissance princes was the patronage of painters, sculptors, and craftsmen. Machiavelli, a believer in the essential malice of men's spirits, and the merits of allowing it full play in pursuit of power, nevertheless maintained that a prince should also demonstrate a love of excellence, 'by advancing gifted men and honouring those who excel in any art'. The odious Sigismondo, the tyrant of Rimini, fits this injunction well: there were artists, as well as thugs, in his retinue. Even so gory a feud as the one that led to the massacre of the Baglioni family had a sequel for which later generations have cause to be grateful. The mother of one of the victims commissioned Raphael to paint a memorial to her murdered son: the beautiful *Deposition* now in the Borghese Gallery, Rome.

It would not have occurred to any painter of Raphael's time to treat a non-secular commission literally. The proper way for a painter to deal with human passions was to contain them within classical allegory. As only relatively well educated people were likely to see such paintings, let alone appreciate them, this was the method of communication and suggestion that was expected of him. On the other hand, the arts of war, as a recognized part of a nobleman's breeding, were not to be despised as mere subjects for painting. Uccello's three great panels, *The Battle of San Romano*, celebrate the apparatus and panoply of war no less than the event (Plate 2). The panel in the Uffizi, based most directly on the actual course of the battle, once hung in Lorenzo de Medici's bedroom. The realism, movement, and sense of occasion are, to modern eyes, a bonus.

Leonardo da Vinci's images of war (Plates 3, 4) are infused with his customary intellectual curiosity that brings every jotting of his to life. There is no suggestion, in his studies for death-dealing machinery, that the end is more ignoble than the means. His famous letter to Ludovico Sforza, recommending his prowess as a military engineer, is not the submission of an artist but a fluent exercise in salesmanship: 'I have plans for making a cannon, very convenient and easy of transport, with which to hurl small stones in a manner almost of hail, causing great terror to the enemy from their smoke, and great loss and confusion . . .'. The fact that Leonardo's illustrations of his instruments of death are also works of art is an accident of the times. Dürer, in much the same mood of high-minded detachment, drew armour and weapons with fastidious care (Plate 7). Michelangelo did not; but then, his subject was the human body, which he treated as a theme or an idea rather than as a muscled machine of the kind invented by Pollaiuolo. Michelangelo's *Combat of horsemen and foot-soldiers* (Plate 6), one of the surviving drawings for his lost fresco of the battle of Cascina, is a violently imagined physical action, more to do with the artist's dark inner struggle than with any passage of arms between Pisans and Florentines.

Man has found it necessary to make a distinction between homicide sanctioned by the State, formalized as 'war', and homicide by political bandits, known in modern times as 'terrorism'. Artists have been commissioned by monarchs or warlords to commemorate the feats of armies: there are examples in these pages, from Uccello onwards. But, for every battle that has found its way into the history books, or on to a palace wall, there have been thousands of unrecorded but equally murderous encounters unsanctioned by the State. No doubt much of the savagery that was a feature of life in Reinaissance Italy, where autonomous cities raided one another for loot, would fall into this category. What it is really like to live one's life in a constant state of war, as in much of Europe in the Middle Ages, or indeed parts of the world today, can be glimpsed in the work of such an inconspicuous artist as Callot, whose etchings are a record of what happens to civilians when military bravos have the run of their lands (Plate 13).

Bruegel's *Triumph of Death* (Plate 10) enlarges the argument.

Here is war as a scourge of men, a terrible visitation inseparable from death itself. The image of an advancing horde of skeletons armed with swords and spears has a vivid modern parallel in the film *Jason and the Argonauts:* the incongruity of living men fighting dead ones already reduced to skull and bones is both acceptable and frightening. Goya's horrifying image of Saturn eating his children, his own flesh and blood, stirs a similar, long-buried dread. But it is in his series of aquatints, *The Disasters of War,* that he asks the most penetrating questions about man's inhumanity (Plate 39). The outrages inflicted on the human body, the reduction of brain, flesh, and tissue to offal, as seen in the *Disasters,* is as much an embittered reproach as an appeal for indignation. 'I saw this', writes Goya under one plate; 'And this', he adds under another. The realism is awesome: *le monstrueux vraisemblable,* as Baudelaire called it, the monstrous made to seem true.

If there is such a thing as morality in war, it is inevitably the one-eyed mortality of partisanship. James Gillray's 'promis'd horrors' of the French invasion (Plate 33) are sheer propaganda; his shafts of sarcasm and dislike are aimed at adversaries at home, not across the Channel. Paul Revere's distorted version of the Boston Massacre is an image created in what he understandably regarded as a moral cause. Doré and Daumier, detesting the Russians, turned images of war against them in their cartoons. The Soviet painter who, years after the event, showed the bloodless coup at the Winter Palace in 1917 as a glorious revolutionary feat of arms was indifferent to the prosaic reality.

National heroes have immortality of a kind conferred on them by grateful authorities in their role as patrons of the arts. The death of Nelson quickly assumed an iconographic significance for the English. Benjamin West's equally influential, though less historically accurate, painting of the last moments of the young General Wolfe (Plate 22) is another satisfyingly patriotic work. (West was by birth an American, as also was John Singleton Copley, who painted the equally true-blue *Death of Major Peirson,* illustrated in Plate 24.) The hero-worship that shines through in any picture of Napoleon's victories as painted by Gros must give French viewers the same satisfaction (Plate 46). John Trumbull's version of the climax to the Battle of Bunker Hill (Plate 32), which his side actually lost, is an example of how a patriotic painting can help a nation to remember a shattering event with charity and pride: the hero of the hour, killed in action, was the newly appointed General of Militia, Dr Joseph Warren, who had preferred to fight as a common soldier.

It is not often that a whole community of artists gets caught up in war, as happened to the Impressionists and their friends in 1870. Monet and Pissarro took refuge in England, where they found Daubigny. Boudin moved to Brussels. Other artists joined up. Manet, with his strong Republican sympathies, enlisted in the National Guard as an artillery officer, where he found himself serving under Meissonier. His two brothers joined the Mobile Guard, as did their friend Antoine Guillemet, who had been one of the *Refusés* in 1866. Other artists who donned uniform included Puvis de Chavannes, Carolus-Duran, Félix Bracquemond and James Tissot. Degas tried to join the infantry but was posted to the artillery, owing to his weak right eye. Berthe Morisot's mother wrote during the siege of Paris that Degas said he had not yet heard a shot fired, but was curious to find out if he could stand the noise. The only casualty among the group was Frédéric Bazille, killed on 28 November in the battle of Beaune-la-Rolande. He had enlisted in the Zouaves, a light infantry regiment. Renoir mourned him as 'that gentle knight, so pure in heart; the friend of my youth'. Of all this company, Manet was the only one who left a record of the events he had lived through. He did not dignify them in a painting; but his lithographs speak for themselves.

The outbreak of war in 1914 swept artists, like everyone else, into the great maw. Only a handful, however, found themes in what followed. These, for the most part, were official war artists, men with a licence to observe rather than fight. Nearly all of them survived. Others, among them painters of brilliant promise, did not. Of the Germans, Franz Marc was killed at Verdun in 1916, his only image of war the visionary *Fate of the Animals* painted in 1913 (Plate 54). His friend and fellow Expressionist, August Macke, who might have overtaken him, was an even earlier victim, killed in September 1914. George Grosz served on the Western Front and was shortly afterwards discharged, whereupon he continued to vent his spleen on

the Prussian military (Plate 71), whom he held responsible for the whole obscene affair. Egon Schiele, called up in 1915, was given a job guarding Russian prisoners. He survived the hostilities, only to die in the influenza epidemic of 1918.

Of the French painters already prominent in 1914, Braque found himself a *poilu* in the infantry, and received two citations for bravery before being badly wounded on the Artois front. His skull was trepanned, and after a long spell in hospital he was demobilized in 1916. Matisse was exempt. As a Spanish citizen, Picasso was spared the experiences of his friend Braque. And there is a weird irony in his collaboration on Diaghilev's ballet, *Parade,* which opened in Paris in 1917, virtually within earshot of the German guns, and which the audience greeted with shouts of *'Sales Boches!'*

In more recent times, the reporting of war by photographers, and by television, has helped to shift public attitudes away from patriotic euphoria towards a realistic acceptance of the true squalor and cost. Photography has shown us more of war than even most soldiers usually experience. The literal, black-and-white image can be more shocking, moving, or disturbing, than most paintings. Although some artists have lifted war reporting into the planes of imagination, it is the photographic image that sticks in the mind, from the American Civil War (Plate 47) and the Crimean War (Plate 48) onwards. Like Isaac Rosenberg's rat on the parapet, we have a privileged, unscathed view of death and horror; even of unbearable events that happen in the wake of war, such as a living death in a concentration camp. The question is, does all this enhance our awareness of the evil, or help us to grow a protective skin against it?

Some painters of war have tried to duplicate the camera's-eye view; and there is no lack, in war museums, of panoramic illustrations of famous actions, as meticulous in detail as a blown-up picture on a cinema screen. But illustration of war, in this formal sense, seems to fall into the old, one-eyed stereotype: 'Our side good, their side bad'. The serious artist sets himself the sterner task of refining common thoughts into uncommon emotions, conjuring up images which, as in Goya's *Disasters of War,* transfigure the event. There is no more obvious example in this century than Picasso's *Guernica* (Plate 73).

Here is a painting in which the immediacy of the subject, bombs falling on a defenceless homestead, catches the spectator's breath as it would if he were present. Yet no bomb is to be seen, no explosion, no aeroplane. The subject, typically, is people. The instrument of their distress is outside the painting. Their fears, their cries, the disintegration of their minds and faculties, are what the painter describes. Thirty years after the war that produced this work, an American artist, Rudolph Baranik, took a single image from it – the head and outstretched arm of the dead man at the left of the picture – and turned it into a poster protesting against the war in Vietnam. Like Picasso's original, it was not in colour.

But love, as well as hate, is engendered by war, with its poignant camaraderie, and the helpless sense of pity that young men's deaths inspires in the living. Artists are likely to share these feelings, as is shown in their work. Paul Nash, from the Somme in the spring of 1917, wrote home to his wife: 'There is an easy confident strength, an easy carriage and rough beauty about these men which would make your heart jump and give you a lumpy throat with pride . . .'. Like the poets, he was able to recognize natural beauty even in this hell-hole: 'The dandelions are bright gold over the parapet, and nearby a lilac bush is breaking into bloom'. He would need this tenderness towards the soldiers, and towards nature, if he was to achieve the obverse in his paintings – the 'blasphemy' of sunset and sunrise, 'nothing but the black rain out of the bruised and swollen clouds all through the bitter black of night . . .'. The landscape of *Oppy Wood,* in fact, or of the dreadful *Menin Road* (Plate 62).

There is love, of a recognizable kind, in Henry Moore's records of Londoners sleeping through the Blitz, deep down in underground railway stations (Plates 82, 86). The experience, he confessed, 'humanized' what he had been doing before. One senses it, too, in Eric Kennington's *The Conquerors* and in Ben Shahn's helmetless GI, dead on some Pacific shore (Plate 85). And surely it was love that prompted Franz Marc to paint his prophetic *Fate of the Animals.* His emotions were wholly with God's other creatures, not Man alone. It is a thought we are only now catching up with; maybe just in time.

Albrecht Altdorfer (*c.* 1480–1538)
1 Alexander's Battle

Panel, 62½ × 47¾ in. 1529. Munich, Alte Pinakothek.

Altdorfer, an early Renaissance painter, combines the physical action of Alexander's victory over Darius at the Battle of Issus (333 BC) with the appropriate grandeur of the elements. The fierce engagement is truthfully related, in detail suggesting an eye-witness account; and something of the brutal mêlée that distinguishes real warfare is conveyed in the charging, scurrying figures. The traditionally grandiloquent aspect of war, the waving banners and brave standards, also finds a place in the composition. For Renaissance artists there was still an ennobling dimension to what, in later times, has become an 'outlawed' activity, however actively it is still pursued for political ends.

Paolo Uccello (1397–1475)
2 Niccolò Mauruzi da Tolentino at the Battle of San Romano

Panel, 71½ × 126 in. About 1456–69. London, National Gallery.

Among painters of the Middle Ages, war was seen as a ceremonial parade or tournament; since few painters had ever taken part in battle, the rites of war were usually represented in the formal terms appropriate to the celebration of victories. Uccello's distinctive style, in which pattern-making is predominant, brings to this famous panel a feeling of order which makes it a masterpiece of illustrative art. The figures advance with a purposeful energy emphasized by the tilting lances and the slope of the hills. Individuals emerge from the bright, coherent pattern, picked out in brilliant detail: silver foil for armour; gilt, blues, and reds for saddlery, harness, and plumes.

The noble formality of the action has its counterpoint in the background, where foot-soldiers in hand-to-hand combat add a touch of unstructured realism to what is essentially an exercise in figurative, even geometrical, composition. Panels of the same subject by Uccello in the Louvre and in the Uffizi depict the engagement in its later stages. This one shows the beginnings of the battle, with the Florentines and their leader, Niccolò da Tolentino, confronting the Sienese forces under Bernardino della Ciarda on 1 June 1432.

Leonardo da Vinci (1452–1519)
3 A large cannon being raised on to a gun carriage

Pen and ink, 9⅞ × 7¼ in. Windsor, Royal Library.

One of Leonardo's many achievements, reinforced by later scholarship, was as a military engineer. He was a fertile inventor of warlike machinery, and left drawings for all kinds of offensive weaponry as well as defensive apparatus against all known forms of attack. These devices were offered to Ludovico Sforza, in a letter in which Leonardo wrote of his plans for 'bridges, very light and strong and suitable for carrying very easily . . . and others, solid and indestructable by fire or assault'. He adds: 'I also have plans for making cannon, very convenient and easy of transport, with which to hurl small stones in a manner almost of hail. Also I can make armoured cars, safe and unassailable, which will enter the serried ranks of the enemy with their artillery, and there is no company of men-at-arms so great that they will not break it . . . In short, I can supply an infinite number of different engines of attack and defence'.

The large cannon in this marvellous drawing commands the artist's admiration; but it is the straining, heaving figures that give the work its extraordinary feeling of human effort and persistence.

(right) **Profile of a warrior wearing a helmet and cuirass**

Silverpoint, $11\frac{1}{4} \times 8\frac{1}{8}$ in. About 1480. London, British Museum.

Leonardo drew warriors either as beautiful youths or as semi-grotesque veterans, of whom this is a celebrated example. It probably dates from his time in Verrochio's workshop, and may be taken from a relief in bronze, now lost, representing the Persian king, Darius. The drawing is expressive of kingly power in battle, and the face, though close to caricature, has a savage dignity.

(right) **Head of a man shouting in profile to the left**

Red chalk. 1503. Budapest, Museum of Fine Arts.

Leonardo's *Battle of Anghiari* survives only in copies (see Plate 5) and in drawings done in preparation for the large, ambitious composition, which was conceived as a wall-painting for the Great Hall of the Palazzo Vecchio. It was done as a complement to – and in competition with – a similar commission undertaken by Michelangelo. What the world has lost is suggested in the wonderfully vigorous drawings, so expressive of furious action that the spectator's own imagination has no difficulty in filling in the surrounding scene.

Leonardo da Vinci (1452–1519)
4 *(left)* Studies for the Battle of Anghiari: Head of a man shouting, and a profile.

Black and red chalk. 1503. Budapest, Museum of Fine Arts.

Peter Paul Rubens (1577–1640)
5 The Battle of Anghiari

After Leonardo. Black chalk and gouache. 1505. Paris, Louvre.

Leonardo's original from which Rubens made this grisaille was already obliterated when the painter embarked on it: he may have had to take the subject from an engraving by Lorenzo Zacchia. But the basic design remains: two prancing horses face to face, in attitudes of energetic tension. Rubens has not hesitated to turn the crowded, tight-knit composition into a powerfully conceived unity, catching the essence of Leonardo's concept in lines of confident and dramatic vigour.

Antonio Pollaiuolo (c. 1443–96)
6 *(top)* Battle of the nude men

Engraving, $15\frac{1}{2} \times 23\frac{3}{4}$ in. London, British Museum.

Antonio Pollaiuolo and his brother Piero are noted for their portrayals of men and warriors, in which the well-muscled athleticism of the combatants is offered for our admiration. Vasari says that Antonio flayed corpses so as to record the bones and sinews. Typically, he shows all the muscles in action – realistic, but anatomically impossible. The *Battle of the nude men* is more a a celebration of the masculine form than an image of men engaged in a fight to the death. There is a balletic quality to the composition in which the foreground scuffles contribute an energetic counterpoint.

Michelangelo (1475–1564)
(bottom) Combat of horsemen and foot-soldiers

Pen and ink, 7×9 in. 1504. Oxford, Ashmolean Museum.

This drawing belongs to a series of preparatory studies for a fresco of the battle of Cascina commissioned by the Republic of Florence to decorate the council hall in the Palazzo Vecchio, commemorating an historic victory by the Florentines over their Pisan neighbours. It was to have hung close to Leonardo's *Battle of Anghiari* (Plate 4), facing the altar. The fresco seems not to have progressed beyond the cartoon stage, and even that was in fragments by the time Vasari described it.

It evidently showed how the Florentine troops were bathing in the Arno on a hot day when the alarm was sounded. They waded out of the water, donned their clothes and armour, and ran to engage the Pisan force bearing down on them. It may well have been Michelangelo's masterful studies for this work that convinced Pope Julius II that he was the man to paint the Sistine Chapel ceiling, despite

Michelangelo's protests that he was not a painter but a sculptor. Though the setting of this drawing is unstated, there is no doubt what the scene conveys as the rearing legs of the horses threaten the cowering infantrymen, and the dismounted figure on the right is caught in the split second of releasing his spear. The furious penwork gives the drawing added force. The hatching is so dense that iron rust in the ink has corroded the paper.

Albrecht Dürer (1471-1528)
7 Martyrdom of the Ten Thousand

Wood transferred to canvas, 39×34 in. 1501. Vienna, Kunsthistorisches Museum.

Atrocities are rarely committed in the heat of battle. Dürer's version of a legendary outrage was commissioned by his patron, the Elector Frederick the Wise of Saxony, who wanted it for the chapel in his castle at Wittenberg, where he had a collection of the martyr's relics. Dürer has not spared his patron the cold-blooded detail of how the victims were put to death. The painting nevertheless achieves dignity and grandeur – a testament to Dürer's artistry.

8 & 9 Mining operations at the siege of Chitor

Double miniature from a manuscript of the Akbarnama; paintings by Bhura (left) and Sarwan (right). $13 \times 7\frac{1}{2}$ in. and $13 \times 7\frac{7}{8}$ in. About 1590. London, Victoria and Albert Museum.

Akbar, who reigned over the Mughals from 1556 to 1605, had a lifelong predilection for painting as well as for conquest, and had his own reign chronicled in the Akbarnama. As miniatures, the pictures are remarkable for their vigour and realism, telling of the feats of Akbar on the field of battle, out hunting, and as a tamer of wild animals. He took artists on his campaigns, much as modern armies do, which accounts for the vivid and convincing action in these two miniatures.

Pieter Bruegel (c. 1520-69)
10 The Triumph of Death

Oil, $46 \times 63\frac{3}{4}$ in. About 1562. Madrid, Prado Museum.

War is death. Bruegel's awesome vision of the fate that awaits all men could stand as a testament to that fact. The forces of death, stylized here as skeletons, swarm like the troops of an invading army. They fight with men's weapons, and perpetrate atrocities of man's invention. They are merciless, implacable, cruel. Men cannot fight against them with any hope of winning. Those who try to escape are netted like shoals of fish. There is nowhere to run to, nowhere to hide. Death will win, every time.

Pieter Bruegel (c. 1520-69)
11 The Fight of the Money Bags

Print, $9\frac{3}{8} \times 12\frac{5}{8}$ in. 1564. London, British Museum.

Jan Muller (1571-1628)
12 Bellona leading the armies of the Emperor against the Turks

Engraving, $27\frac{3}{4} \times 20\frac{1}{8}$ in. 1600. Frederick Mulder Collection.

Jacques Callot (1592-1635)
13 *(top)* A Hanging
(bottom) The Firing Squad

From *Les Misères et les Malheurs de la Guerre*. Etchings, $8\frac{1}{8} \times 11$ in. and $8\frac{1}{8} \times 11\frac{1}{4}$ in. 1633. Oxford, Ashmolean Museum.

Callot lived through cruel times. As a boy, his native Nancy was a cockpit for Catholic and Protestant militants, and in later years the Wars of Religion brought banditry and casual terror to the country-side. Such scenes found their way into his series of eighteen etchings, *The Miseries and Misfortunes of War*, published in Paris in 1633. Apart from their vivid picture of the times, his prints are notable for introducing a new technique for etching on copper: the use of a more resistant varnish than the traditional wax, affording much better protection to the plate.

Jacques Callot (1592-1635)
14 Recruitment of Troops

From *Les Misères et les Malheurs de la Guerre*. Etching, 8¾ × 11⅛ in. Oxford, Ashmolean Museum.

Diego Velázquez (1599–1660)
15 The Surrender of Breda ('Las Lanzaz')

Oil, 121 × 143¾ in. 1635. Madrid, Prado Museum.

'In victory, magnanimity' was one of Churchill's precepts for statesmanship among nations. Here, Velázquez represents the surrender of the keys of Breda by the defeated general, Justin of Nassau, to the victorious Ambroglio Spinola on 5 June 1625, to end an occupation of the city by the Dutch that had lasted since 1590. The civilized observances on both sides give the painting dignity and grace. The artist has treated the soldiers of both groups with much sympathy, humanizing the scene by means of expression and character – dejection, fatigue, comradeship. The victor's gesture of embrace unites the adversaries in a moment of Christian brotherhood, after the miseries and enmity of war.

Tintoretto (1518–94)
16 The Battle of the Adige

Oil, 107½ × 152 in. About 1579. Munich, Alte Pinakothek.

This painting is the second in a cycle of four, known as the Gonzaga Cycle, first series, and was painted for the city of Mantua by order of the Duke Guglielmo Gonzaga. Tintoretto was obliged to submit his designs for close examination, to ensure their historical accuracy. In the execution of the commission, the painter made use of assistants, but the over-all magnificence of the composition is characteristically his own. It represents, in realistic attitudes, the actuality of close combat, in an age when scenes of war were commonly set at a distance from the spectator.

Willem van de Velde the Younger (1633–1707)
17 The Battle of the Texel

Oil, 59 × 118 in. 1687. Greenwich, National Maritime Museum.

William Hogarth (1697–1764)
18 The March to Finchley

Oil, 40 × 52½ in. 1749-50. London, the Thomas Coram Foundation.

In this, one of the 'comic history paintings' which helped to make Hogarth's name, the marching troops of the title are tiny figures in the distance. The anecdotal interest is in the foreground, where life of a more ordinary kind is going on: prostitutes at the windows, Jacobites muttering plots, lovers, drinkers, and hobbledehoys going about their business. Each figure, and event, is linked to the next, in a kind of pictorial caption, culminating in an over-all impression that war, in this allegorical guise, means the exploitation of man by man, of man by woman, and of man by his own weaknesses and appetites.

Robert Home (1752–1834)
19 The Death of Colonel Moorhouse at the Storming of Bangalore

Oil, 59 × 78½ in. About 1791. London, Army Museum.

Home's composition for this version of a British feat of arms against the tribesmen of India in 1791 strongly resembles the formula chosen by Copley (Plate 24) and Maclise, in both of which paintings the marksman is being killed in turn by the hero's troops. There is also a close kinship between the dusky sepoy, closely attending to the dying officer's last moments, and the redskin chief whom Sir Benjamin West shows in an almost identical attitude in his *Death of General Wolfe* (Plate 22).

Paul Sandby (1725–1809)
20 The Encampment on Blackheath

Watercolour, 12½ in × 17¼ in. London, British Museum.

In June 1780, England came as close to suffering a violent *coup* as it has at any time since. A crowd of some 50,000 led by Lord George Gordon marched on Westminster, demanding repeal of legislation granting relief to Roman Catholics. The so-called Gordon Riots which followed forced the government to proclaim a state of martial law. Troops were moved into London's parks and open spaces, including Blackheath, where Paul Sandby hastened to capture this study of camp life among the militia.

George Stubbs (1724–1806)
21 Soldiers of the 10th Light Dragoons

Oil, 40 × 50 in. Windsor Castle, Royal Collection.

Portraits by Stubbs tend to contain something of his quirky personality. In this picture of four Light Dragoons, the formalities of uniform and turnout are not allowed to disguise the stolid, almost bucolic nature of the three young men standing on the right. The horse is perhaps a more wooden creature than Stubbs's habitual hunters and Classic winners; but the picture has an engagingly non-military air about it, despite its having been commissioned by the Prince of Wales, who happened to be Colonel Commandant. The right-hand soldier, in the 'Present Arms' position, is perhaps bestowing its salute on the owner. If so, he risks a reprimand for not looking to his front.

Benjamin West RA (1738–1820)
22 The Death of General Wolfe

Oil, 59½ × 84 in. 1770. Ottawa, National Gallery of Canada.

This well-known painting, one of the most admired of its time, marks a turning point in the development of history painting; this gives it an academic significance, even if, to modern eyes, it seems too formal and contrived to portray a real incident. The fate of the gallant young General Wolfe at Quebec was an emotive event, comparable with that of another national hero, Nelson, at the moment of an even more historic triumph. The novelty of West's painting was that it showed the participants in contemporary costume rather than in the classical fancy dress which, up till then, had been *de rigeur* in history painting, even when the subject was a recent event. Reynolds himself went to remonstrate with West when he heard what the painter was up to. He did not persuade him to change his mind, and eventually made handsome amends by confessing: 'West has conquered . . . I foresee that this picture will not only become one of the most popular, but occasion a revolution in the art.'

For all that, the *Death of Wolfe* is hopelessly unhistorical. Of those shown in the composition, only the hero actually took part in his own death scene. The other prominent figures have been identified; and not one of them was there. The Cherokee chief, watching the dying Christian with close attention, ought to be wearing moccasins, say the pundits. Such matters did not bother the public, who thronged to see the painting at the Royal Academy in 1771. Garrick re-enacted the scene in front of the picture for the enraptured crowds; and sales of the print eventually realized £15,000.

Philip de Loutherbourg (1740–1812)
23 The Battle of the Glorious First of June

Oil, 41¾ × 57½ in. 1795. London, National Maritime Museum.

This is probably de Loutherbourg's masterpiece among marine paintings, as appropriately heroic as Turner's *Battle of Trafalgar*, which owes a lot to it. The two paintings actually hung together for a while in one of the state rooms of St James's Palace, Turner's having been commissioned by George IV. This was perhaps an acknowledgement of the kinship between the two, and also a measure of the esteem in which de Loutherbourg's picture was held some thirty years after he painted it. For its date, the *Glorious First of June* is notably uninhibited, the uproar of the occasion being splendidly orchestrated by the artist's flashing brush. The action, in which Lord Howe drove the French fleet back to Brest, at a cost to the enemy of seven ships and 3,000 men, marked the first engagement of the Napoleonic Wars in the English Channel.

John Singleton Copley RA (1737–1815)
24 The Death of Major Peirson

Oil, 97 × 144 in. 1784. London, Tate Gallery.

Major Francis Peirson was the young officer who took command on the island of Jersey when a strong French force attacked on 5 January

1781. He led the small British garrison on a counter-attack, recaptured the town of St Helier, and crushed the attempted invasion. At the moment of victory he was mortally wounded; whereupon his black servant seized a rifle and killed the French soldier who had shot his master. All this is depicted in Copley's painting, which is distinguished by such realistic detail and narrative power that the Duke of Wellington said in later years that this was the only picture of a battle that ever satisfied him, 'inasmuch as the artist only attempted to represent *one* incident and but a small portion of the field, the rest being necessarily concealed by smoke and dust'. The painting's heroic realism made it no less of a propaganda success than Benjamin West's *Death of General Wolfe* (Plate 22), with which it has much in common as an analogue of patriotic martyrdom.

Emanuel Gottlieb Leutze (1816–68)
25 Washington crossing the Delaware

Oil, 149 × 255 in. 1851. New York, Metropolitan Museum of Art, Gift of John Stewart Kennedy 1897.

L. N. Van Blarenberghe
26 The Surrender at Yorktown, 18 October 1781

Oil. 1785. Versailles, Musée National.

John Trumbull (1756–1843)
27 The Surrender of General Burgoyne at Saratoga, New York, 17 October 1777

Oil. 1816–20. Yale University Art Gallery.

In the centre stands Major-General Horatio Gates; to his left in the painting is General John Burgoyne, with his sword, politely returned by Gates. In the background, above Burgoyne's hand, is the face of Major-General Friedrich Adolf Riedesel; in front of the cannon is Colonel Daniel Morgan, then of the 11th Virginia Regiment, clad in buckskin.

The painting, despite Trumbull's title, does not represent the actual surrender of the British forces, at which Lieutenant-Colonel James Wilkinson, Deputy Adjutant-General of the Northern Department, representing Gates, was the only American staff officer present. After the soldiers had laid down their arms, General Burgoyne and his staff, accompanied by Wilkinson, rode to General Gates's headquarters and there were entertained at a sumptuous dinner. Later the British troops marched between parallel lines of American soldiers; after that Burgoyne and Gates emerged from headquarters and the formal military protocol of offering the sword to the victor and of its return took place. Careful as Trumbull was in his effort to make accurate portraits, this did not always extend to the dress. Wilkinson wrote that Burgoyne wore 'a rich royal uniform, and Gates a plain blue frock'.

John Trumbull first planned the painting in 1786, but did not start this small oil until 1816. In 1824 he completed the large, heavy-handed replica of it now in the Rotunda of the Capitol.

Jacques Louis David (1748–1825)
28 Napoleon Crossing the Alps

Oil. About 1804. Versailles, Musée National.

Lady Elizabeth Butler (1846–1933)
29 Scotland for Ever

Oil, 40 × 76 in. 1881. Leeds, City Art Gallery.

Edward Villiers Rippingille (1798–1859)
30 The Recruiting Party

Oil on panel, 32 × 53½ in. 1822. Bristol, City Art Gallery.

A farmer's son from King's Lynn, Rippingille went to Bristol as a young man and became a close friend of the painter Francis Danby. He led a somewhat wayward life, but numbered some interesting people among his circle, including the poet John Clare. *The Recruiting Party,* which includes portraits of several local personalities and friends, was exhibited at the Royal Academy in 1822. It tells its own simple story: the young country lad being tempted by the King's shilling; the recruiting officers conducting themselves with treacherous good humour; the neighbours reacting with indifference or polite concern; the old mother quite overcome; the sister – or perhaps the girlfriend – hovering anxiously as the fateful little drama runs its course.

Sir David Wilkie RA (1785–1841)
31 Chelsea Pensioners reading the Gazette of the Battle of Waterloo

Oil, 36½ × 60½ in. 1822. London, Wellington Museum, Apsley House.

History painting was still in the ascendant when Wilkie celebrated this great event, which he embroidered with his popular skills as a figure and character artist. Like other famous set-pieces, such as Copley's *Major Peirson* (Plate 24), he managed to bring together in his composition many references which spectators would be pleased to recognize. The excited crowd is a visual anthology of London types, of whom the old soldier seated at the right of the table is perhaps the most eloquent. He stares bleakly into space, uncomforted by either beer or 'baccy'. Wilkie's picture was a huge success when exhibited in 1822 at the Royal Academy, where a handrail had to be erected to protect it from the crush.

John Trumbull (1756–1843)
32 The Death of General Warren at the Battle of Bunker Hill

Oil, 20 × 30 in. 1786. Yale University Art Gallery.

The Battle of Bunker Hill, on the Charlestown peninsula, was one of the most costly, in terms of casualties, that the British had to fight in their attempt to crush the American Revolution. Devastated by fierce musket fire, they stormed the redoubt at the second attempt, at the cost of 2,500 killed and wounded, or forty per cent of their total force. It was not a battle for British artists to commemorate; but John Trumbull, who watched it at a distance, turned it into an heroic event for the revolutionaries by focusing on the death, at the height of the action, of Dr Joseph Warren, the newly elected general of American militia, who had chosen to fight at Bunker Hill as an ordinary ranker. Trumbull was only nineteen at the time; it was not until 1786, eleven years later, when he was in London, that he painted this picture.

James Gillray (1757–1815)
33 Promis'd Horrors of the French Invasion

Aquatint, 12 × 16½ in. 1796. London, British Museum.

Gillray's sub-title to this scathing print is 'Forcible reasons for negotiating a Regicide Peace' – a reference to Edmund Burke's newly published 'Thoughts on a Regicide Peace' and to the invasion scare. In Gillray's imagined horrors, the Whigs have turned out in support of the dreaded French revolutionaries to overturn the government. St James's Palace is on fire; Charles James Fox is laying into William Pitt with a birch; Canning is trussed up on a lamp standard. A revolutionary bonnet has been hung on the lamp outside Brooks' (Whig) Club, while French troops burst into the Tory stronghold, White's. The Duke of Richmond's head rolls on the street like a football, and a patriotic bull is tossing Burke with every appearance of satisfaction. Some of the royal princes are being tipped unceremoniously over the balcony: for once, perhaps, the Royal Family has Gillray's hypothetical sympathy.

Paul Revere (1735–1818)
34 The Bloody Massacre perpetrated in King Street, Boston, 1770, on 5 March, by a party of the 29 Regiment

Line Engraving, 12½ × 11¼ in. 1770. Boston, Mass., Museum of Fine Arts. Bequest of Charles Hitchcock Tyler.

Paul Revere, a potent figure in American folk history, was a former artillery officer turned goldsmith and copperplate printer. He was involved in the Boston Tea Party, was head of a secret society to keep an eye on the British, and a rouser of the minute-men on his famous ride from Charleston to Lexington on 18 April 1775. The 'Bloody Massacre' at Boston which this print depicts became an emotive event in the series of ruptures which led to the War of Independence, or, as it is known in the United States, the Revolutionary War. On 5 March

1770, a mob surrounded a British sentry on duty outside the Customs House in Boston, taunted him, and threw snow and ice at him. Seven other soldiers emerged, plus an officer, whereupon the demonstrations grew noisier and more threatening. Shots rang out, and five of the mob fell dead or mortally wounded.

Revere's version, printed within three weeks of the event, takes liberties with the facts for propaganda purposes: it shows the soldiers in the attitude of a firing squad, apparently mowing down an innocent crowd of citizens at point-blank range. At the ensuing trial, the soldiers were defended by American lawyers who all later became rebel leaders. Two were found guilty of manslaughter, and the other six were acquitted.

Revere, it seems, had stolen the idea from another printer, Henry Pelham, but beaten him to publication. Whatever the facts of the incident, it was Revere's version that people believed – and, no doubt, wanted to believe. This scrap of paper hastened the outbreak of the rebellion in 1776.

Francisco de Goya (1746–1828)
35 Execution of a Rioter

Detail of Plate 37

Jacques Louis David (1748–1825)
36 The Sabine women stopping the battle between the Romans and the Sabine men

Oil, 152 × 204¾ in. 1799. Paris, Louvre.

David's incarceration as a political prisoner in 1795 (he had been a champion of the recently fallen Robespierre) gave him an opportunity of planning a fresh start to his career. The theme he chose for this painting was not the rape of the Sabine women, as is often mistakenly supposed, but the subsequent raid on the Roman abductors by the women's aggrieved menfolk. The children in David's painting, therefore, are the children by their Roman husbands. Hersilia, one of the Sabine women, dominates the centre of the composition with a wide-flung gesture that appeals to both her Roman consort, straddled in the foreground, and to her Sabine father, the bearded figure on her right. The two men are caught at a moment of indecision; should they fight one another, or not?

This suggestion of reconciliation even in the midst of bitter conflict persuaded Frenchmen that David's latest work contained a message for the times, an appeal for peace between the families of France now tearing each other apart. *The Sabines* was put on public view, for a fee payable at the door. It made David a fortune, and restored him, with Napoleon's blessing, as the premier painter of the Republic.

Francisco de Goya (1746–1828)
37 Shooting of the Spaniards by the French on the Third of May, 1808

Oil, 104¼ × 136 in. 1814. Madrid, Prado Museum.

Goya recorded this event in 1814, six years after it happened. By then, the French occupation of Madrid was over. Goya, after an investigation to determine his allegiance – he had been given a decoration by the French, though he never wore it – was reinstated as First Painter to the Spanish monarchy. The third of May, 1808, followed a day on which mamelukes butchered a crowd of demonstrators in the streets near the royal palace. Rioters who had been caught were later taken out and shot beside the hill of Principe Pio. In Goya's account – though he was not an eye-witness – the civilians are caught in the very presence of death. The levelled rifles, aimed by faceless men, accentuate the terrible proximity. The living, the dead, and those in the instant of dying, share the lantern's neutral light. The executioners stand in shadow, their well-drilled line made more menacing by its deliberate lack of perspective. No-one here is a hero. Man degrades man, and is himself degraded.

Eugène Delacroix (1799–1863)
38 The Massacre at Chios

Oil, 20¼ × 15 in. 1824. Paris, Louvre.

This is the painting that the young Delacroix extensively repainted, in a state of high excitement at discovering Constable's *The Hay Wain*, loaned to the Salon of 1824, with its revelations of fresh colour and free brushwork. He later called Constable 'an admirable man, one of England's glories', adding: 'He and Turner were real reformers. They

broke out of the rut of traditional landscape painting. Our school profited greatly by their example.' The subject treated here is the slaughter of Greeks by Turks on the island of Chios in 1822, in which 20,000 islanders were reputedly killed and the rest carried off as slaves: an emotive subject, well calculated to cause a sensation at the Salon. It stands today as one of the great manifestations of the Romantic movement in France.

Francisco de Goya (1746–1828)
39 *(top & bottom)* Two plates from The Disasters of War: 'Duro es al paso' and 'Estagos de la guerra'

Aquatints, 5¼ × 6¾ in. About 1812.

For all the passion of his response to war, Goya was not, in the political sense, a partisan. He did not take a doctrinal stand, only a human one. His heroes were the common people, whose sufferings he recorded in the series of 82 aquatints done between 1812 and 1823. Besides being illustrative of scenes which he had witnessed or been aware of, the plates are symbolic of the rape and despoliation of his homeland. He seems to have intended them as a public gesture; but ironically, the return of King Ferdinand in 1814 only ushered in a new round of repression and cruelty as the régime paid off old scores and persecuted the liberals.

The *Disasters*, therefore, were never published in Goya's lifetime. The first edition appeared only in 1863, under the auspices of the Royal Academy of San Fernando. Both the plates illustrated, done early in the series, show outrages perpetrated by the French during the occupation. The Spaniards' detestation of their persecutors was all the more bitter for their earlier expectation that the liberated Republicans would relieve them of the tyranny of their own rulers. Goya's titles to the plates are rich in laconic sarcasm. His last word, however, is a hopeful one: an allegorical group showing Peace as a ripe countrywoman, in company with Labour, a peasant. Goya captioned it *Esto es lo verdadero* – 'This is the truth'.

40 Christian Wilhelm von Faber du Faur (1770–1857)
Auf der grossen Strasse von Mohaisk nach Krymskoje

Lithograph, 8½ × 12¾ in. 1812. Cologne, Wallraf-Richartz Museum.

Nicolas-Toussant Charlet (1792–1845)
41 The Baptism of Fire

Lithograph, 18 × 13½ in. About 1818. London, British Museum.

Charlet, who acquired much of his artistic skill from Gros, made a name as a caricaturist and illustrator, particularly of child studies and episodes from the Napoleonic Wars. He is credited with putting some life into lithography, which had tended towards the pastoral and the genteel. He was much admired by his contemporaries, notably Delacroix, who compared him with Molière and La Fontaine as a master moralist. This was carrying enthusiasm to extremes, but it does point to qualities in Charlet which set him apart from the artist-illustrators of his time. Certainly this unheroic vignette, a soldier's first, bowel-churning experience of coming under fire, is a vivid and original image of war.

Théodore Géricault (1791–1824)
42 *(top)* Mameluke unhorsed by attacking Grenadiers: episode from the Egyptian campaign

Black crayon, Indian ink and gouache, 8⅜ × 11⅛ in. About 1818. Paris, Louvre.

(bottom) Field artillery during a battle

Black chalk, pen and ink, watercolour and white gouache. 8¾ × 11¼ in. About 1818. Paris, Louvre.

The development of lithography as a means by which artists could make their work more widely known, and at the same time tackle subjects less constrained by academic convention, was instrumental in releasing some of Géricault's extraordinary energies. The drawings for these lithographs have a pleasing freedom about them, as opposed to the somewhat rhetorical style of military painting at this time. This is a drawing which documents a moment in war as convincingly as any subject that Géricault ever painted.

Théodore Géricault (1791–1824)
43 Wounded Cuirassier

Oil, 21 × 18 in. About 1812. New York, the Brooklyn Museum.

This is a study for Géricault's exhibit at the 1814 Salon, *Wounded Cuirassier Leaving the Field of Battle,* now in the Louvre. In contrast to the form it takes in the finished picture, this sketch has a quality which, for all the freshness and immediacy of the painter's brushwork, gives it a symbolic, almost monumental character. The painting into which Géricault worked this passage stands for France defeated. The sketch seems to stand for France defiant.

Emile-Jean-Horace Vernet (1789–1863)
44 The Battle of Valmy

Oil, 68¾ × 113 in. Detail. 1826. London, National Gallery.

Emile-Jean-Horace Vernet (1789–1863)
45 The Battle of Hanau

Oil, 68½ × 113¾ in. Detail. 1824. London, National Gallery.

Antoine Jean Gros (1771–1835)
46 Napoleon at Eylau

Oil, 209 × 315 in. About 1808. Paris, Louvre.

Gros owed his early good fortune as a painter to a meeting with Napoleon's bride, Josephine, in 1796. She persuaded the great man to sit for his portrait by Gros (to whom she was evidently attracted) by holding him on her lap while he struck suitable attitudes. Gros became the chief propagandist in paint for the Emperor, glorifying his triumphs in each year's Salon. He had no conception of what war was really like, and was concerned only with hero-worship. His romantic myth-making came close to the notions of greater French painters, such as Delacroix and Géricault, but collapsed when he tried applying the same methods to the infinitely less heroic successors to his hero, the mean and pallid Bourbons (one of whom, Charles X, made him a baron). In the end he became a laughing-stock – undeservedly, in the judgement of art historians – and was driven to suicide by jumping in the Seine. It was at Eylau that Napoleon routed the combined forces of Russia and Prussia on a bitter February day in 1807, the year in which he became the overlord of Europe.

Roger Fenton (1819–69)
47 The Field where General Reynolds Fell, Gettysburg, July 1863

Photograph. 1863. London, Colnaghi's.

Roger Fenton (1819–69)
48 A battery in the Crimea

Photograph.

Lady Elizabeth Butler (1846–1933)
49 Balaclava

Oil. 40¹⁵⁄₁₆ × 73¹³⁄₁₆ in. 1876. Manchester, City Art Gallery.

Edouard Manet (1832–83)
50 The Execution of Emperor Maximilian of Mexico

Oil, 99¼ × 120 in. 1867-8. Mannheim, City Art Gallery.

The feelings of agonized protest that make Goya's *The Third of May* (Plate 37) such a potent symbol were shared by Manet, who in 1863 painted the first version of this (for the time) shockingly cold-blooded picture of Maximilian meeting his death before a Mexican firing squad. Maximilian had been encouraged by Napoleon III to assert his claim as emperor of Mexico, and then was abandoned to his fate. The subsequent execution shook France, where Napoleon III was widely reviled for his perfidy and for the fate of Maximilian's young widow,

who went mad. Manet's painting – he did four versions – lacks the intensity of Goya's masterpiece, but makes its point in ways which, to modern eyes, are no less telling. In particular, the separation of the people from the event, which takes place behind a high wall, is close to the realities of political atrocity in our own day. As in his painting of the 'Kearsage' and the 'Alabama' a year later, Manet takes the position of a professional spectator, anticipating the role of the news photographer.

Jean-Louis-Ernest Meissonier (1815–91)
51 The Siege of Paris

Oil, 20⅛ × 26⅜ in. 1870-71. Paris, Louvre.

Henri Rousseau (1844–1910)
52 War (La Chevauchée de la Discorde)

Oil, 45 × 76¾ in. 1894. Paris, Jeu du Paume.

Anonymous
53 No. 36 in an Album of episodes from the Sino-Japanese War

Printed book. 1894. London, Victoria and Albert Museum.

Japan exploded into the modern world in the mood of a medieval nation that couldn't wait to catch up. War with China broke out in August 1894, and the capture of Port Arthur announced Japan's arrival as a power in the world. The Chinese were outfought both on land and sea, and sued for peace. This heady victory infused the Japanese with the spirit of *Nihon Shugi,* a rabid patriotism that was destined to lead them to Pearl Harbour and all that followed. In this painting of a Japanese force over-running a Chinese position, the defenders are shown as a crudely armed peasant army, no match for the smartly uniformed riflemen of Nippon led by their sabre-swishing commander. The action has a compelling energy, both theatrical and realistic.

Franz Marc (1880–1916)
54 Fate of the Animals

Oil, 76¾ × 103¾ in. 1913. Basle, Art Museum.

Marc's empathy with creatures of the natural world was responsible for his sometimes sentimental, sometimes morbid, use of them in what he called the 'Animalisation' of his art. 'Don't we all believe in metamorphosis?' he asked rhetorically in one of his passionate articles. He used colour to express his emotions about animals, which became increasingly agitated with the approach of war. *Fate of the Animals,* painted in 1913, can be seen as an Expressionist vision of the slaughters ahead. The deer and ponies stand for innocence, helplessness, mute suffering. The fury which catches them in a livid crossfire stands for the mechanistic forces that cut down everything in their path. The war was to cut down Marc, too: he was killed at Verdun three years later.

Wyndham Lewis (1882–1957)
55 A Battery Shelled

Oil, 72 × 125 in. 1918. London, Imperial War Museum.

Wyndham Lewis was one of the earliest English painters to absorb Cubism, which influenced his work for the rest of his career. *Battery Shelled* is strong in Cubist design, which was to take Lewis into his Vorticist phase in the years after the war. The painting makes a disturbing impression of violent action contrasted with seemingly total inaction: the soldiers under fire crouch and strain, while those on the left, whom we take to be officers, assume attitudes of complete detachment. One of them even glances out of the picture, as if in search of something more interesting to look at. The shapes of twisted steel, churned-up earth, and shattered trees add their own separate elements to the imagined horror.

C. R. W. Nevinson (1889–1946)
56 La Mitrailleuse

Oil, 24 × 20 in. 1915. London, Tate Gallery.

The tension of soldiers manning the machinery of war gives this strongly Futurist work its remarkable power. The French machine-

gunners, defending a shattered strongpoint, exhibit the concentration and fearfulness of action. A broken cruciform structure seems to pin the left-hand soldier to his post. The bespectacled, clerkish soldier in the right-hand corner is a reminder that these men are not professional warriors but civilians in uniform, defending their land and homes. The spectator is present as a fourth occupant of this tiny space, as close to the drama as if he too were taking part.

Otto Lehmann
57 Stüzt unsre Feldgranen-Zereisst Englands Macht-Zeichnet Kriegsanleihe

Colour lithograph, 38¼ × 27 in. 1914-18. London, Victoria and Albert Museum.

A German war loan poster. The text reads: 'Protect our field grey – destroy England's might – support the war loan.'

John Nash (b.1893)
58 Over the Top: First Artists' Rifles at Marcoing

Oil, 31¼ × 42¼ in. 1917. London, Imperial War Museum.

This is the scene that epitomizes the heart-wrenching sacrifices of the Great War, and haunts the minds of generations then unborn: the moment when men climbed or crawled out of the relative safety of the trenches to face an unseen enemy through a hail of fire. The moment has been captured on cinema film, and by war photographers. Nash tells the truth as these live images also reveal it: fear in the pit of the stomach; death for men who are hit before they can even straighten up; the stumbling run of those still alive, leaving fallen comrades behind; the stricken soldier who collapses on to his knees, in an involuntary attitude of hopelessness and prayer. Snow has blanketed the landscape in a clinical whiteness, on which the blood shows red.

Stanley Spencer (1891–1959)
59 Travoys Arriving with Wounded at a Dressing Station, Smol, Macedonia

Oil, 72 × 86in. 1919. London, Imperial War Museum.

Dewey
60 Our Daddy is Fighting at the Front for you

Colour lithograph, 28¼ × 18½ in. 1917. London, Victoria and Albert Museum.

United States war loan poster.

Anonymous
61 Anti-Trotsky poster

Colour lithograph, 31 × 21¾ in. 1917. London, Lord's Gallery.

The poster represents Trotsky climbing over the walls of the Kremlin, red and dripping with blood, and wearing the Soviet star on a chain. In the foreground Mongolian troops shoot a bound peasant. A vault full of skulls and skeletons lies under the Kremlin walls. The text reads: (top) 'Workers' and peasants' government.' (middle) 'ORDER. All for the Red Army. Pitiless repression and confiscations. All is allowed to the Military Commissars in the interests of the Red Army. Let children perish. Let women die of hunger. Let the peasants be deprived of the seeds they need for sowing. Let moans and tears fill the countryside so that the Red Army lacks nothing. The Commander-in-Chief, Trotsky.' (bottom) 'Published by the Odessa Propaganda Section.'

Paul Nash (1889–1976)
62 The Menin Road

Oil, 72 × 125 in. 1919. London, Imperial War Museum.

The impact of war on Nash was of an unspeakable outrage on a vulnerable intelligence. He spent three years as an infantryman in the Artists' Rifles before being appointed as an official war artist, so that he brought to his paintings of the Front the experience of a combatant as well as the sensibility of an artist and trained observer. *The Menin Road* is a definitive statement, a summing-up of all that Nash saw and felt about the killing-ground of Flanders. It was painted with a particular destination in mind: the proposed Imperial War Museum, London, where these events would be commemorated in a permanent exhibition. Herbert Read, whose war poetry contains images and feelings very close to those of Nash, wrote of his paintings that they told the truth about 'our hellish existence in the trenches . . . Here was someone who could convey, as no other artist, the phantasmagoric atmosphere of No Man's Land.'

George Horace Davis (b.1881)
63 Closing up

Oil, 38 × 60 in. 1919. London, Imperial War Museum.

This is the scene, made familiar in two generations of war fiction, and in the cinematic genre that started with *Hell's Angels,* in which men fought each other in the sky from slow-moving flying machines. It represented the only action of the Great War that came close to the traditional, though romanticized, concept of chivalry in mortal combat. Soldiers might fight bravely and die unhonoured; the pilots achieved personal renown. In this reconstruction, a bombing formation of De Haviland 4 biplanes, attacked by a squadron of Fokker triplanes, closes formation so as to concentrate its fire-power on the swooping, more manoeuvrable, enemy.

Otto Dix (1891–1969)
64 Flanders

Oil, 78¾ × 99½ in. 1934-35. West Berlin, Nationalgalerie.

65 Rehearsing 'Cinderella': by the Kite and Balloon Section, Royal Flying Corps, at Bapaume, 2 January 1918.

Photograph. London, Imperial War Museum.

66 A dead German outside his Dugout, Beaumont-Hamel, November 1916

Photograph. London, Imperial War Museum.

C. R. W. Nevinson (1889–1946)
67 Paths of Glory

Oil, 18 × 24 in. 1917. London, Imperial War Museum.

Nevinson is an artist who owes the greater part of his reputation to his imaginative and personalized paintings from the Great War, in which he served in the Red Cross and army medical corps. A fellow pupil of Paul Nash at the Slade School, he was stirred by the war into work of a fiercer intensity than anything he achieved later. In his war paintings he blends Cubist and Futurist elements to make strikingly personal images, as in the well-known *Star Shell* (London, Tate Gallery). Here his subject is of the kind caught by the camera, its ironic title expressing the embittered, anti-heroic view of the war which replaced the first patriotic euphoria.

Augustus John (1878–1954)
68 Canadian Soldier

Oil, 28½ × 20¾ in. 1918. London, Tate Gallery.

When Augustus John was commissioned, under Lord Beaverbrook, as official artist for Canadian War Records, he was allowed to keep his beard, 'as did one other officer in our army', he recalled later: 'the King'. While exploring the Canadian sector from Béthune to Arras, he came across a friend and fellow war artist, Wyndham Lewis (Plate 55). At Aubigny, where John settled down to draw portraits of Canadian soldiers, there was a restaurant kept by a respectable French matron (as John calls her in his memoirs), a favourite stop-over for soldiers on their way to, or from, the Front. Learning that she had formerly kept a similar establishment in German-occupied territory, Lewis asked her: 'Alors, est-ce qu'on vous a violé, madame?' To which the *patronne,* drawing herself up, replied: 'Monsieur, les Boches se sont conduits beaucoup mieux que vous.'

James Montgomery Flagg
69 'I want you for U.S. Army nearest Recruiting Station'

Lithograph, $39\frac{1}{2} \times 27\frac{3}{4}$ in. 1917. London, Imperial War Museum.

Stanley Spencer (1892–1959)
70 Unveiling a War Memorial at Cookham

Oil, 60 × 60 in. 1921. Private Collection.

War ends at last, the young men come to rest. In an English village everyone who is left turns out for the unveiling of a monument to the fallen, whose names are inscribed in the new stone. They sing a hymn in the sunshine. A few youths lounge on a grassy bank, unconsciously mimicking the dead. A white-clad schoolgirl turns round to catch the eye of one of the boys. Life goes on.

George Grosz (1893–1959)
71 KV: Fit for Active Service

Pen, brush and ink, 20 × $14\frac{1}{2}$ in. 1916-17. New York, Museum of Modern Art.

Kriegsverwendungsfähig, KV for short, was a sentence Grosz feared. 'They still put the call-up papers on the hoardings. To the slaughterhouse!' The Prussians were beginning to scrape the barrel – even a discharged soldier, like Grosz, was liable to be recalled. The artist's bitter opposition to the war overflowed into dislike of his own people. He wrote: 'Day after day my hatred of the Germans is nourished afresh to hot flames . . . From an aesthetic point of view, I am happy about every German who dies a hero's death on the field of honour.'

72 (left) Defenders of the new – and doomed – Spanish Republic

Photograph. 1936. London, National Portrait Gallery (Herald Archive).

(right) Drun falls to the Nationalist Rebels

Photograph. 1936. London, National Portrait Gallery (Herald Archive).

Members of the Spanish Foreign Legion (Nationalist Rebel troops) photographed having a smoke on entering Drun. With them is the only Red Cross nurse to enter the city.

Pablo Picasso (1881–1973)
73 Guernica

Oil, 138 × 308 in. 1937. New York, on extended loan to the Museum of Modern Art from the artist's estate.

Guernica, the most celebrated 'protest' painting of modern times, was Picasso's impassioned response to the bombing by Fascist warplanes of the defenceless Basque market town on 28 April 1937. He ordered a huge canvas, 26 feet long by $11\frac{1}{2}$ feet high, on which to project his horror, as he said at the time, 'at the military caste which has plunged Spain into a sea of suffering and death'.
The painting is in black, white, and grey – the tones of a newspaper which brought the painter the news. It creates a total universe of shock and alarm, from the woman falling from a burning house at the right, to the bull – Picasso's hero-figure – who stands nervously in the open door at the left. The horse, grimacing with pain, is Picasso's symbol of mute suffering: like the bull, he is a participant in the great metaphorical drama, the *corrida*. The remnants of a civilian warrior lie scattered about; the other victims, including the mother with her baby, are in the last extremities of terror. A light bulb, simulating the sun, looks down with its pitiless electric eye. *Guernica* was hung in the Spanish pavilion at the 1937 World's Fair, in Paris. It subsequently travelled to New York, where it remains. Picasso's instructions were that it must not be brought back until democracy is restored in Spain.

74 The Flotsam of War

Photograph. 1936. London, National Portrait Gallery.

Orphaned Spanish children reach the frontier town of Le Perthus in a covered wagon.

Edward Burra (1905–76)
75 Soldiers at Rye

Watercolour, $41\frac{1}{2} \times 81\frac{1}{2}$ in. 1942. London, Tate Gallery.

The cataclysmic event in Edward Burra's strangely solitary life was the eruption of the Spanish Civil War. He was in Madrid at the time, and later recalled the shock of the event: 'churches on fire, pent-up hatred everywhere.'
Already steeped in Spanish art, he was also strongly drawn to Mexico, with its history of blood, beauty and heroism. The Conquistadors reappear in this painting, done in reaction to the vastly greater holocaust that led from the Spanish Civil War. *Soldiers*, painted in 1942, is both exotic and satirical, introducing elements of Burra's highly individual imagination.

Salvador Dali (b.1904)
76 Soft Construction with Boiled Beans: Premonition of Civil War

Oil, $39\frac{1}{2} \times 39\frac{1}{2}$ in. 1936. Philadelphia Museum of Art, Arensberg Collection.

Dali has an essentially Spanish imagination, in which a fascination with death and an intuitive sense of the fantastic remain uppermost. His premonition of the Spanish Civil War, painted in 1936, draws on typical Dali-esque imagery: dismemberment, decomposition, sexual symbolism, pain. The background is the bleak and ageless desert landscape in which so many of his weirder compositions are set. Dali's premonition was quickly overtaken by the event. Shortly afterwards, he was expelled from the Surrealist group and went to live in the United States. He returned to Spain in 55, and lives there still.

Max Ernst (1891–1976)
77 Europe After the Rain

Oil, $21\frac{1}{2} \times 58$ in. 1940-2. Hartford, Wadsworth Atheneum.

Max Ernst's highly charged Surrealist imagination infuses his work with a dreamlike intensity, and over the years commentators have sought to unravel the Freudian symbolism of his statements in paint. As a German, Ernst was not welcome in wartime Europe or, latterly, in the United States; on the other hand, he was condemned by his fatherland as a decadent and a renegade. After the outbreak of war he was interned several times, but eventually managed to reach Lisbon with a quantity of his work, and found his way to America. There, he drew fresh power and imagery from the ancient spaces of Arizona. *Europe After the Rain* dates from this period. It is a realization in his own terms of an historic landscape seen as a bloodstained wilderness. The bird-man personifies the artist in a mythological guise.

Wyndham Lewis (1882–1957)
78 The Surrender of Barcelona

Oil, 33 × $23\frac{1}{2}$ in. 1934-7. London, Tate Gallery.

The Spanish Civil War engaged the passions of many artists and intellectuals in Britain, most of them on the side of the Republicans. Wyndham Lewis, however, as a right-winger, supported the insurgent forces of General Franco. His political sympathies are not overtly apparent in this painting, in which the militaristic figures in armour are in effect allegorical elements in the stylized design. The pictorial references hark back to medieval and early Renaissance treatments of warlike themes: the elongated lances, in particular, are reminiscent of Bruegel's in the *Massacre of the Innocents*. By these means, Lewis was able to make a non-political statement about the event, the human tragedy of which is summed up in the single figure hanging by the neck in the very centre of the picture.

79 Remaining Possessions

Photograph. 1936. London, National Portrait Gallery.

The Spanish Civil War: a girl combatant looks after the mascot of the insurgent troops.

Ben Shahn (b.1898)
80 This is Nazi Brutality

Letterpress print, $38\frac{1}{4} \times 28\frac{1}{8}$ in. 1942. Washington, Library of Congress.

81 The Victims of Belsen

Photograph. 1945. London, National Portrait Gallery.

During the advance of the 2nd Army the huge concentration camp of Belsen was relieved. Some 60,000 civilians, mostly suffering from typhus, typhoid and dysentry, were dying in their hundreds daily, despite the frantic efforts being made by medical services rushed to the camp. The camp was declared a neutral area before advance patrols arrived and the Allied Military Government stood by to reach the camp at the earliest possible moment, to be faced by the most indescribable scenes – 60,000 people starving and without water for over six days. The camp was littered with dead and dying and on closer investigation it was discovered that the huts capable of housing about 30 people in many cases were holding as many as 500; it was impossible to estimate the number of dead among them. The others were too weak to remove the bodies so they just had to remain. In many cases they had died by suffocation, being too weak to move. Despite all this horror S.S. guards still remained in command of the camp, including the Commandant. After liberation the S.S. men were made to cart away and bury in their thousands the unfortunate civilians who had been slowly tortured to death.

82 (top) The Bearers of Bad News (after Lecomte du Nouy). And Who Next?

1939. London, National Portrait Gallery.

(bottom) Surviving the Blitz

Photograph. 1940. London, National Portrait Gallery.

Leonard Rosoman (b.1913)
83 House Collapsing on two Firemen, Shoe Lane, London

Oil, 36 × 30 in. 1940. London, Imperial War Museum.

Paul Nash (1889–1976)
84 Totes Meer (Dead Sea)

Oil, 40 × 60 in. 1940-41. London, Tate Gallery.

The Second World War reintroduced Paul Nash to hostilities, and for the second time he succeeded in being appointed an official war artist. 'I want to use what art I have as directly as possible in the character of a weapon,' he said. He became fascinated by shot-down aircraft, lying around the English countryside like mechanical corpses from another world. At this time he was also absorbed in the symbolism of oceans threatening the land, so that when he was shown a huge dump outside Oxford – a graveyard of enemy planes – he saw it as a metallic sea of dead creatures piling up against the shore, presided over by a rising moon, its only visitor a marauding owl.

Ben Shahn (b.1898)
85 Death on the Beach

Tempera, 10 × 14 in. 1945. New York, Mrs Rosalie Berkowitz Collection.

An American painter born in Lithuania of Jewish parents, Ben Shahn has used folk art and folk themes to give his work a broad appeal, though always with an insistence on realistic essentials. He could be a strongly committed 'political' painter, as in his reaction to the Sacco and Vanzetti murder trial of 1920 and the consequent witch hunt for supposed agitators. *Death on the Beach* stands as a grim memorial to the American troops who attacked the Japanese, island by island, in the South Pacific.

Henry Moore (b.1898)
86 Tube shelter perspective

Chalk, watercolour and pen, 18¾ × 17 in. 1941. London, Tate Gallery.

It took an artist of Moore's genius to recognize the dignity and pathos of Londoners at war: not fighting fires, or defying the Blitz, but sleeping, deep underground, where by day the tube trains still ran. Seeing his fellow men and women in such conditions, stoically surviving, moved him to some of his most powerful work. He said: 'I saw hundreds of Henry Moore Reclining Figures stretched along the platforms . . . The impact made by the whole improvized succession of scenes down here in the underground was quite important for me. It humanized everything I had been doing.' What Moore was trying to portray in these studies was 'the depth of this place where these people were talking and sleeping, the distance they were away from the war that was raging above their heads, but of their awareness of it in their faces, in their attitudes, in the stale air around them.'

Anonymous
87 She Talked . . . this Happened

Colour half-tone, 20 × 13¼ in. 1939-45. London, Victoria and Albert Museum.

English poster issued by the Ministry of Information during the Second World War.

88 (left) Caron – You won't Scuttle this one

London, National Portrait Gallery.

Anonymous
(right) Maneater

Colour lithograph, 30 × 20 in. 1942. London, Victoria and Albert Museum.

89 (left) The Shape of Things to Come

Photograph. 1939. London, National Portrait Gallery.

A photographic impression of Adolf Hitler as many people would have liked to see him.

Anonymous
(right) O Tommy!

Lithograph. 1943. London, National Portrait Gallery.

A crude attempt by Japanese propaganda artists to copy Hollywood film posters. Leaflet dropped in Malaya over Allied lines in an attempt to weaken morale.

90 Belsen Concentration Camp Victims

Photograph. 1945. London, National Portrait Gallery.

Two small children who were starved to death by the Nazis.

Henry Moore (b.1898)
91 Pink and Green Sleepers

Chalk, watercolour and pen. 12½ × 21¼ in. 1941. London, Tate Gallery.

Moore's war drawings turned his subjects back into the organisms from which, in nature, he was used to finding human forms. There is a monumental dimension in these sleeping forms, which in another mood can also be seen as bodies neatly laid out in shrouds, as in a catacomb; or as some kind of human pupae, waiting to be born.

Vasco Taskovski
92 The Riders of the Apocalypse (1939)

Oil, 45¼ × 54 in. 1971. Belgrade, The People's Army Club.

Vasco Taskorški here is strikingly successful in giving a demonic rush of movement to the Apocalyptic bearers of war, famine, pestilence and death. As with other Yugoslav artists of today, his feeling is strongly anti-militaristic and this gives an added impetus. Colour plays its part in the intensity of effect, ranging from an icy blue to yellow, red, and the sinister purple cloud beneath. The horsemen of the original vision – depicted with so much grandeur by Albert Dürer – are fittingly described in the more general term 'Riders', in that they seem to bring a combination of sinister modern weapons into action against a suffering multitude.

Roy Lichtenstein (b.1923)
93 Whaam!

Acrylic, 68 × 160 in. 1963. London, Tate Gallery.

The explosion of Pop Art in the 1960s caused a widespread fallout of fragmented matter, all of it ephemeral and none of it, by previous standards, the stuff of art. Lichtenstein's straight-faced homage to the folk images of comics and children's magazines impressed a public who felt themselves at home with this modern art. The fact that works like *Whaam!* were sheer mimicry was not a disqualification. Lichtenstein carefully painted in each of the coloured dots that make up the original printed image, retaining the coarse tones and emphatic lines which are part of the strip illustrator's technique. In all this, the painter keeps his own feelings out of sight: the image is all. *Whaam!* epitomizes the persistence of war stories, myths, and inventions as part of the modern culture.

Anonymous
94 I Want Out

Offset Lithograph 40 × 30 in. 1971. London, Victoria and Albert Museum. Gift of Mr Jack Rennert.

Re-issue of an American anti-Vietnam poster depicting Uncle Sam, originally issued by the Committee to Unsell the War in 1971.

95 *(top)* Allied prisoner after the Liberation of Singapore

Photograph. London, National Portrait Gallery.

(bottom) Fortune of War

Photograph. 1950. London, National Portrait Gallery.

An American soldier in a jeep bound for the front line in Korea watches as this elderly refugee flees the advancing North Korean troops. The old man has all his worldly goods on his back as he trudges on his way, seeking safety.

96 I want you for U.S. Army

Lithograph, 39½ × 27¾ in. 1972. London, Imperial War Museum.

A savage satire on James Montgomery Flagg's call to arms (Plate 69), published as a protest against the Vietnam war.

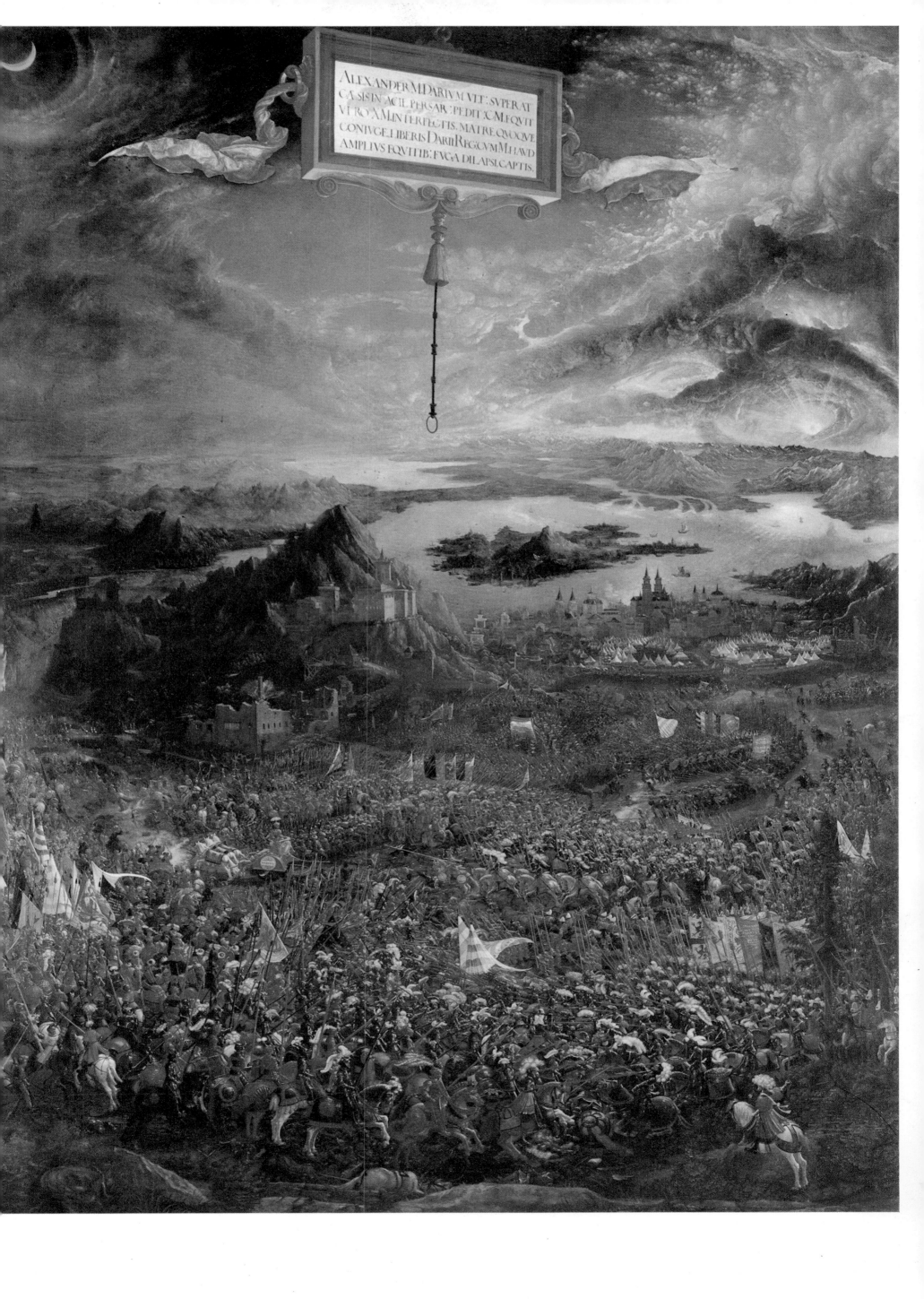

ALEXANDER·M·DARIVM·VLT·SVPERAT
CÆSIS·IN·ACIE·PERSAR·PEDIT·:C·M·EQVIT
VERO·X·M·INTERFECTIS·MATRE·QVOQVE
CONIVGE·LIBERIS·DARII·REG·CVM·M·M·HAVD
AMPLIVS·EQVITIB·FVGA·DILAPSI·CAPTIS·

1

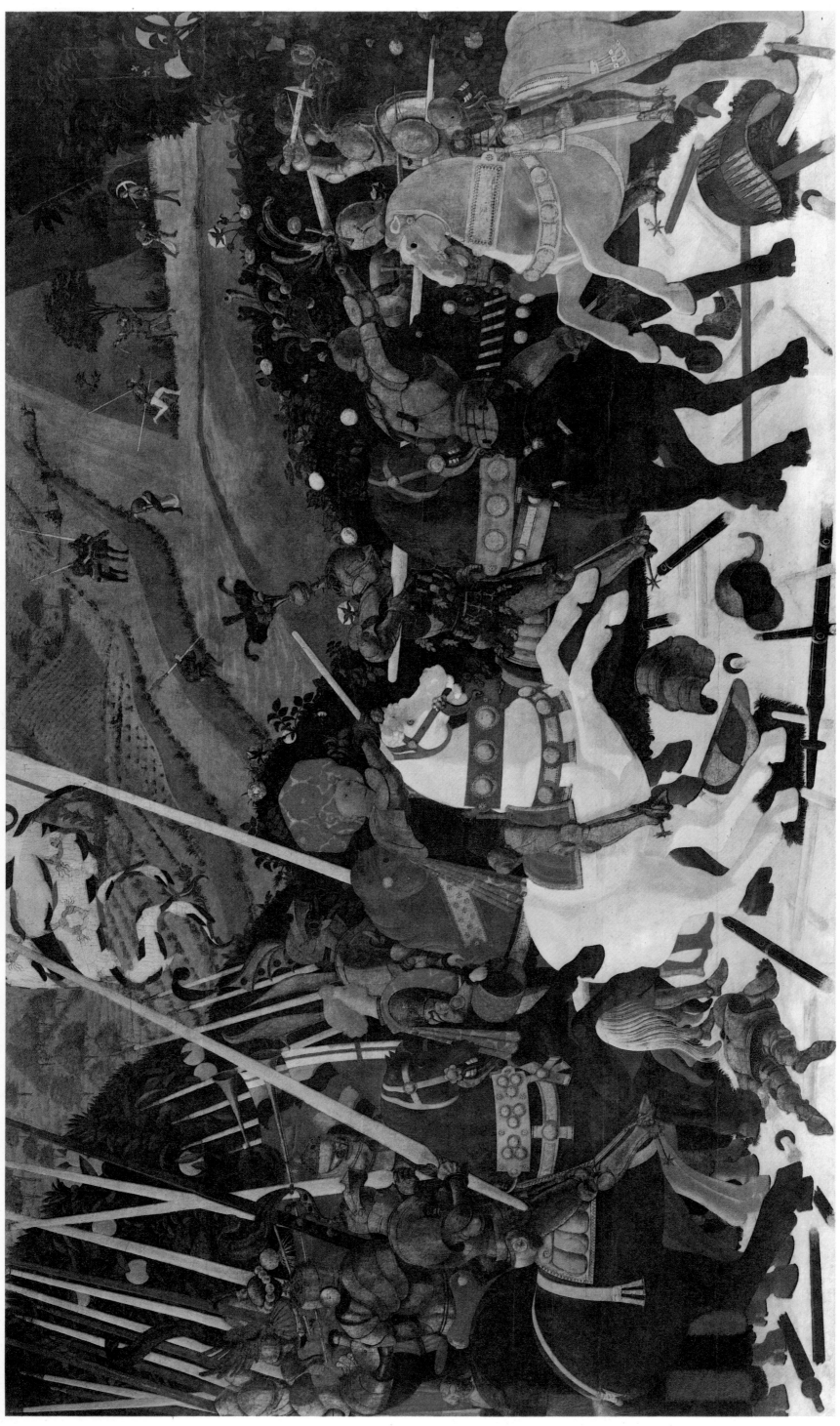

2

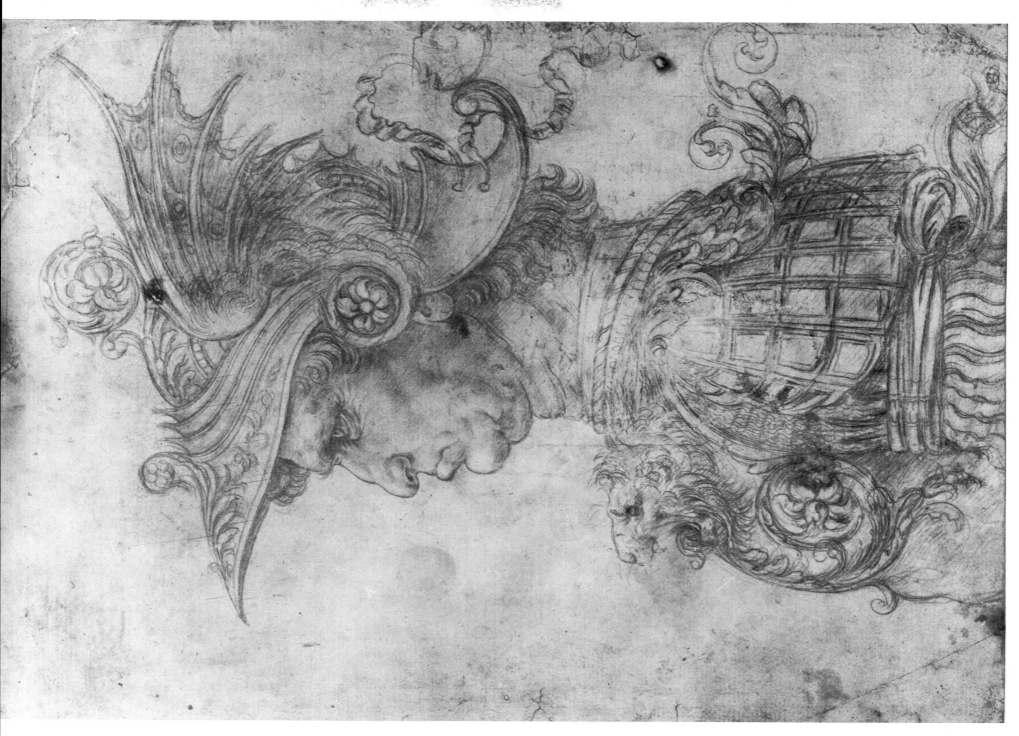

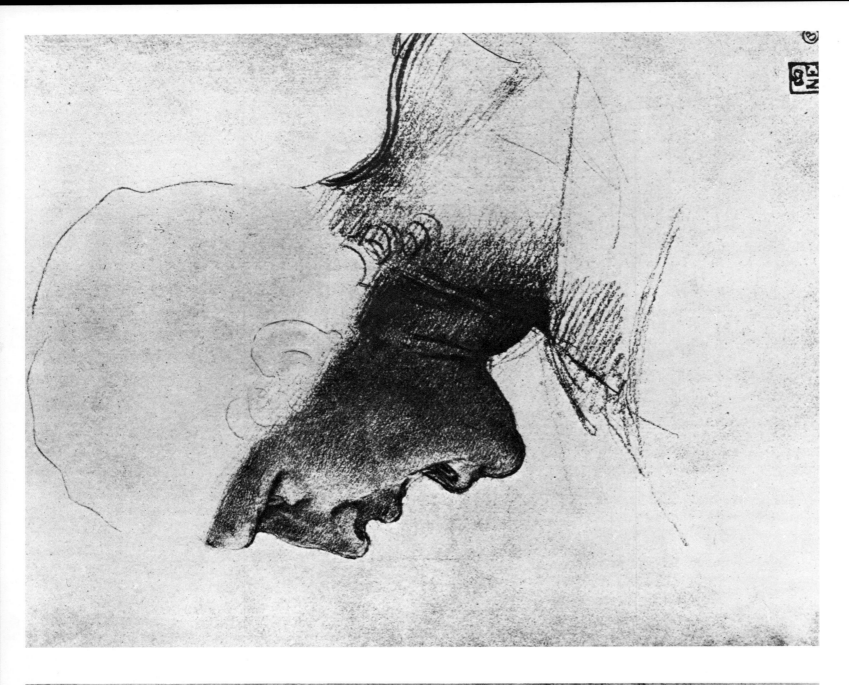

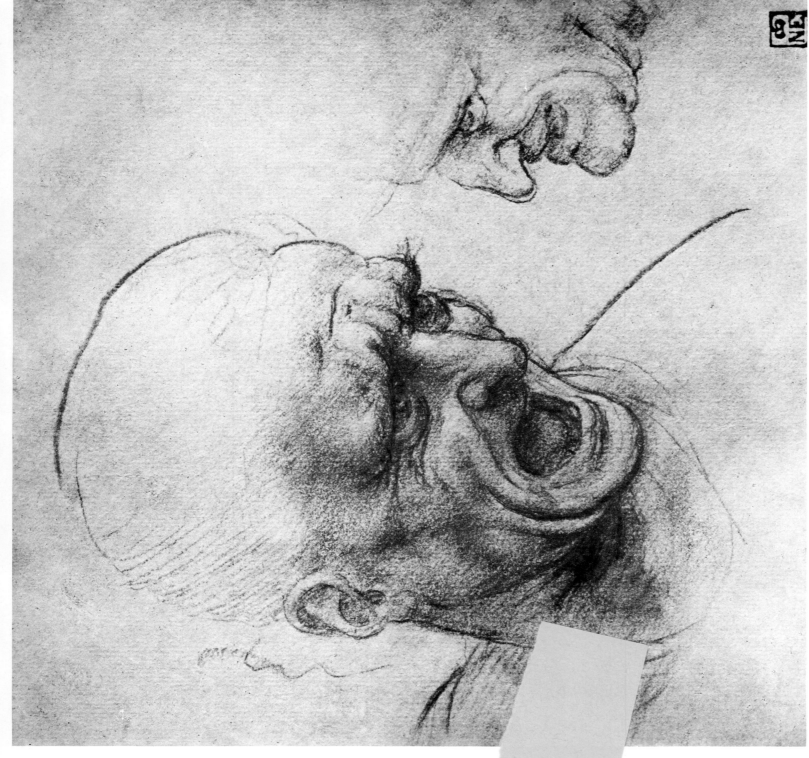

4

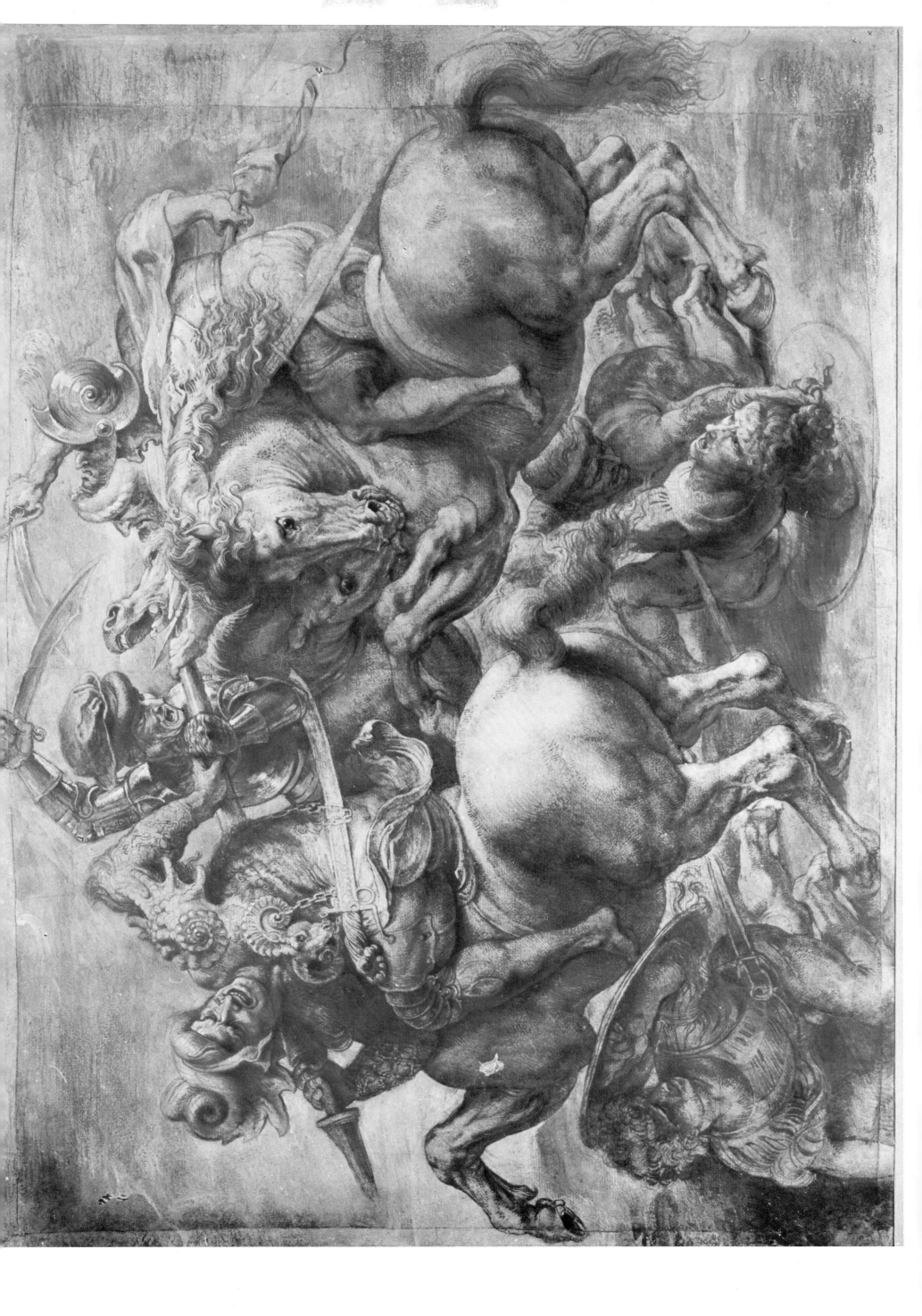

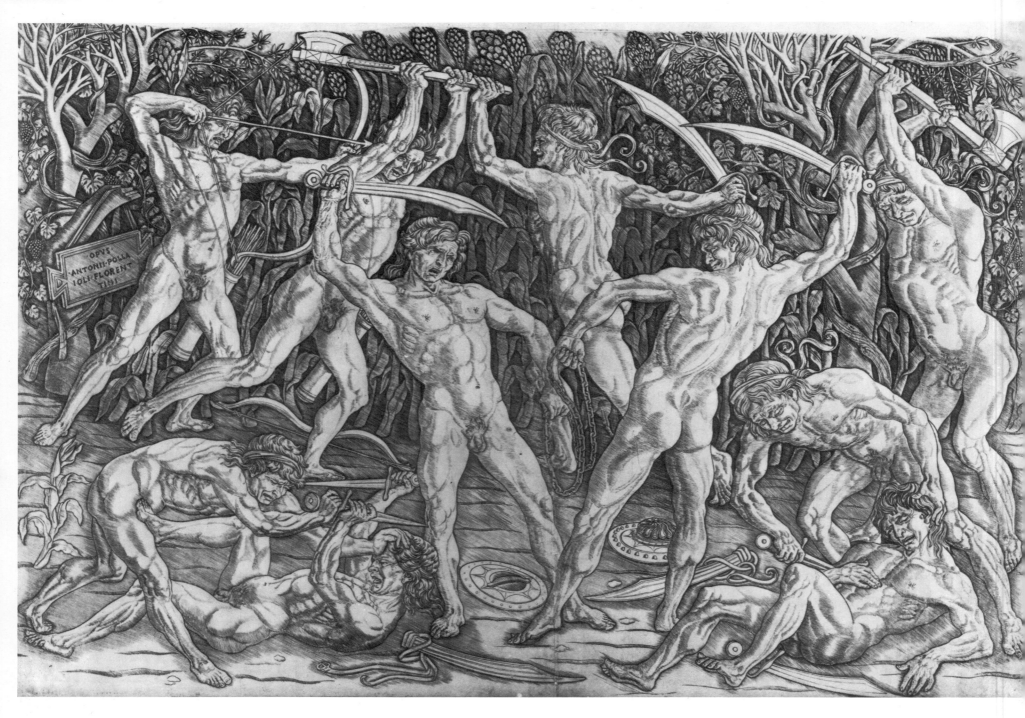

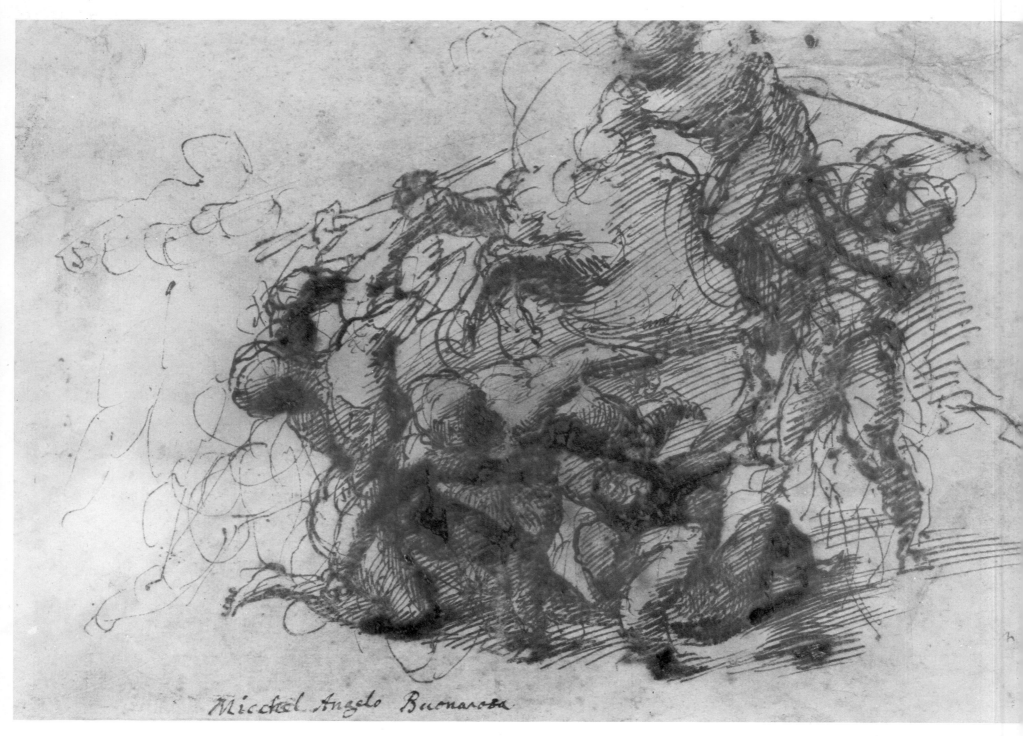

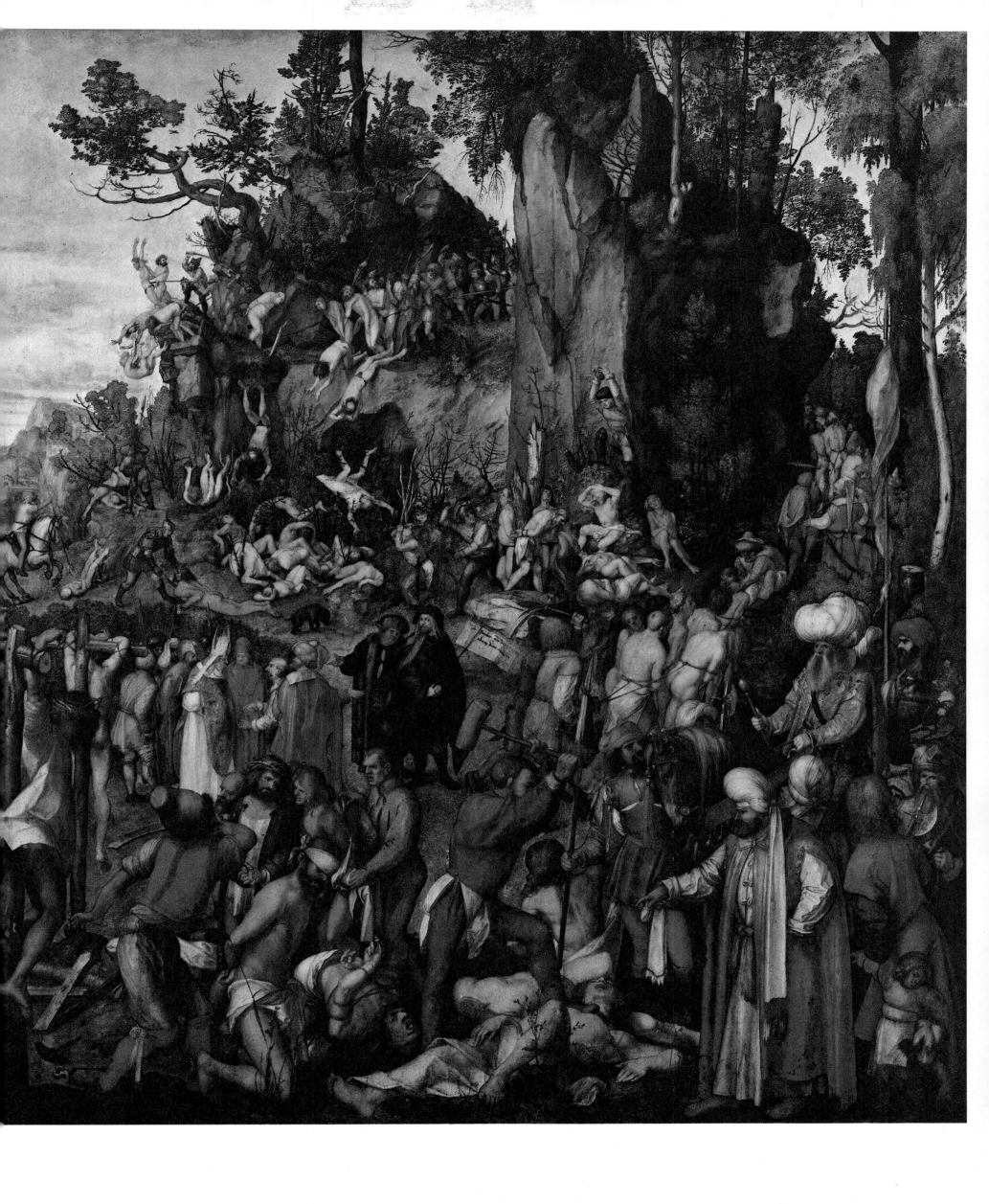

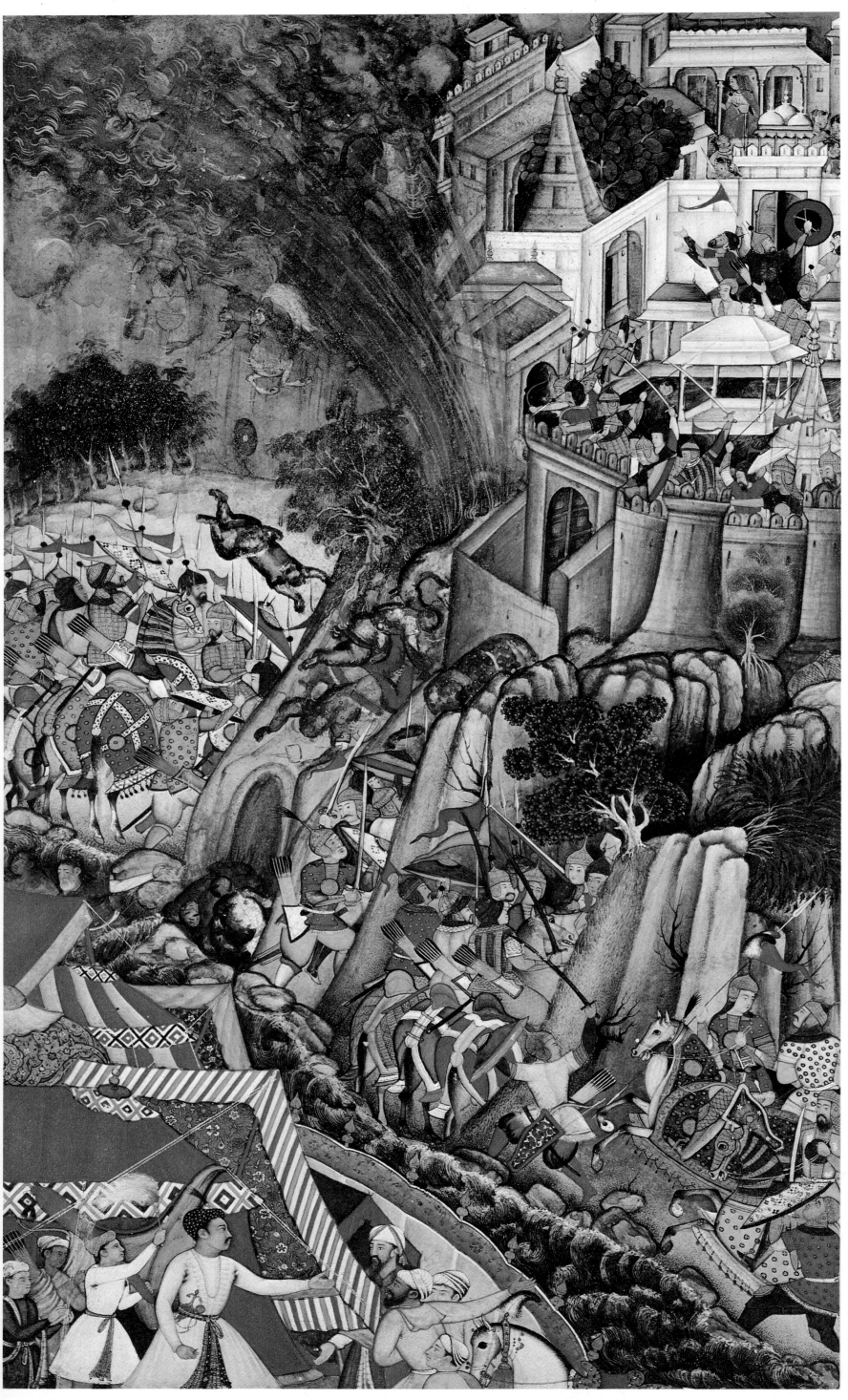

8

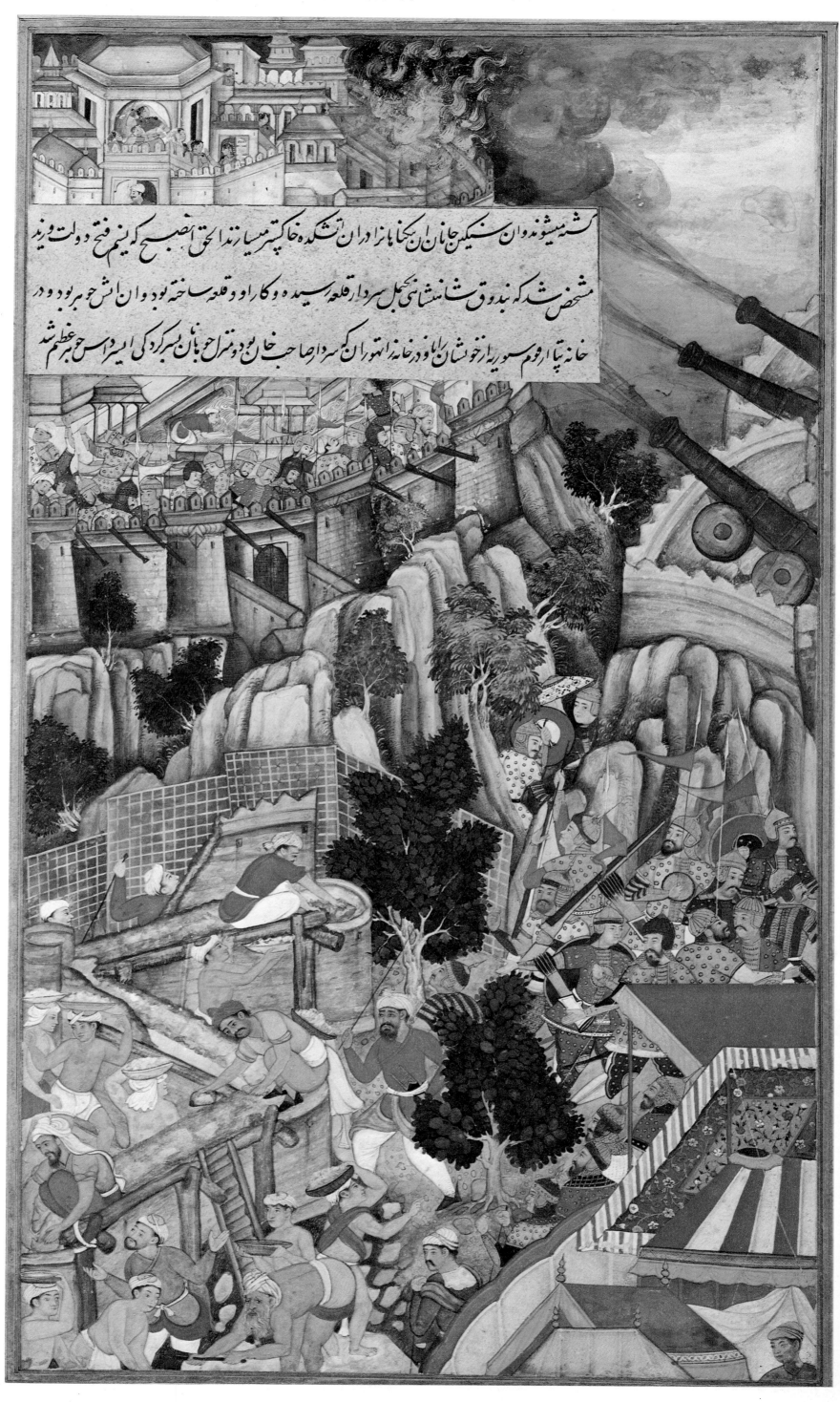

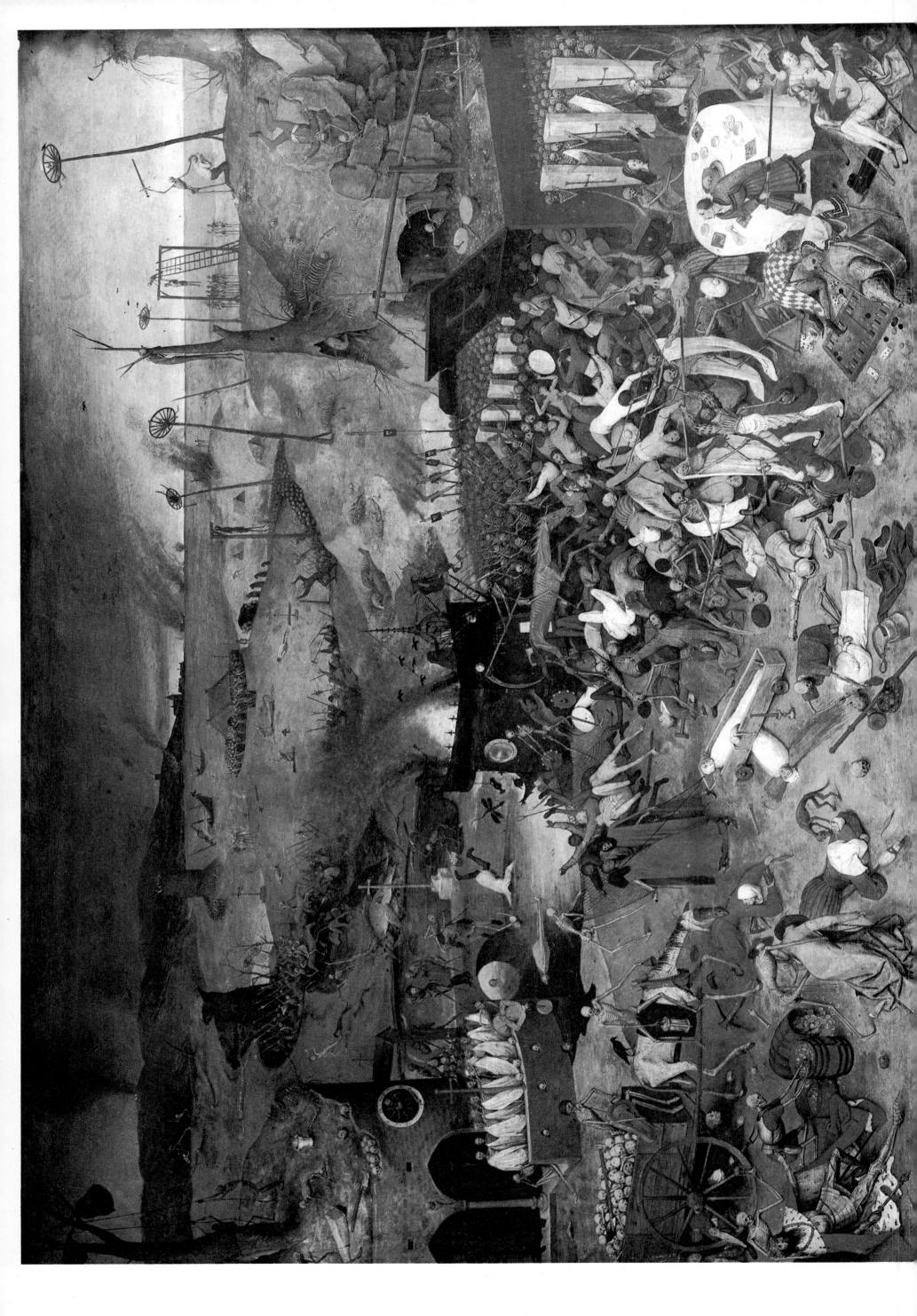

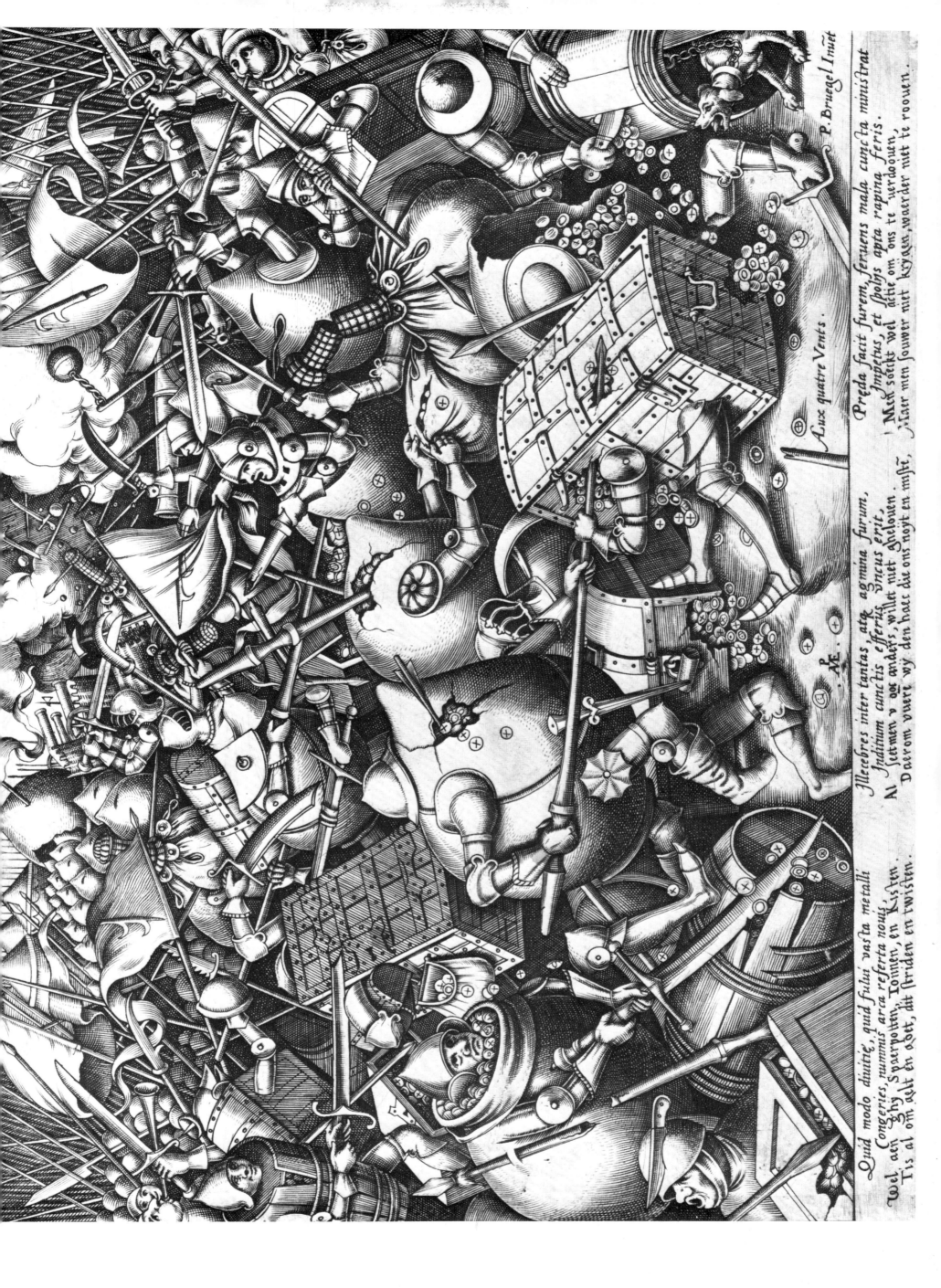

Lux quatre Vents. *P. Bruegel Inuet*

*Preda facit furem, feruens mala cuncta ministrat
Impetus, et spolijs apta rapina feris.*
Mich soeckt wel achte om ons te verdooum,
Maer men souuer niet kyaqen,waerder niet te roouen.

*Illecebres inter tantas, atq, agmina furum,
In ditium cunctis efferuis, fraeus erit.*
Al jnetmen v ons anders, willet niet ghelouen.
Daerom duere wy den haec die ons noyt en mast,

*Quid modo diuitie, quid fului vasta metalli
Congeries, nummis arca referta nouis.*
Wel, aen ghy, Spacrpotten, Tonnen, en Kisten,
Tis al om aelt en aott, dit striden en twisten.

11

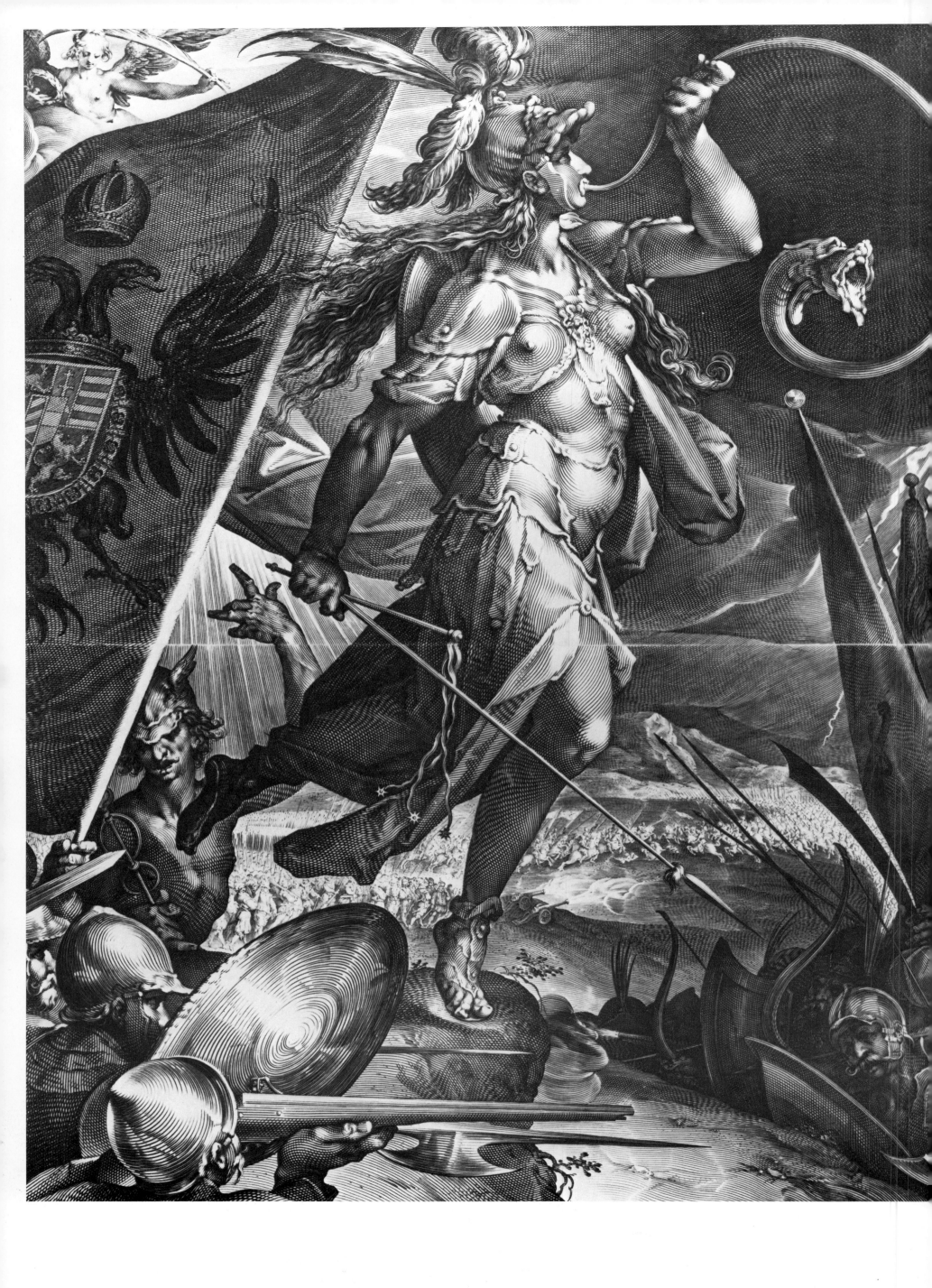

FRUCTUS BELLI.

Callot inv. et fec.

A la fin ces Voleurs infames et perdus, Monstrent bien que le crime (horrible et noire engeance) Et que c'est le Destin des hommes vicieux
Comme fruits malheureux a cet arbre pendus, Est luy mesme instrument de honte et de vengeance, D'esprouver tost ou tard la iustice des Cieux. Y

S. le Clerc inv. Avec privil. du Roy. P. Giffart fc.

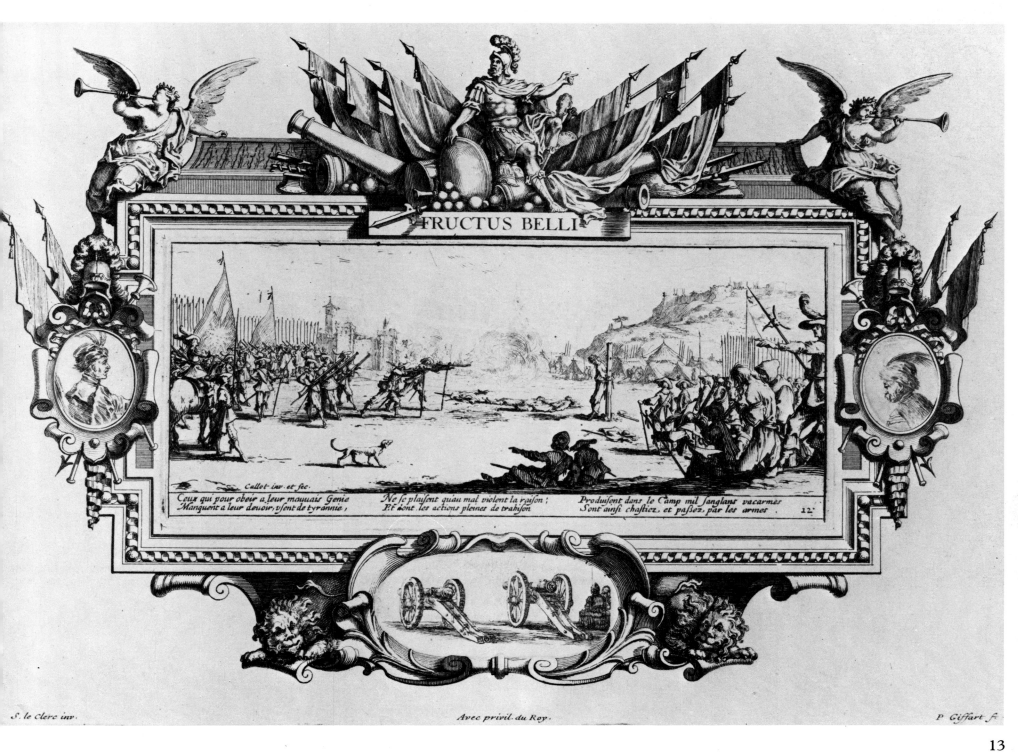

FRUCTUS BELLI

Callot inv. et fec.

Ceux qui pour obeir a leur mauuais Genie Ne se plaisent qu'au mal violent la raison; Produisent dans le Camp mil sanglans vacarmes
Manquent a leur denoir, vsent de tyrannie, Et font les actions pleines de trahison Sont ainsi chastiez, et passez par les armes. 12.

S. le Clerc inv. Avec privil. du Roy. P. Giffart fc.

13

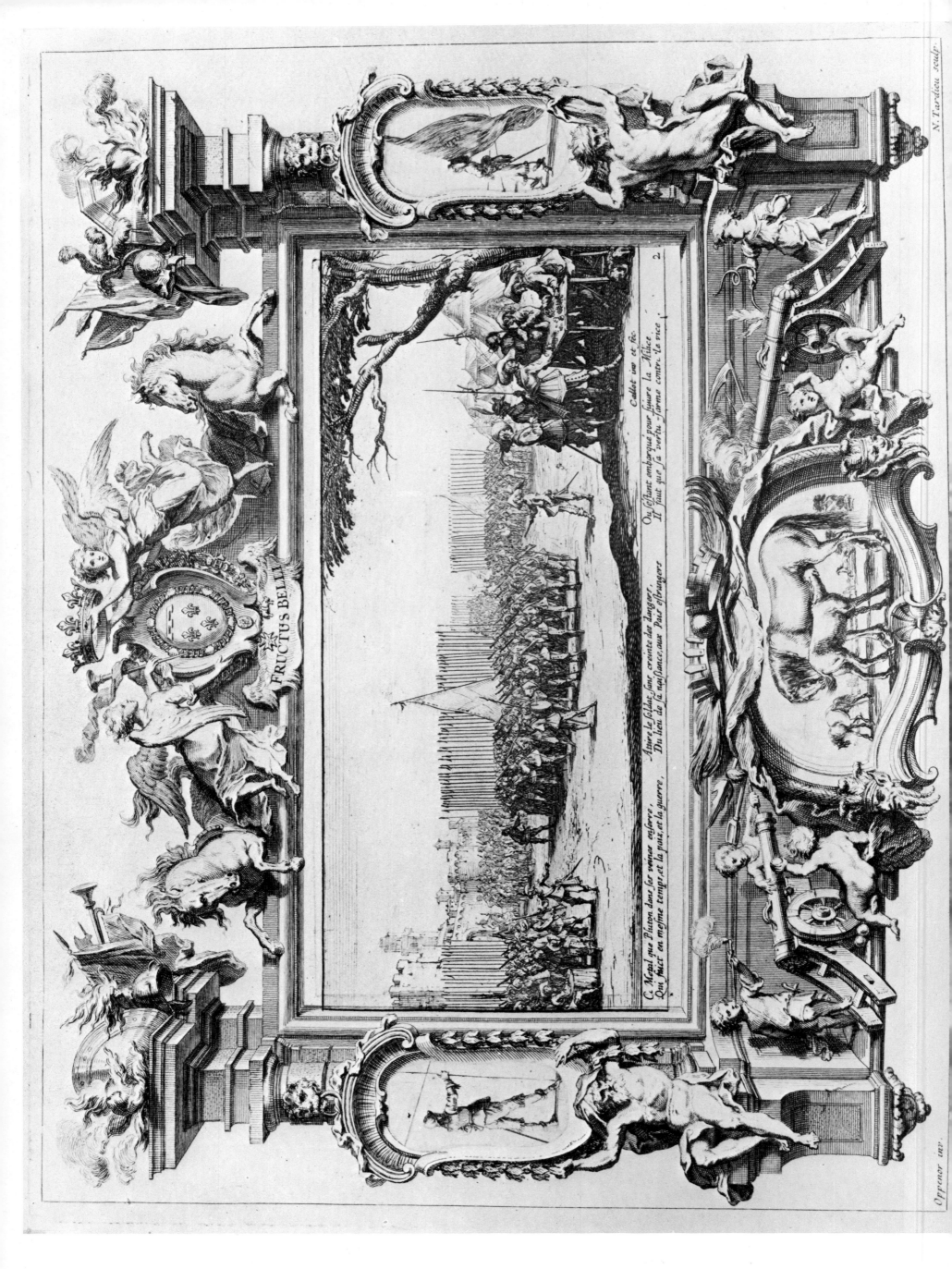

FRUCTUS BELLI

C. Mopal que Pluton dans fee venue efpleree
Qui fuit en mefme temps, et la paix, et la guerre,

Alure le foldat fane crainte des danger,
Du lieu de la naiffance, aux Pais eftrangers

Ou seftant embarqué pour fuivre la Milice
Il faut que fa vertu farme contre la vice

Callot inv et fee.

2

N. Tardieu sculp.

Oppenor inv.

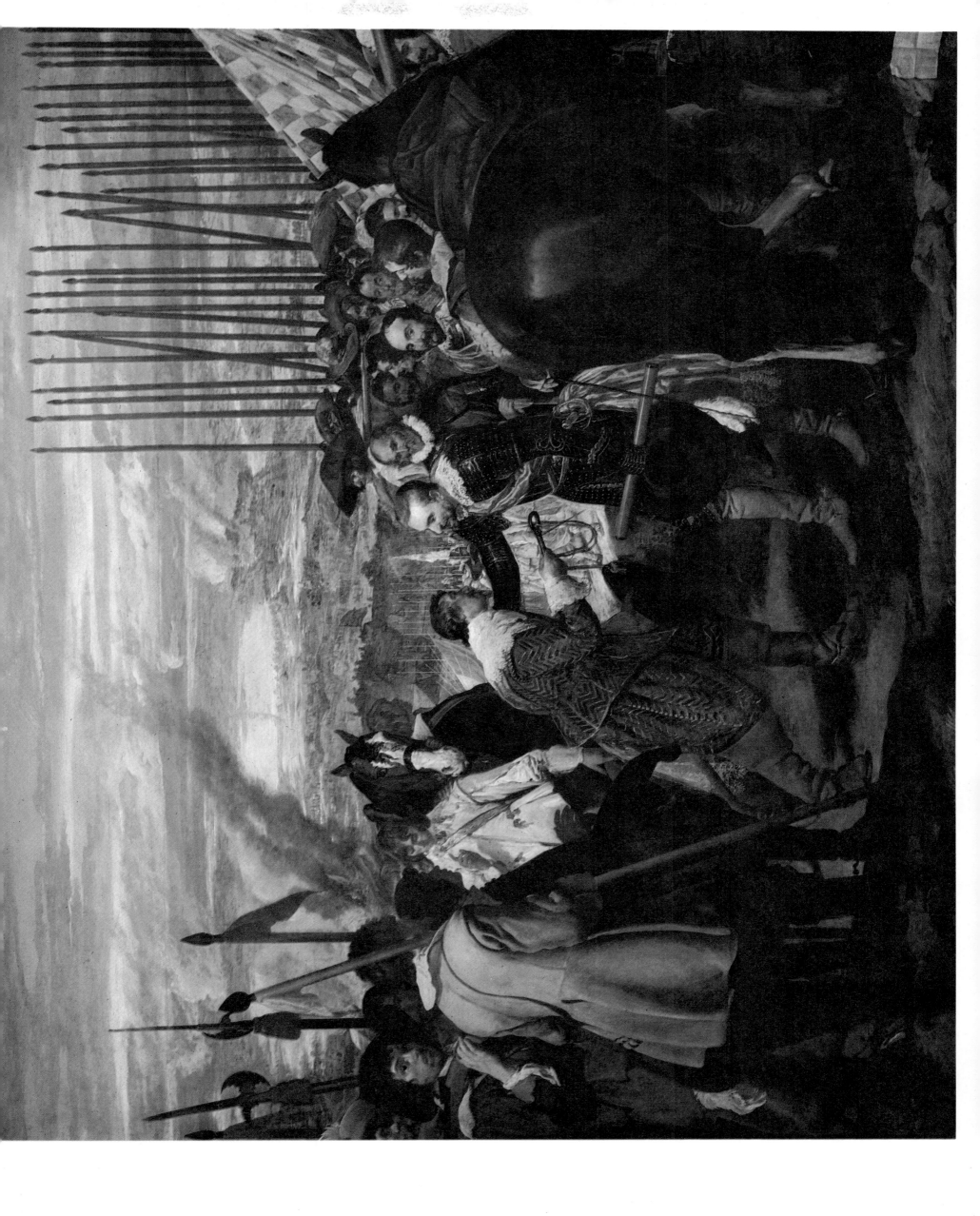

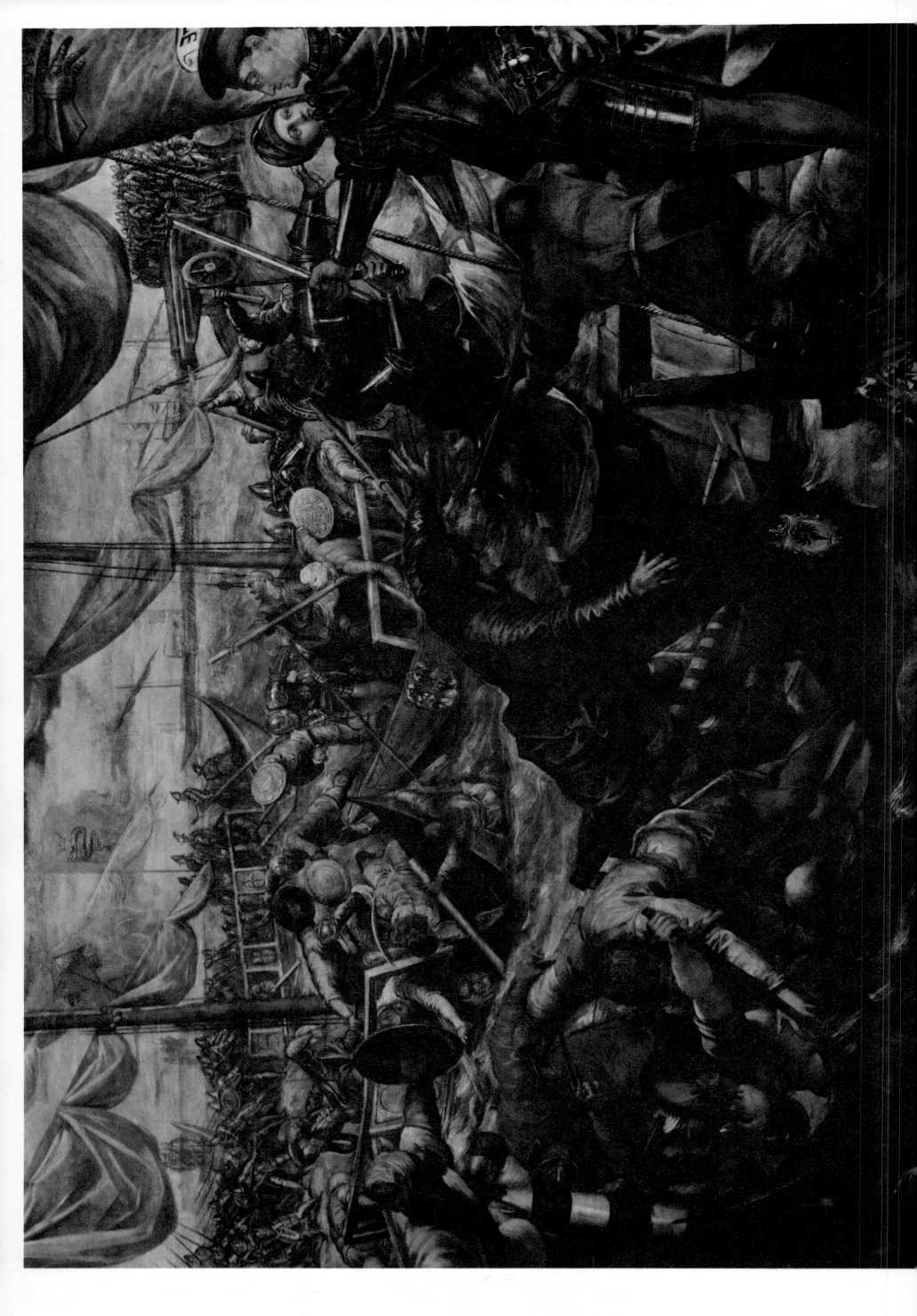

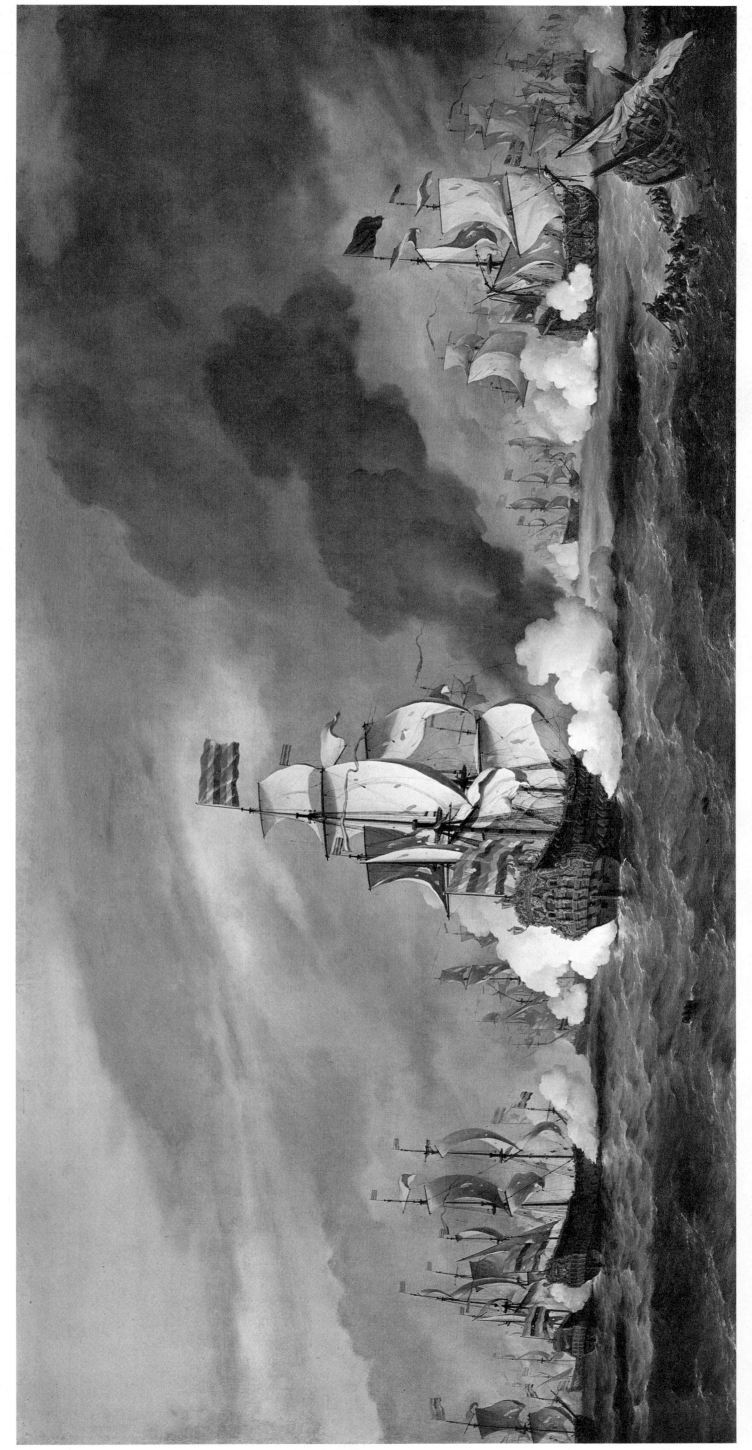

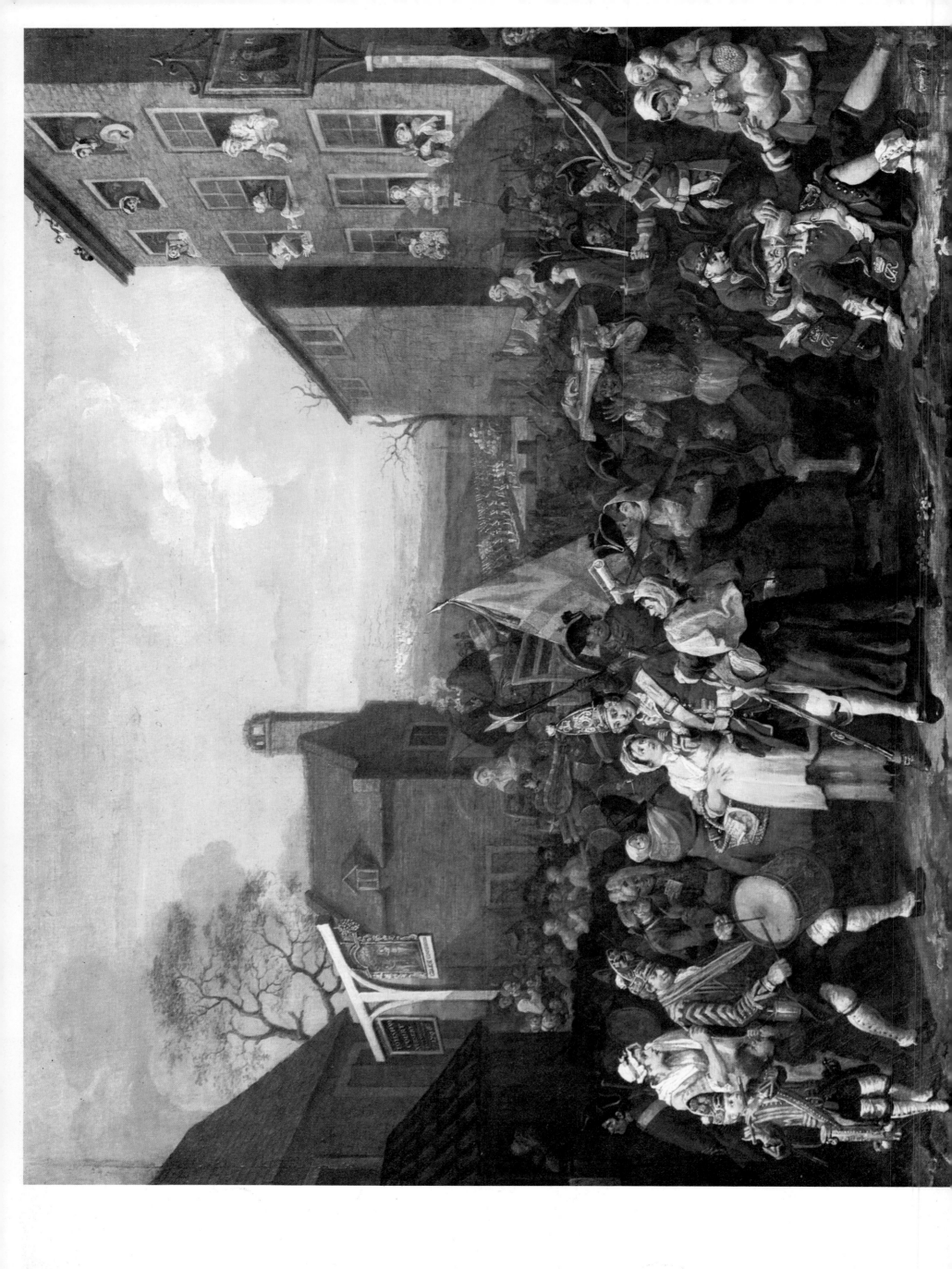

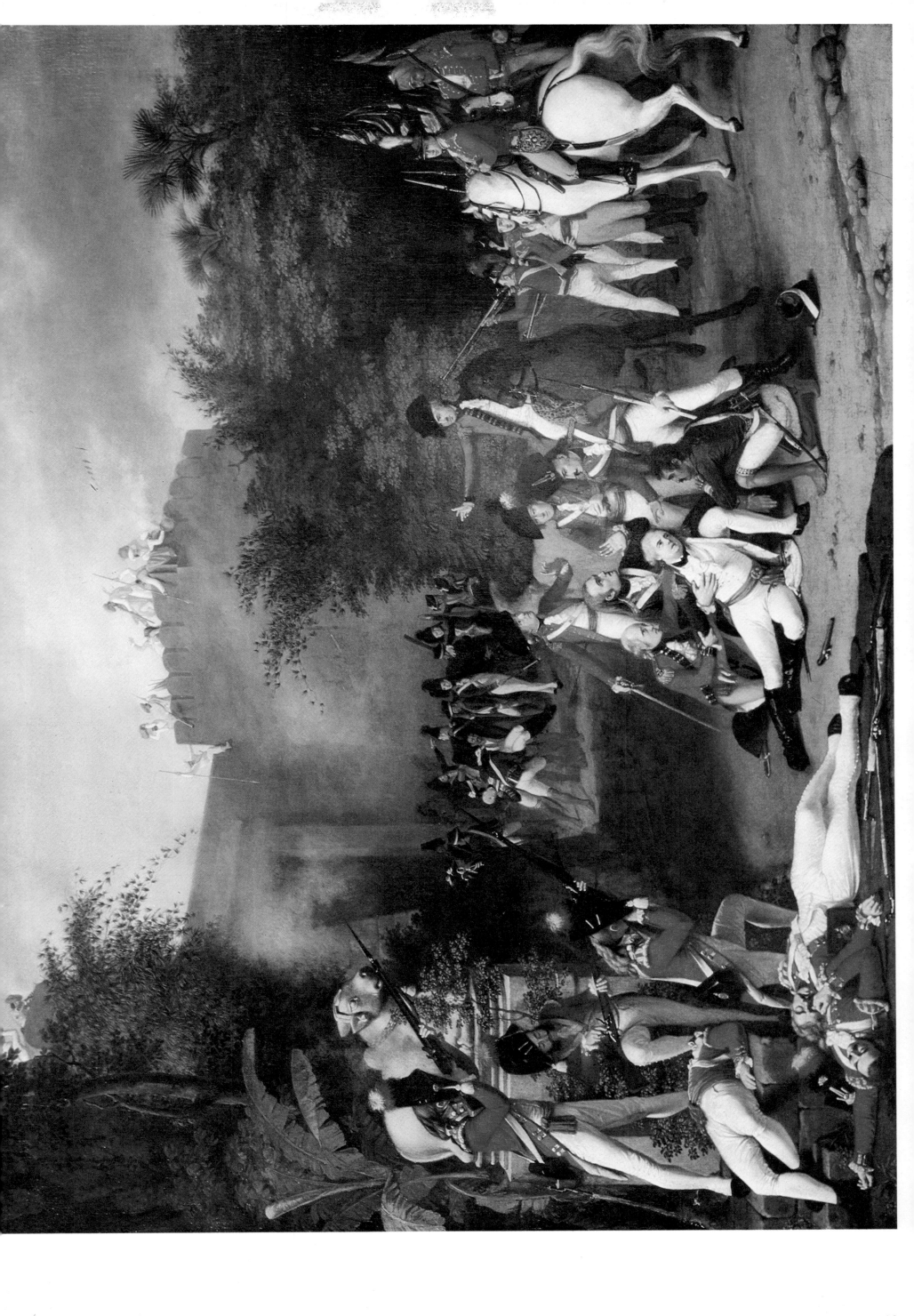

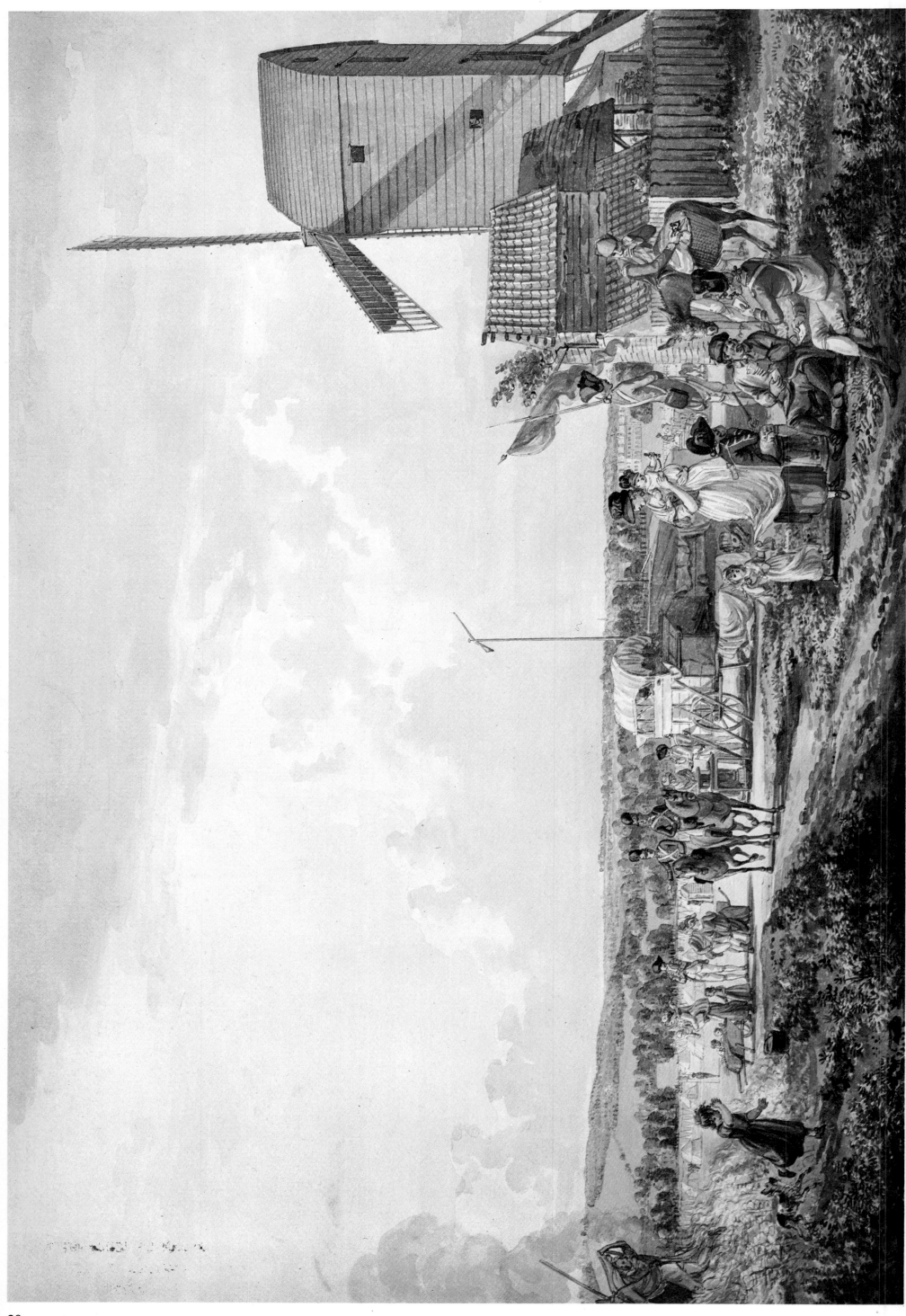

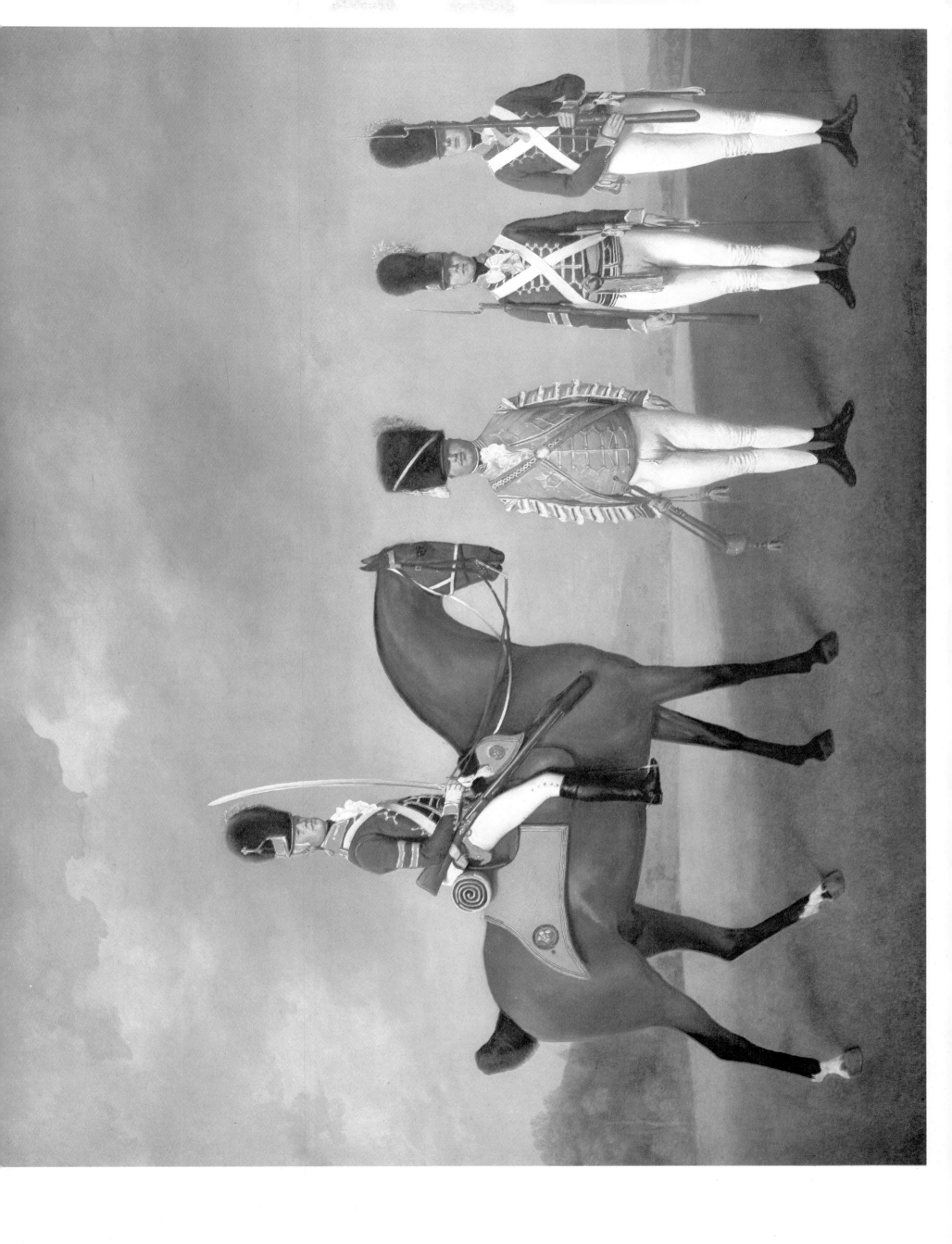

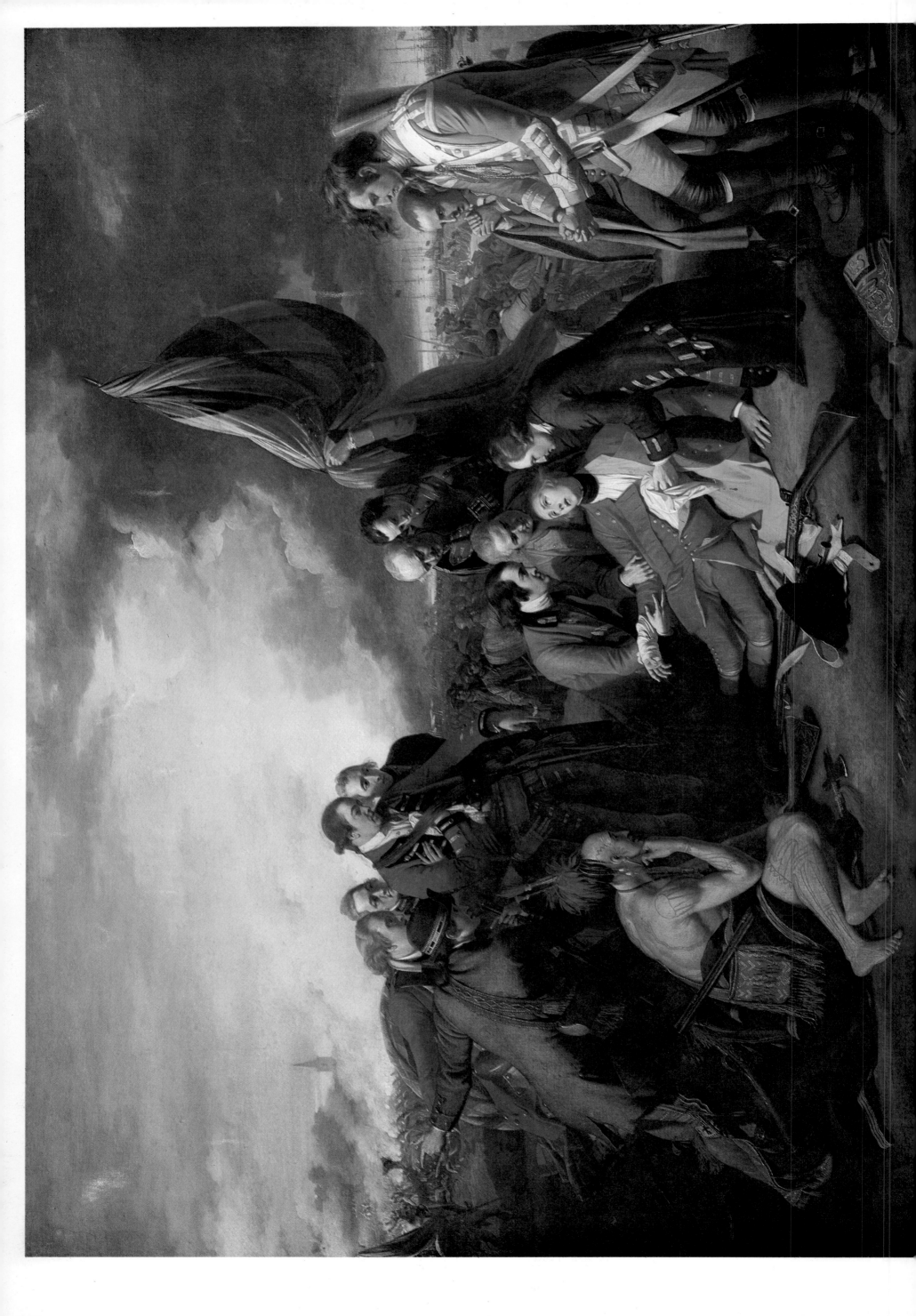

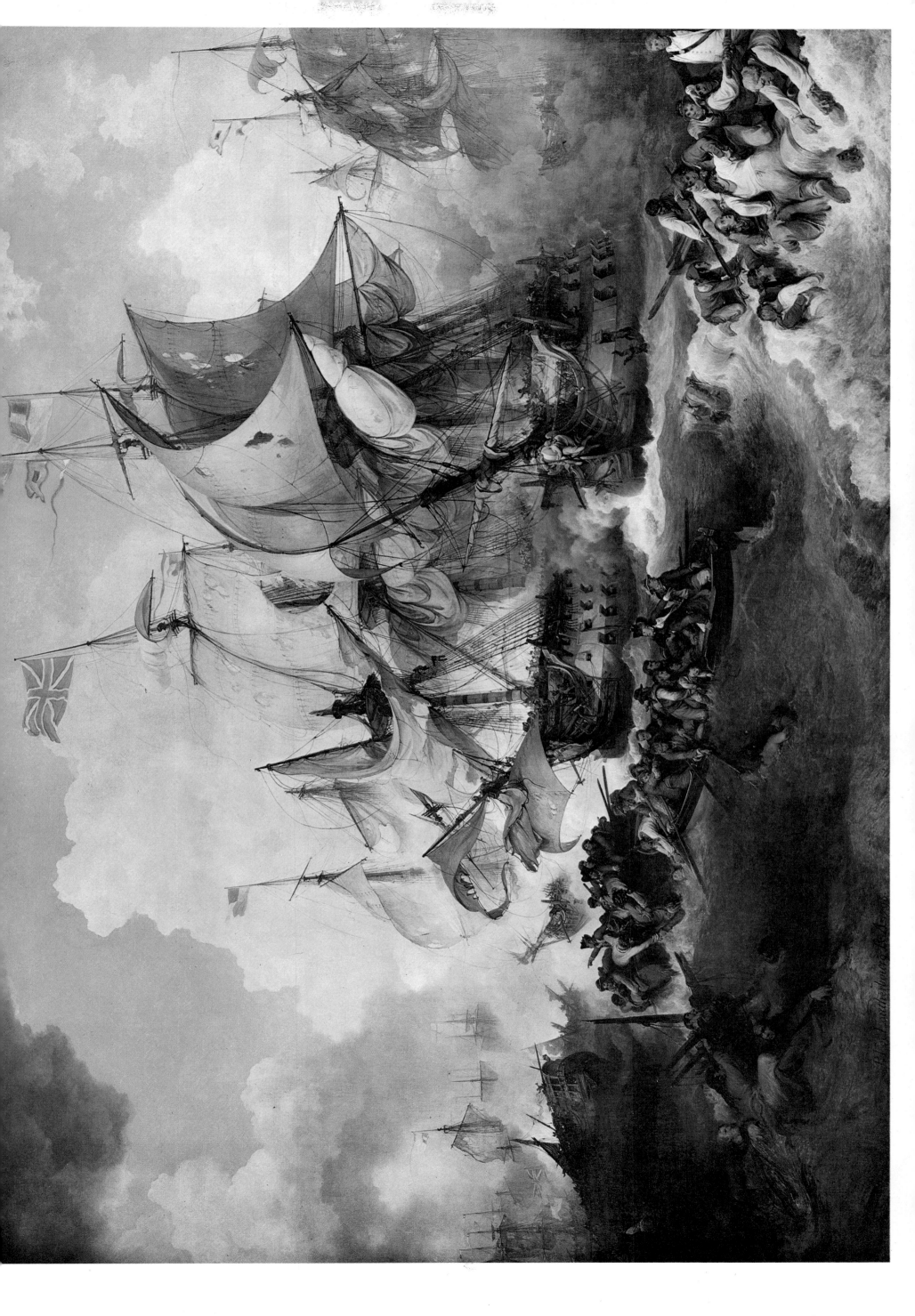

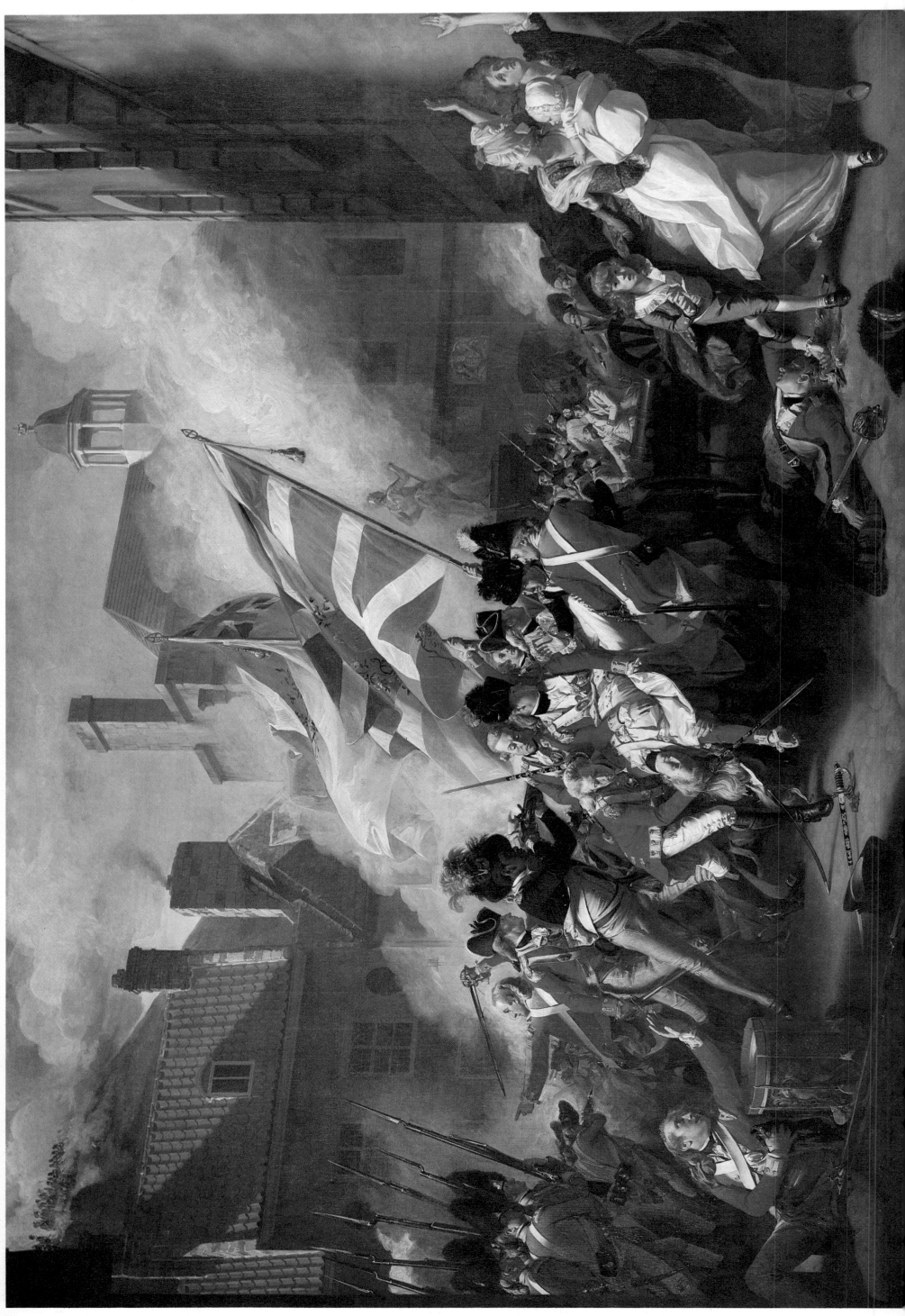

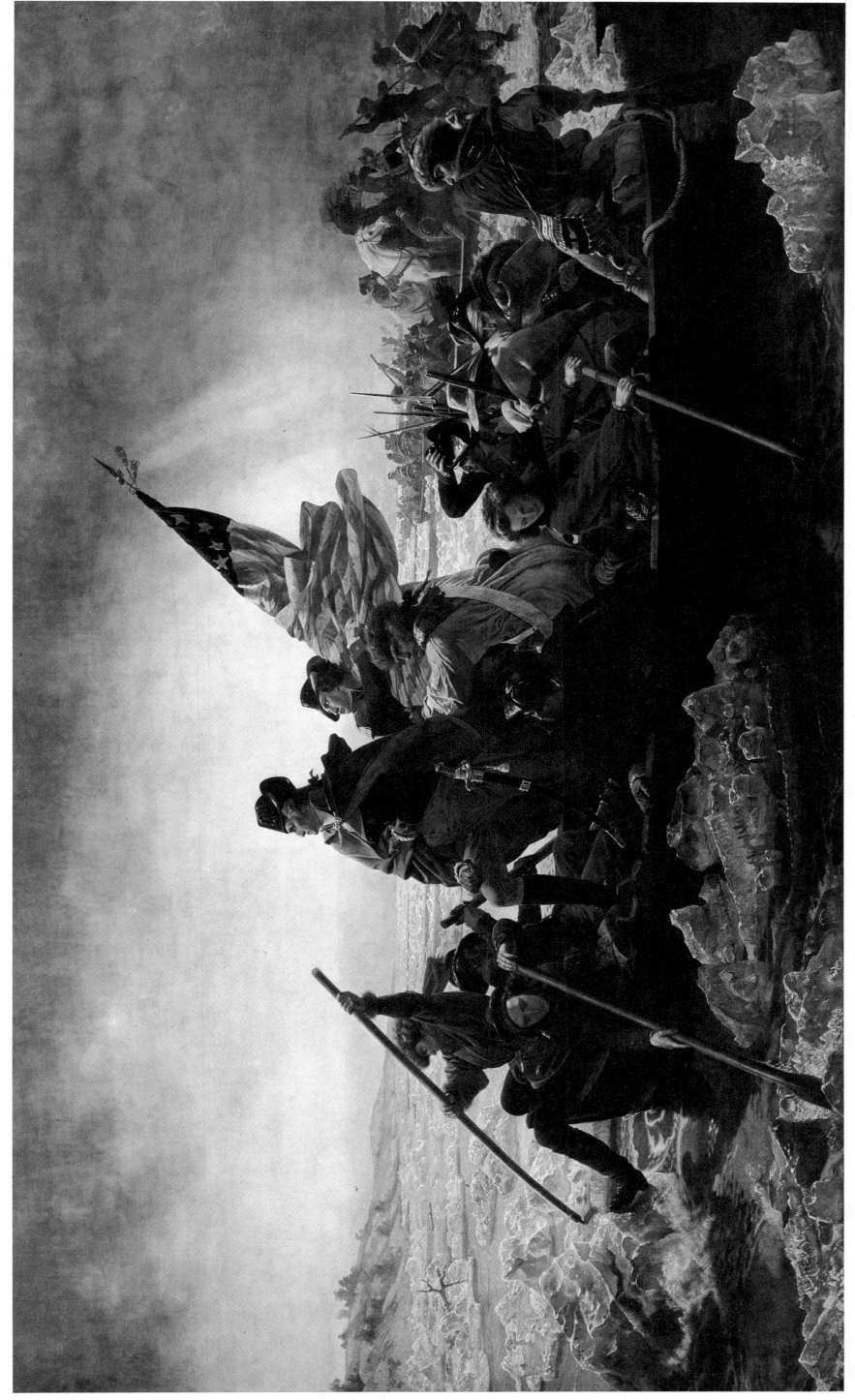

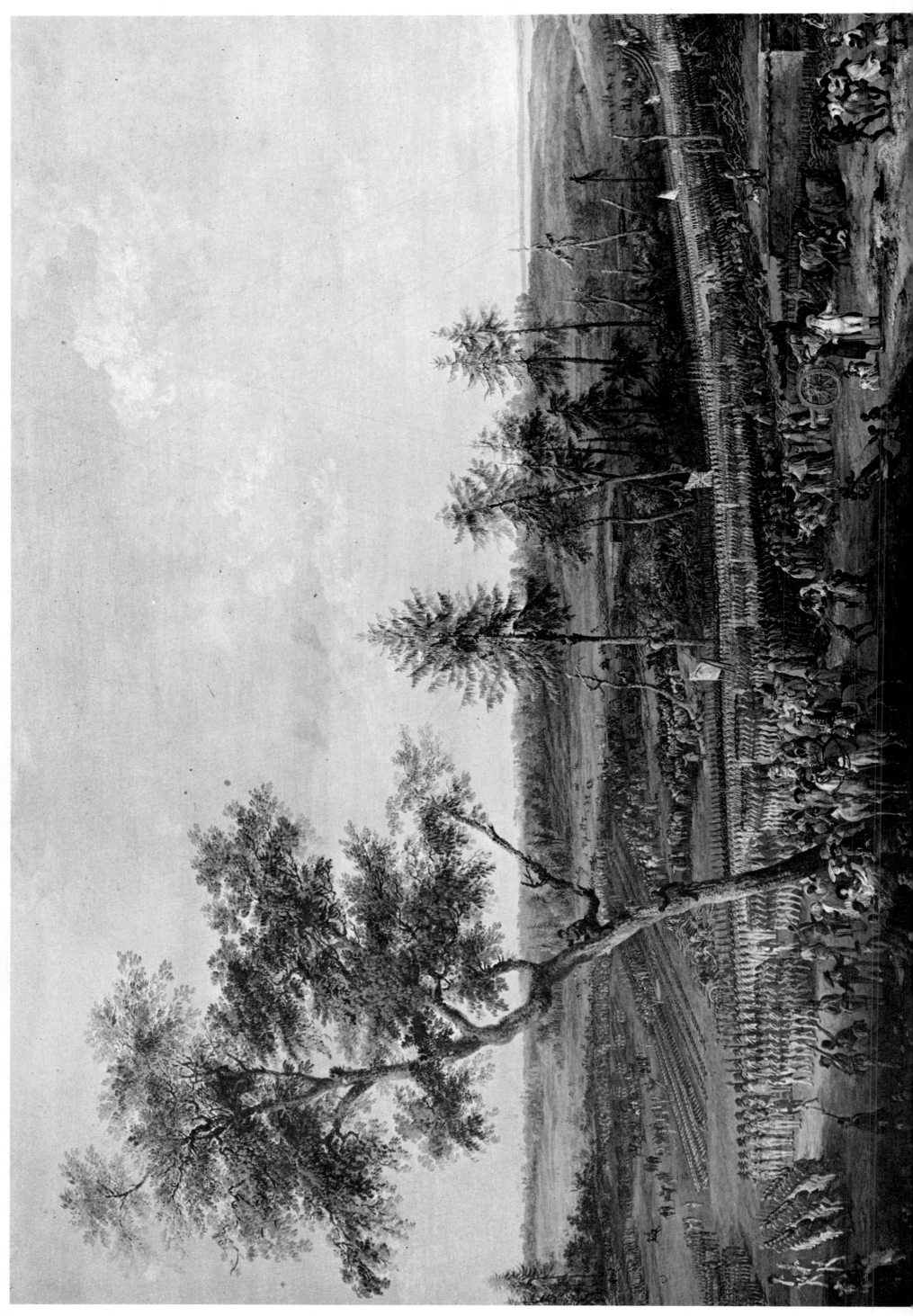

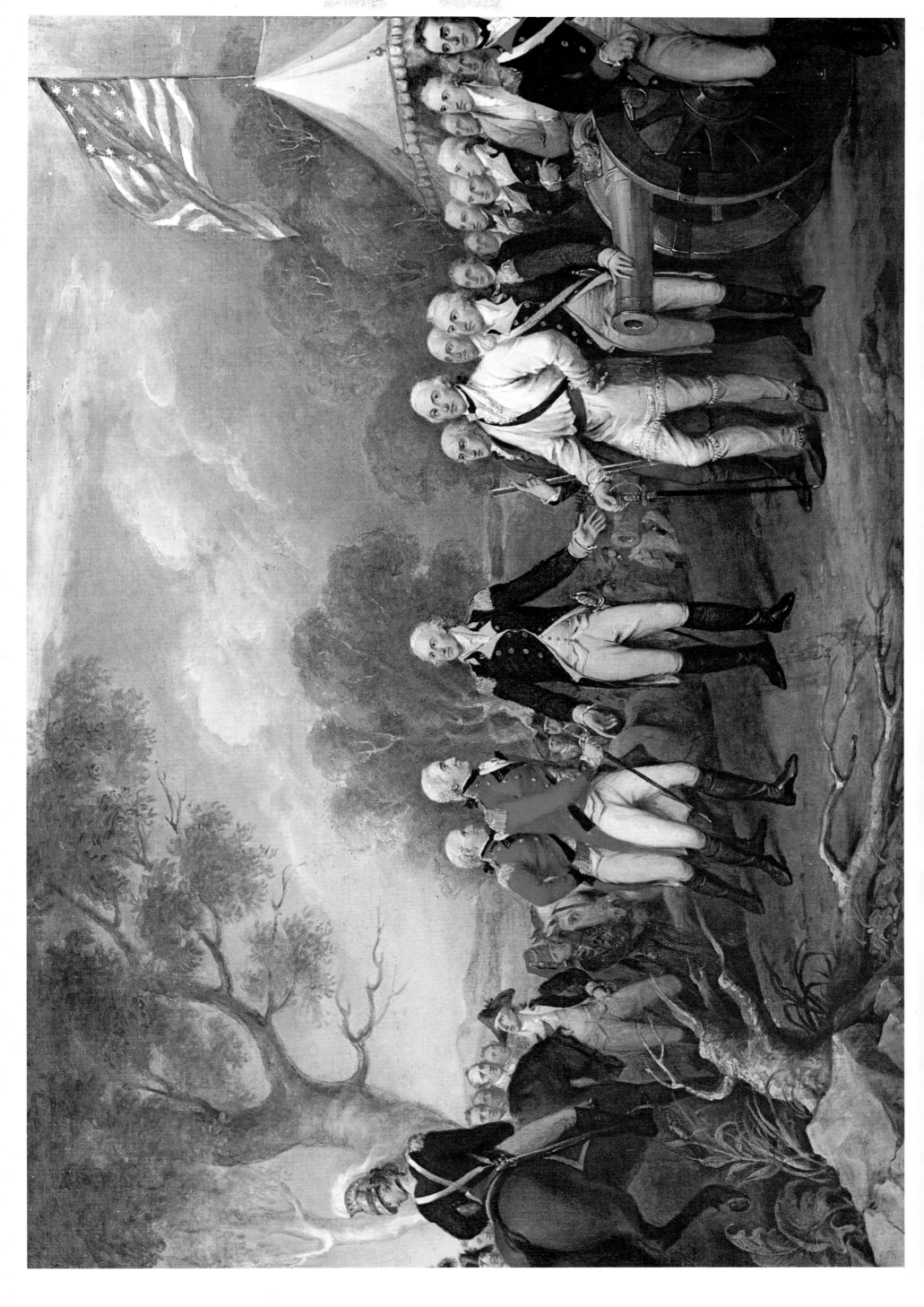

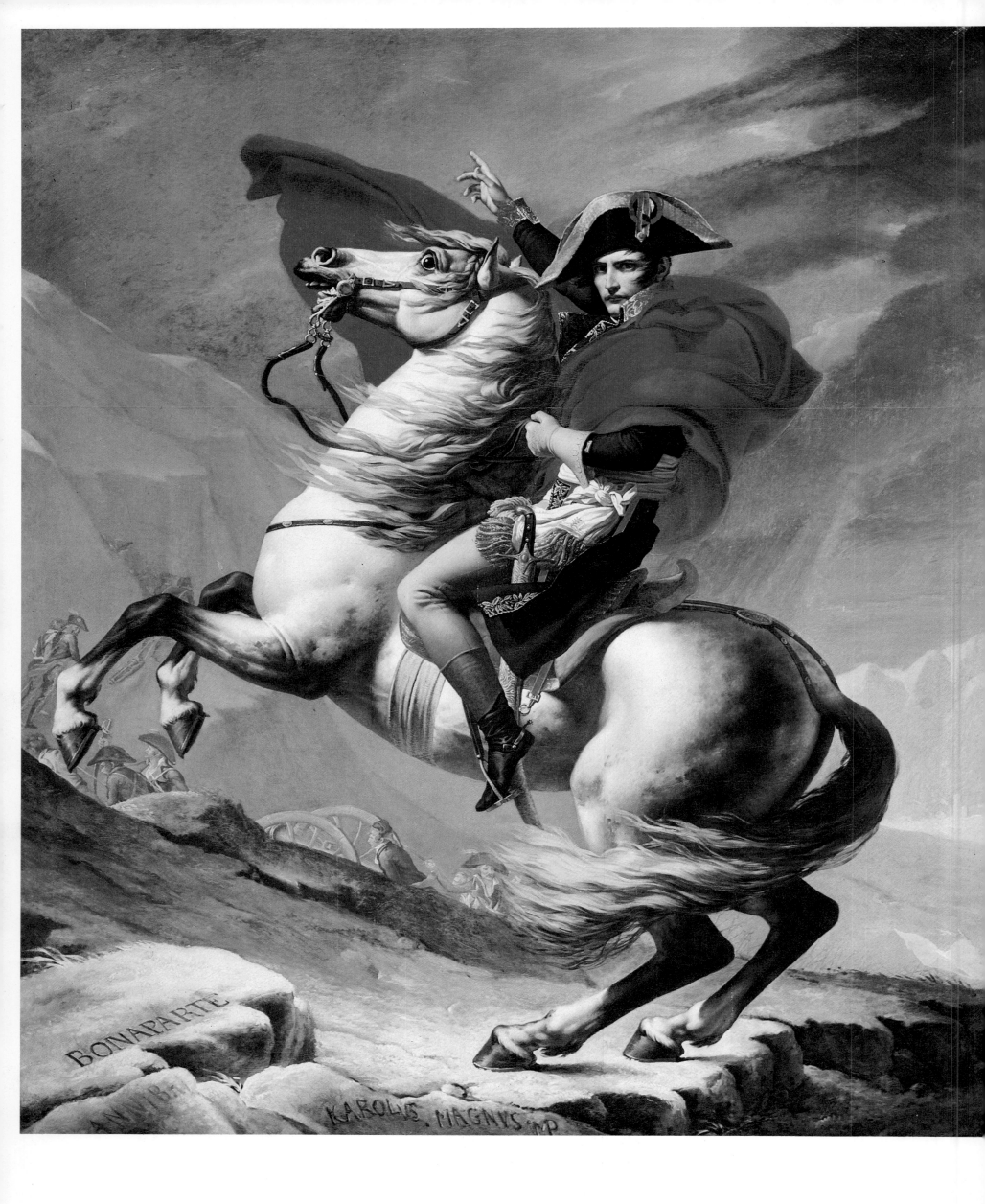

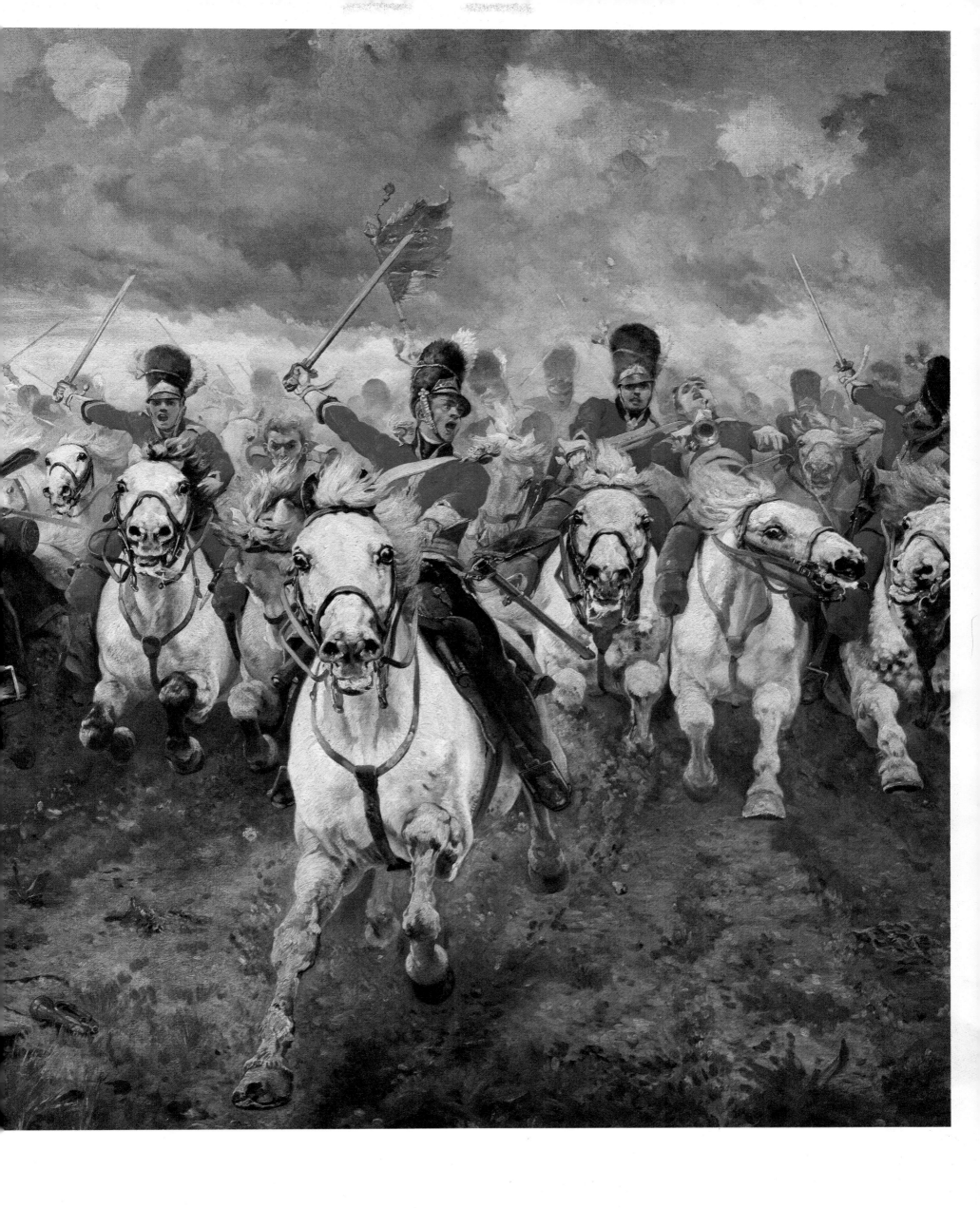

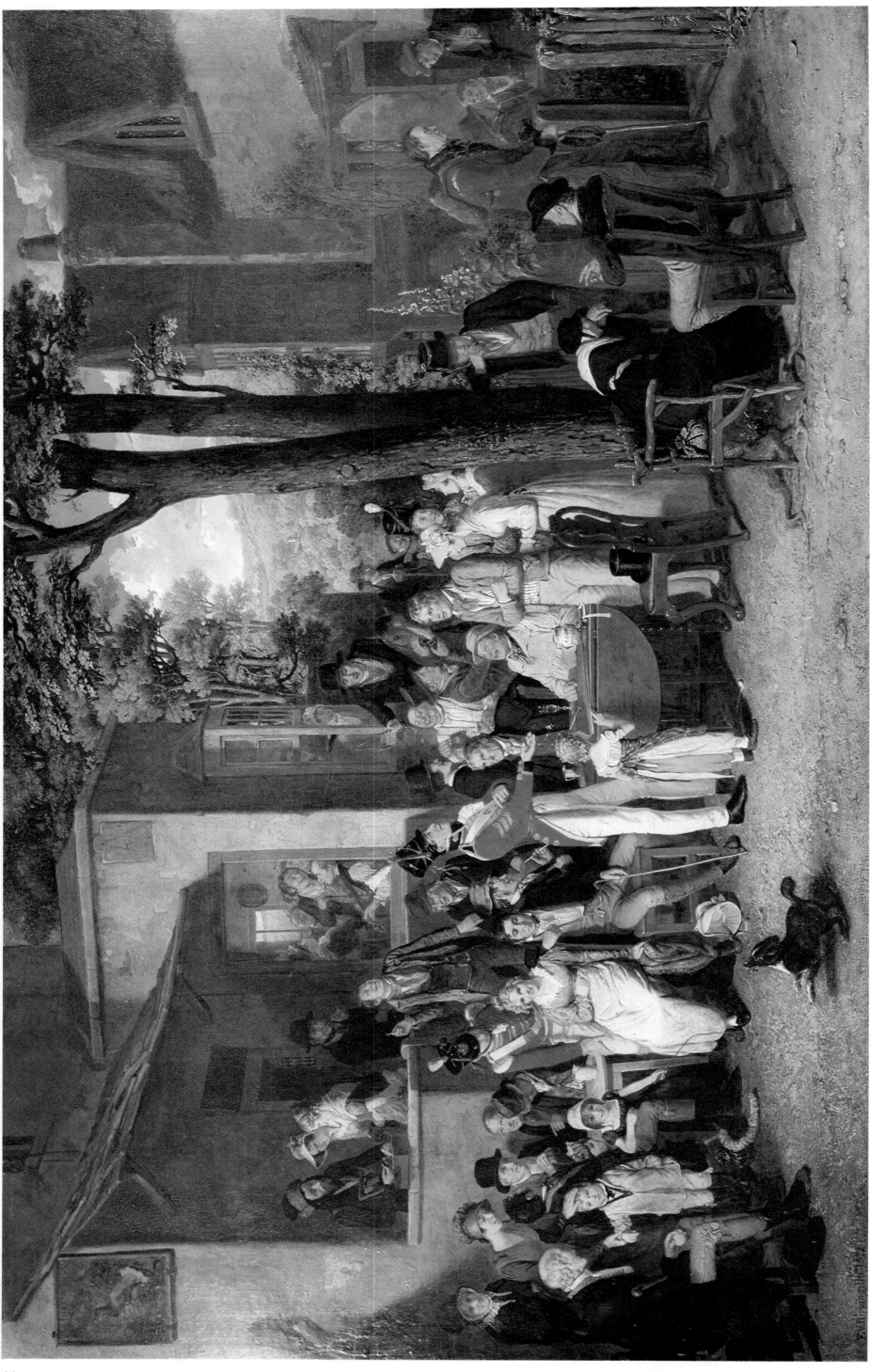

30

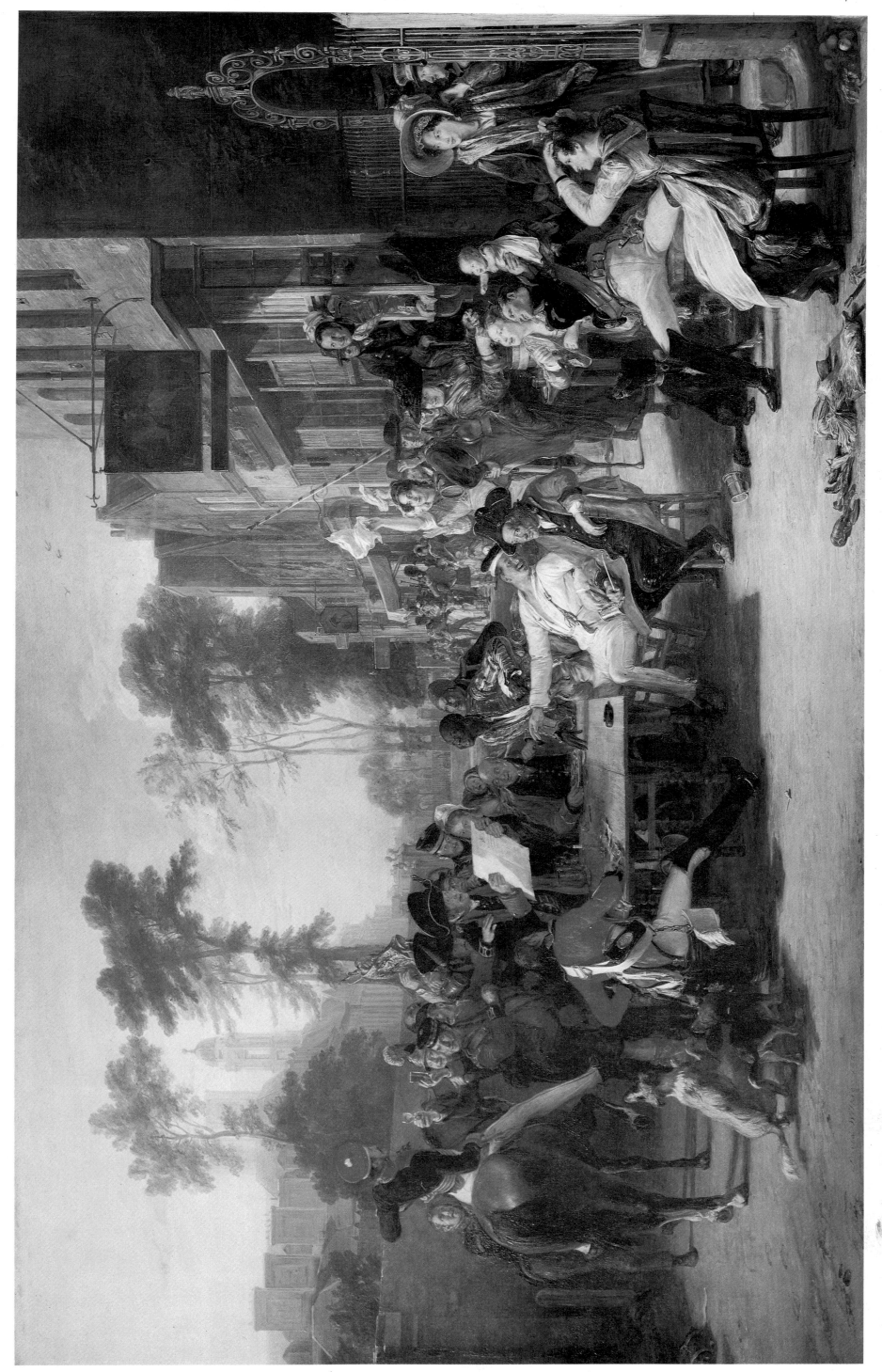

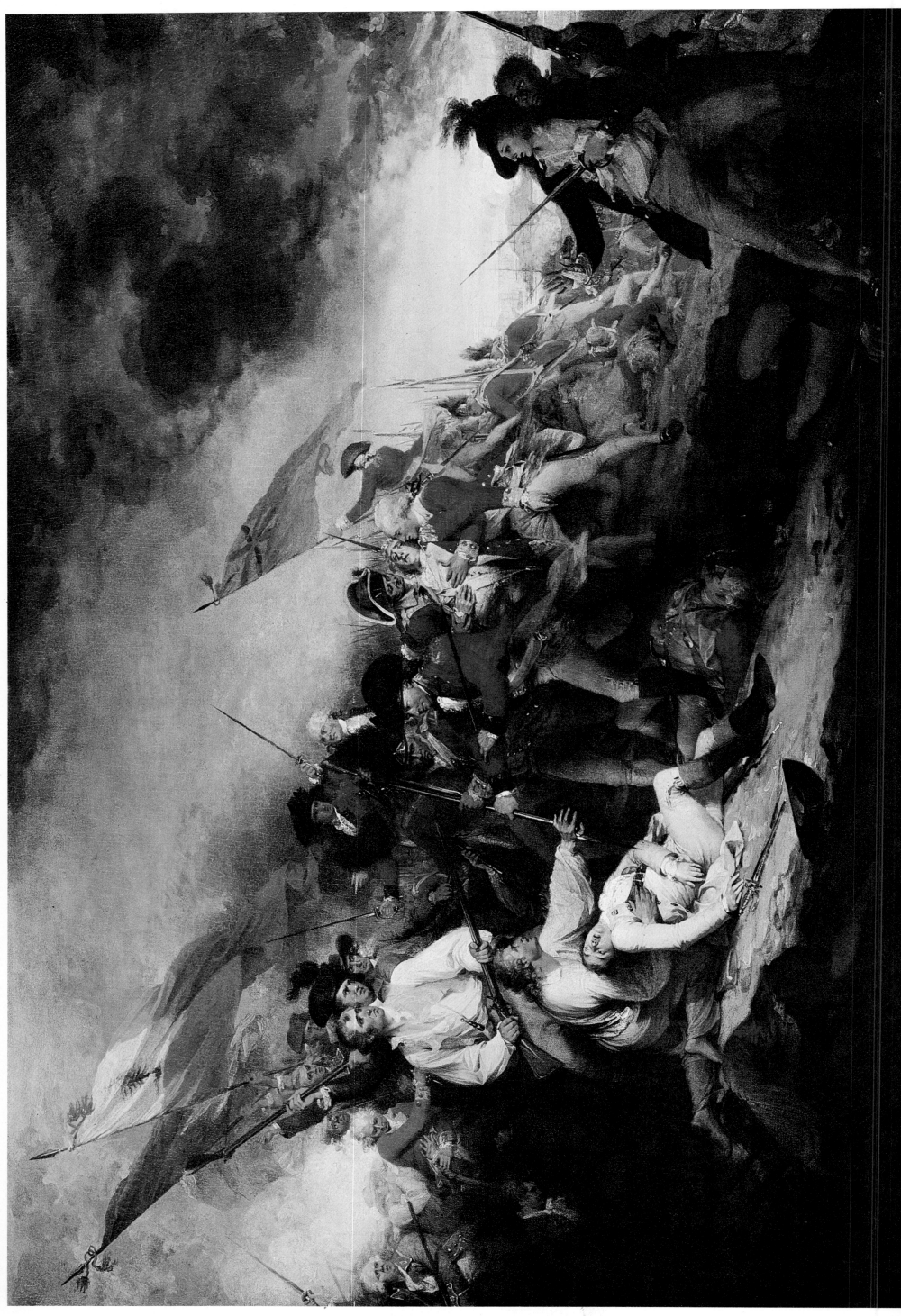

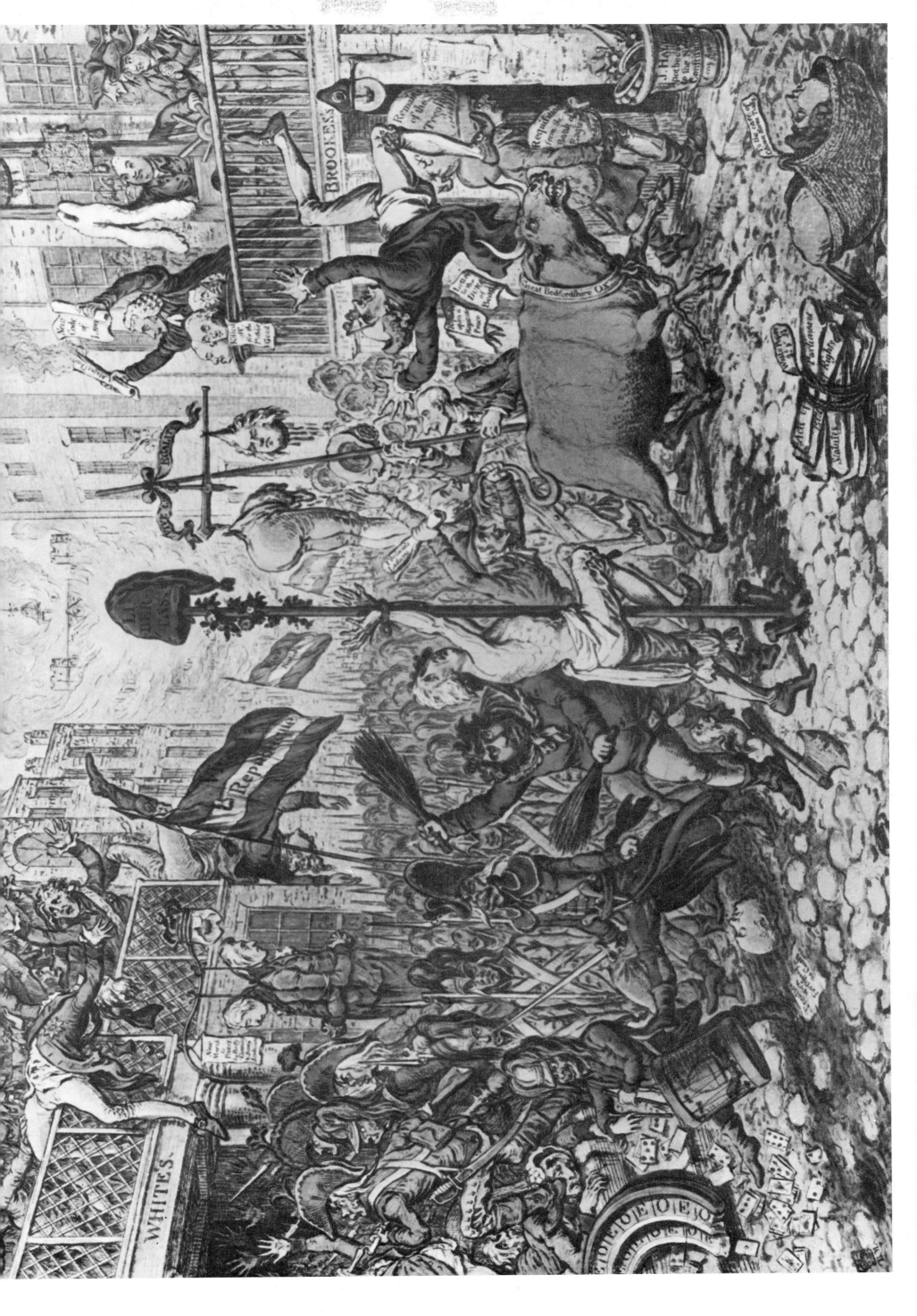

33

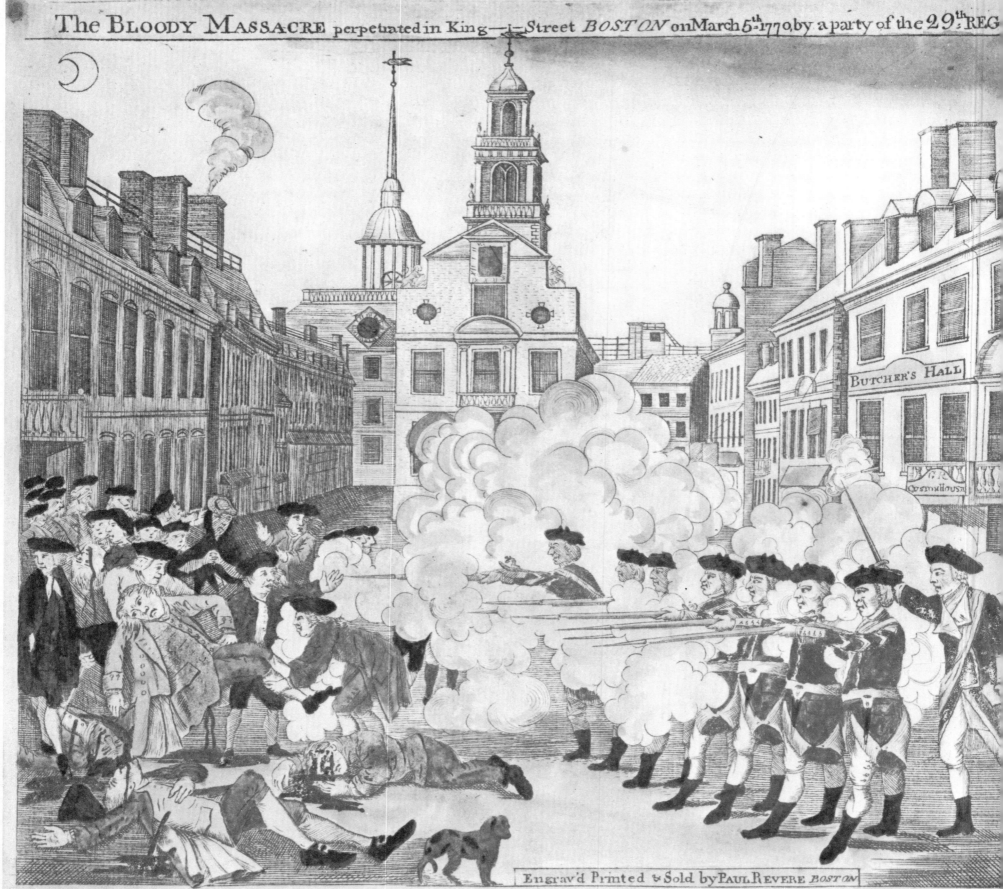

The BLOODY MASSACRE perpetrated in King—ι—Street BOSTON on March 5th 1770, by a party of the 29th REG.

BUTCHER'S HALL

Engrav'd Printed & Sold by PAUL REVERE BOSTON

UnhappyBOSTON! see thy Sons deplore,
Thy hallow'd Walks besmear'd with guiltless Gore:
While faithless P—n and his savage Bands,
With murd'rous Rancour stretch their bloody Hands;
Like fierce Barbarians grinning o'er their Prey,
Approve the Carnage, and enjoy the Day.

If scalding drops from Rage from Anguish Wrung,
If speechless Sorrows lab'ring for a Tongue,
Or if a weeping World can ought appease
The plaintive Ghosts of Victims such as these;
The Patriot's copious Tears for each are shed,
A glorious Tribute which embalms the Dead.

But know, FATE summons to that awful Goa,
Where JUSTICE strips the Mud'rer of his So
Should venal C—ts the scandal of the Lan
Snatch the relentless Villain from her Hand
Keen Execrations on this Plate inscrib'd
Shall reach a JUDGE who never can be bri

The unhappy Sufferers were Mess.rs SAM.l GRAY, SAM.l MAVERICK, JAM.s CALDWELL, CRISPUS ATTUCKS & PAT.k Ca
Killed. Six wounded two of them (CHRIST.r MONK & JOHN CLARK). Mortally

34

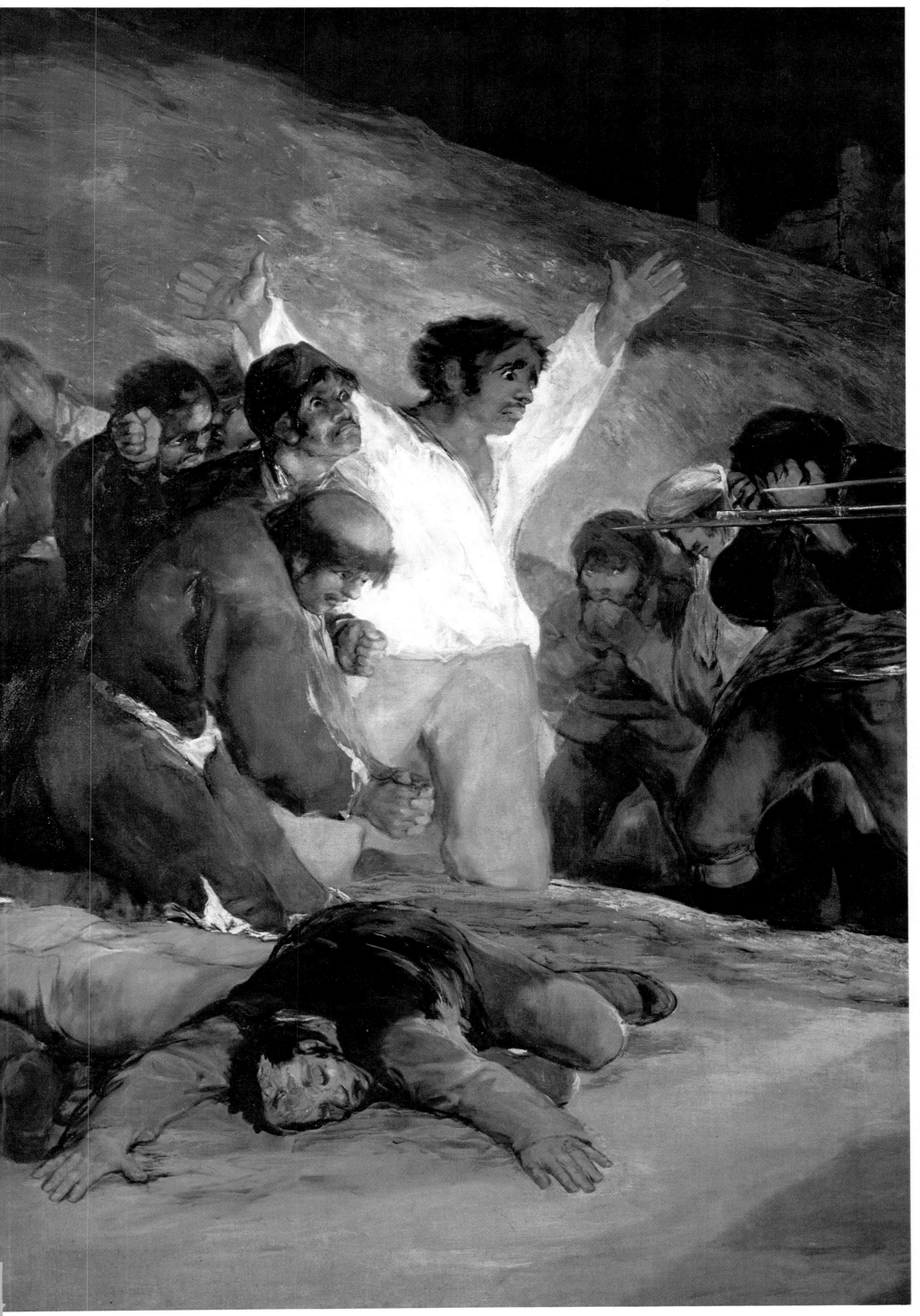

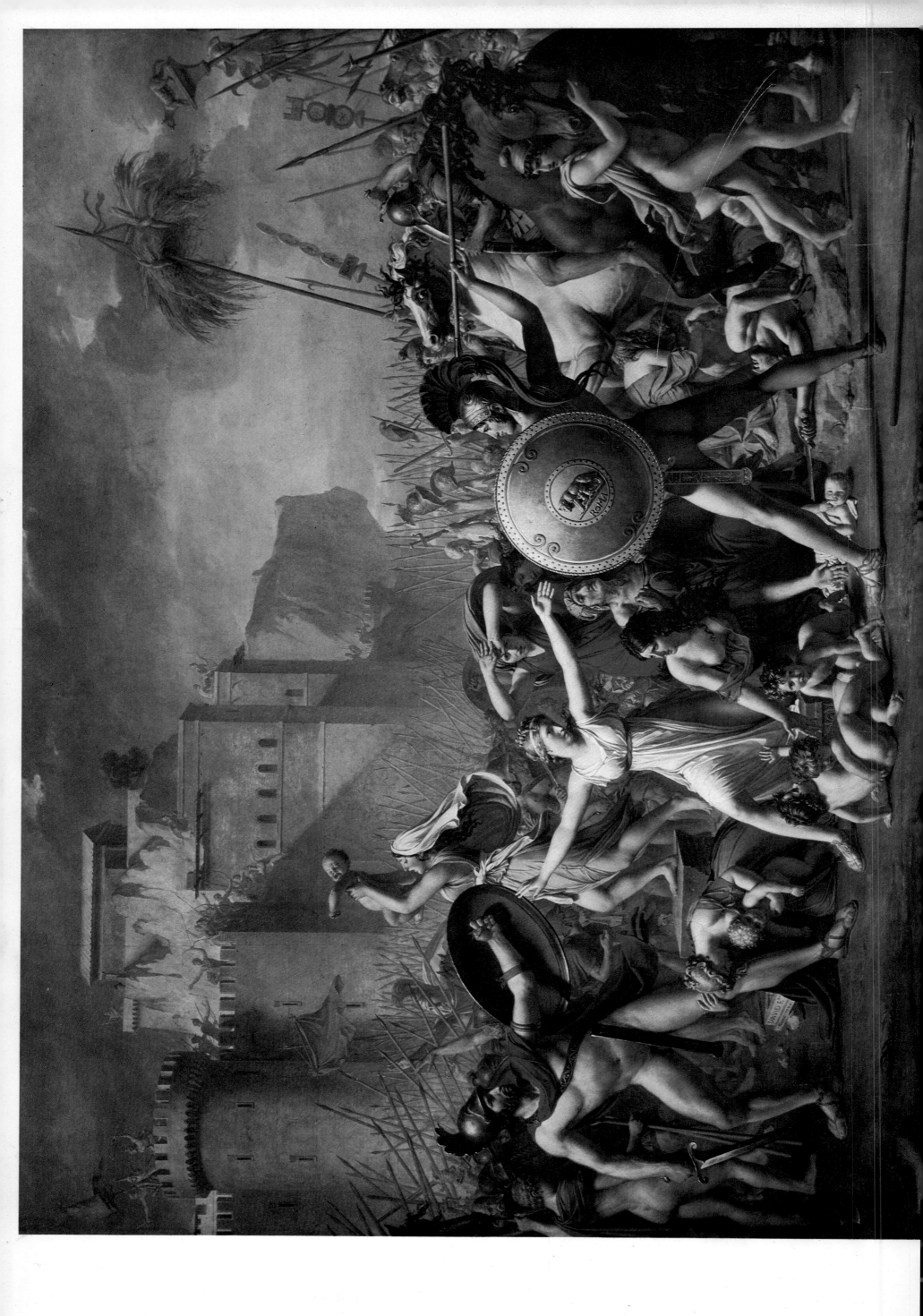

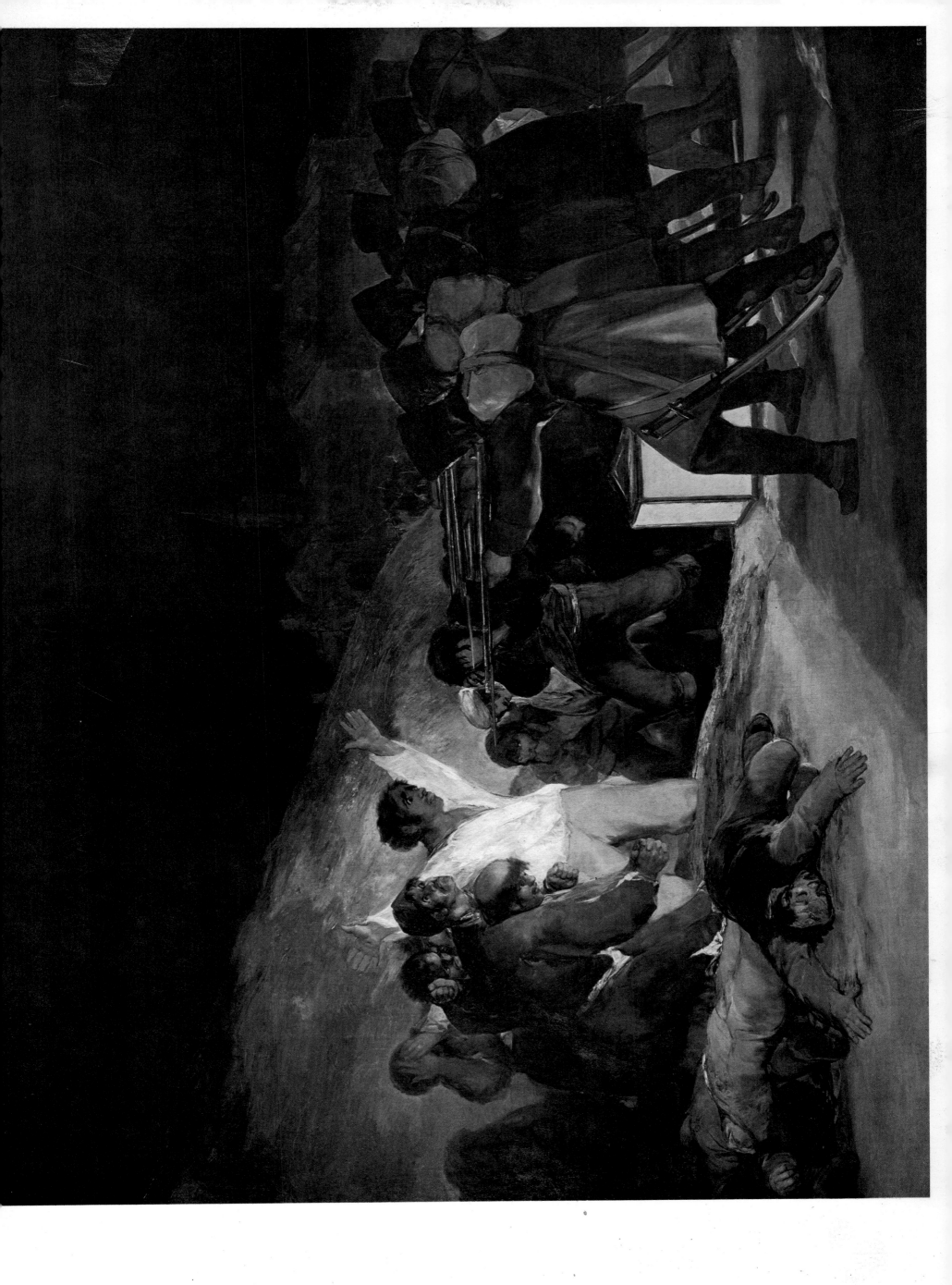

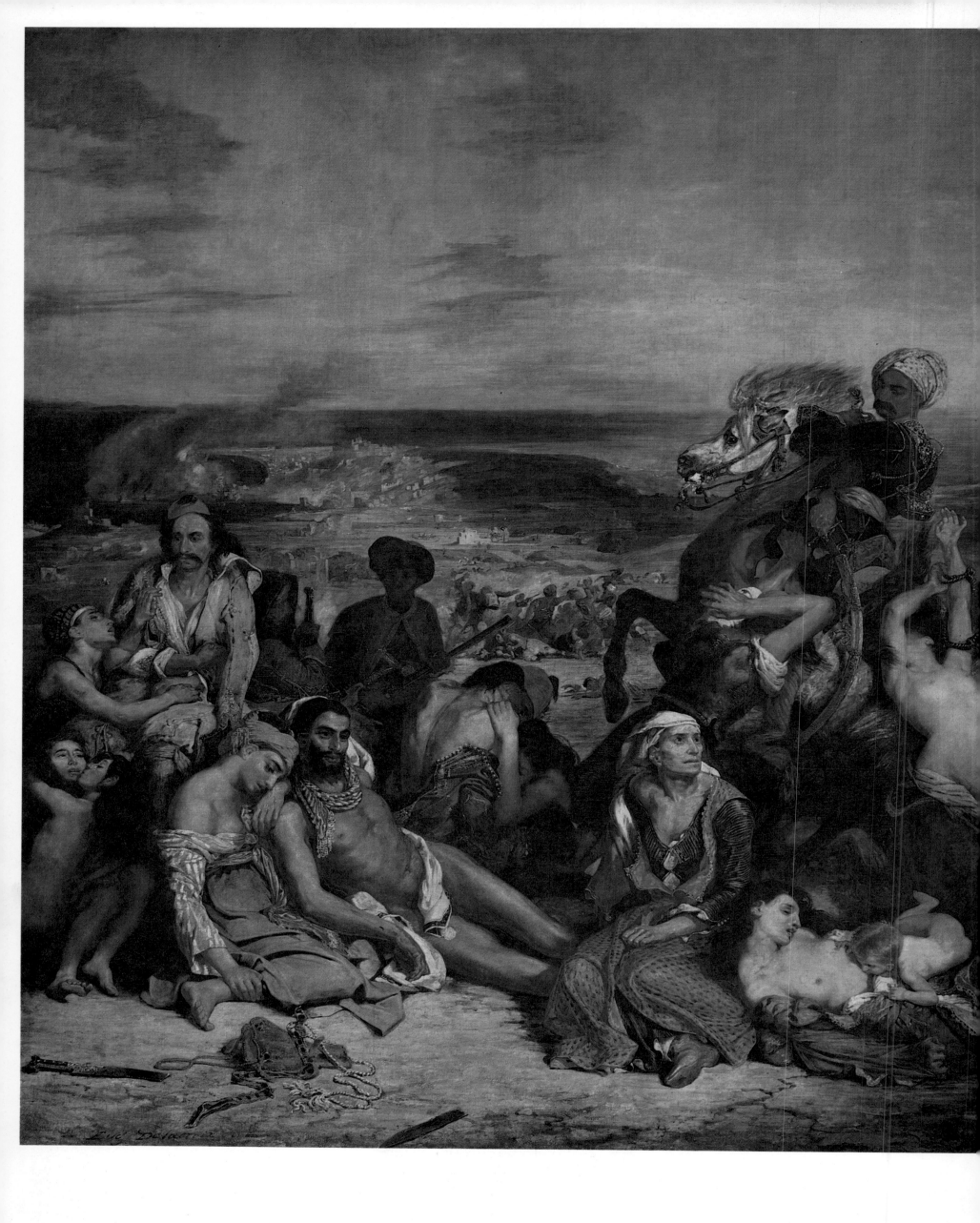

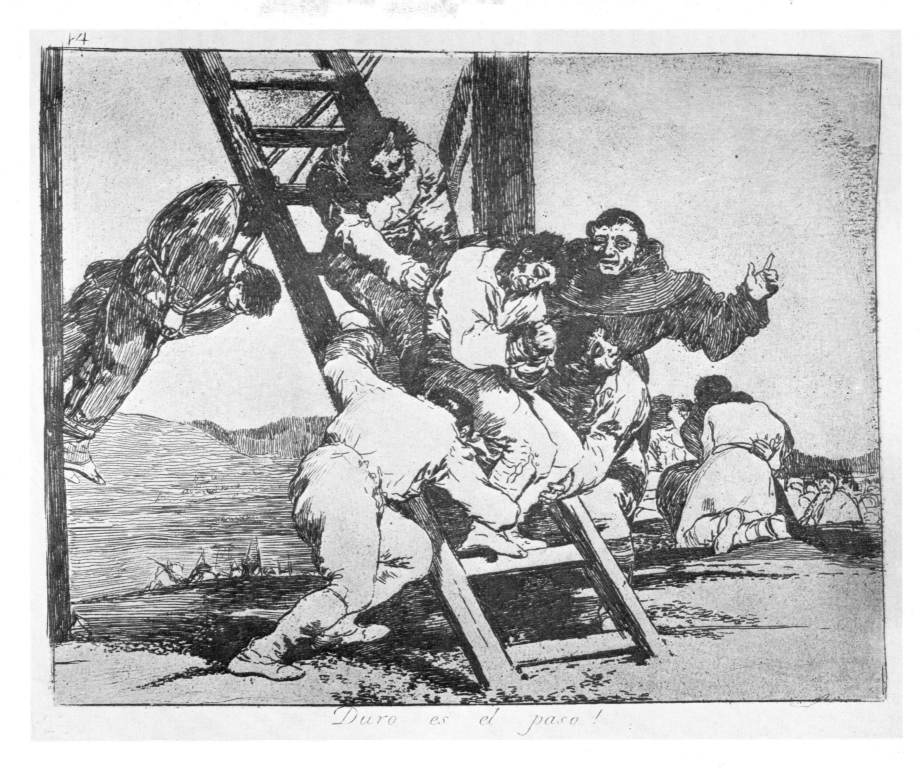

Duro es el paso!

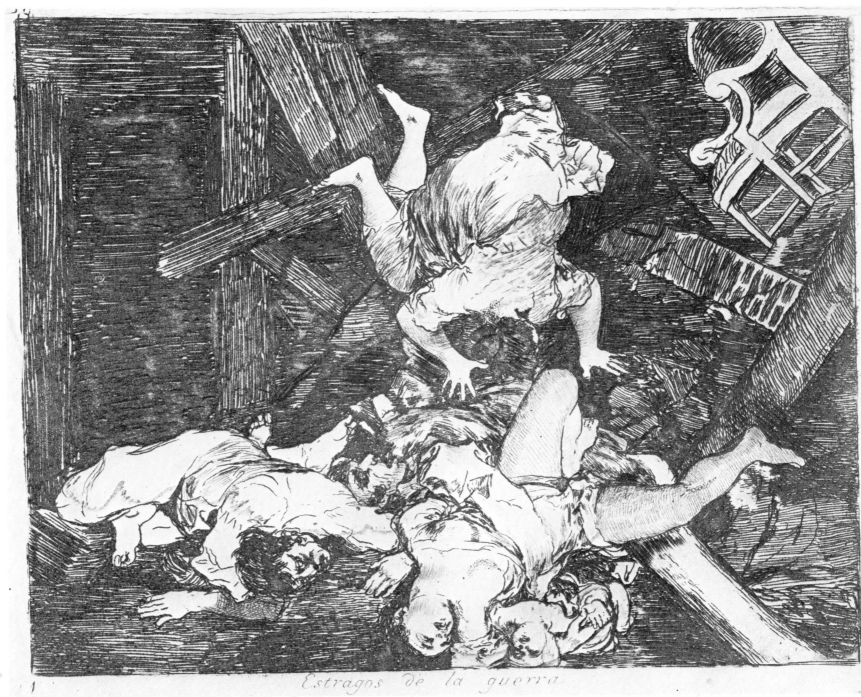

Estragos de la guerra.

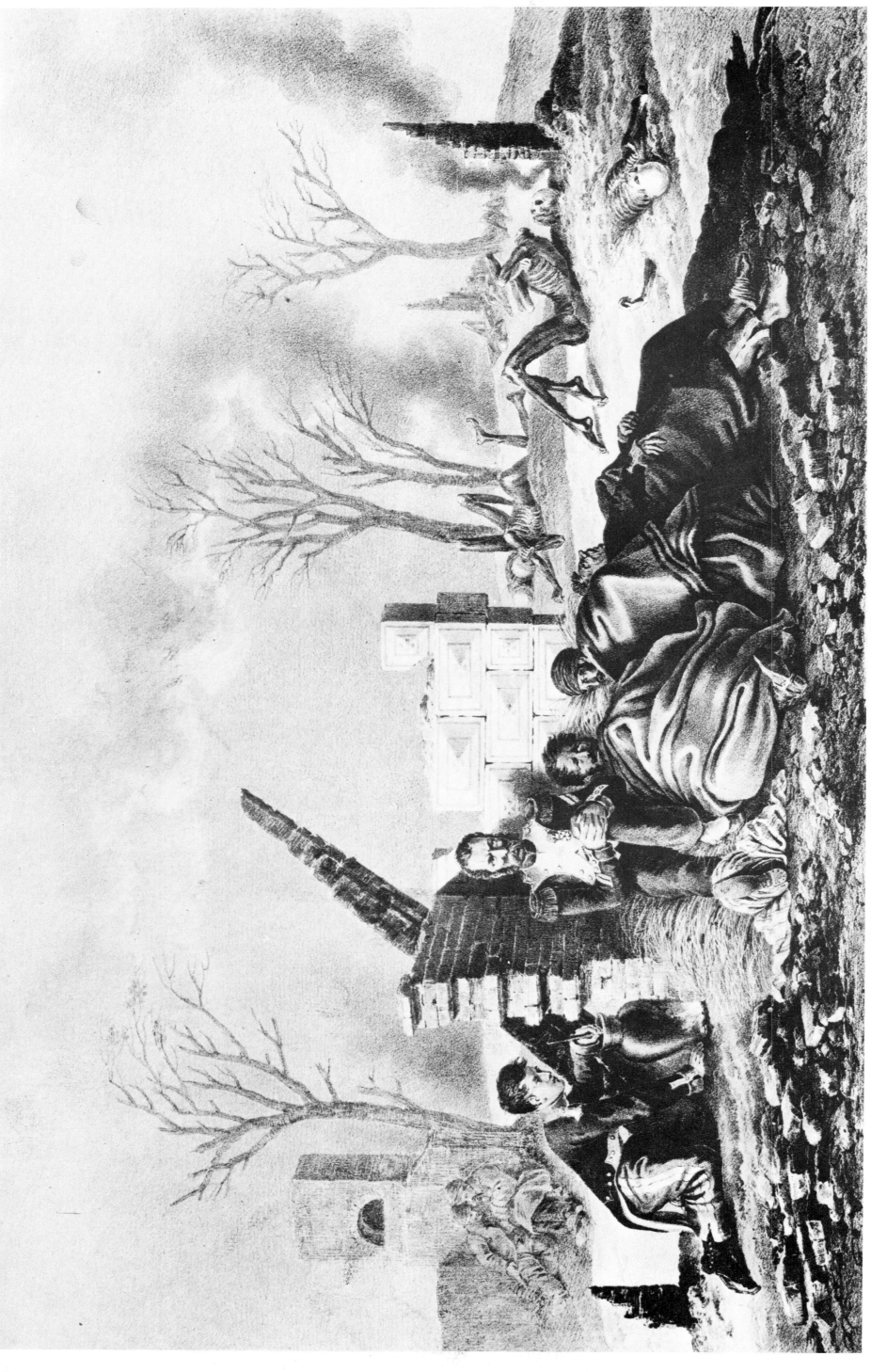

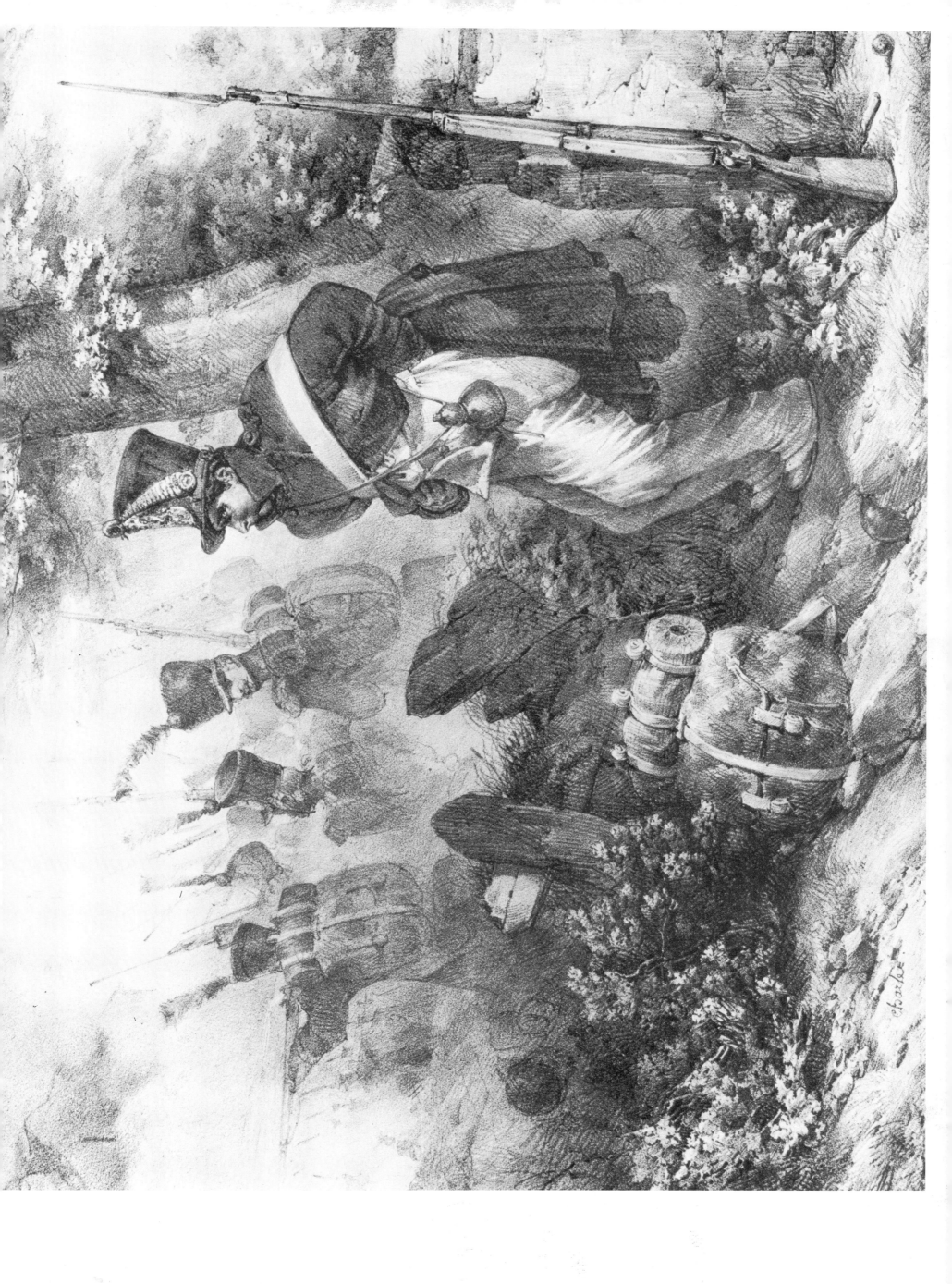

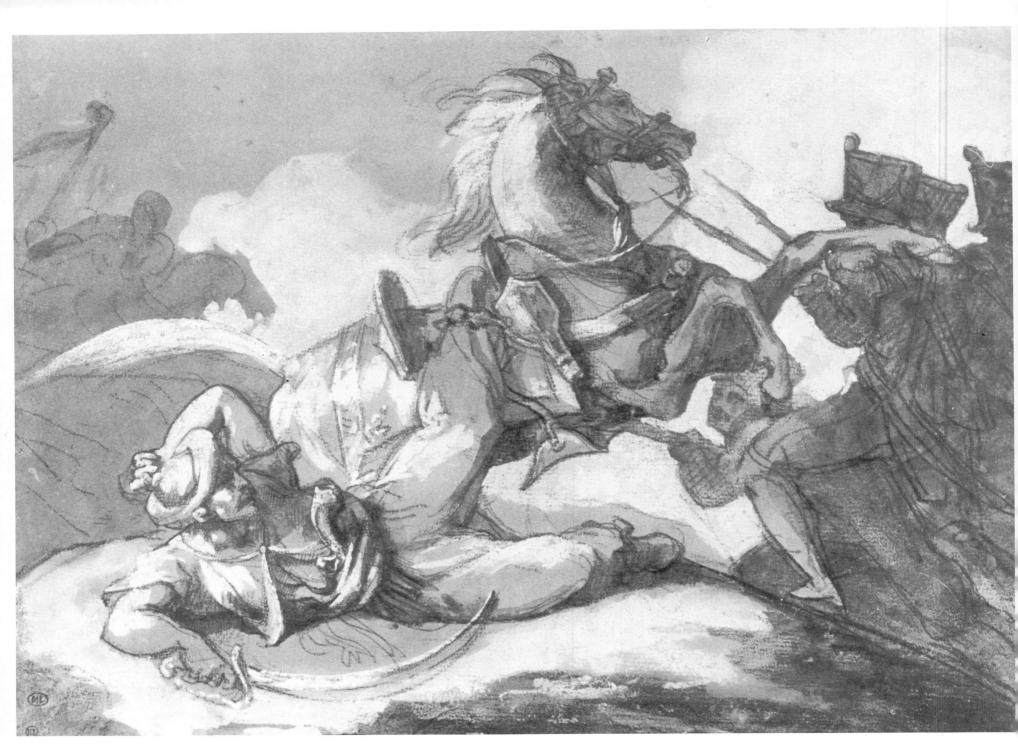

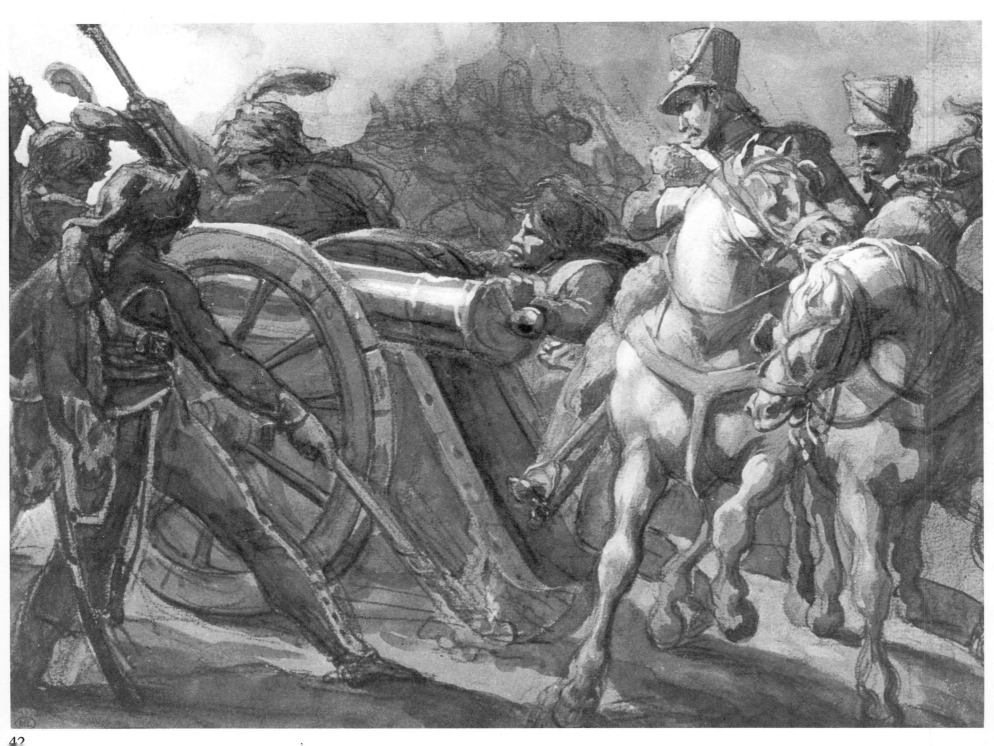

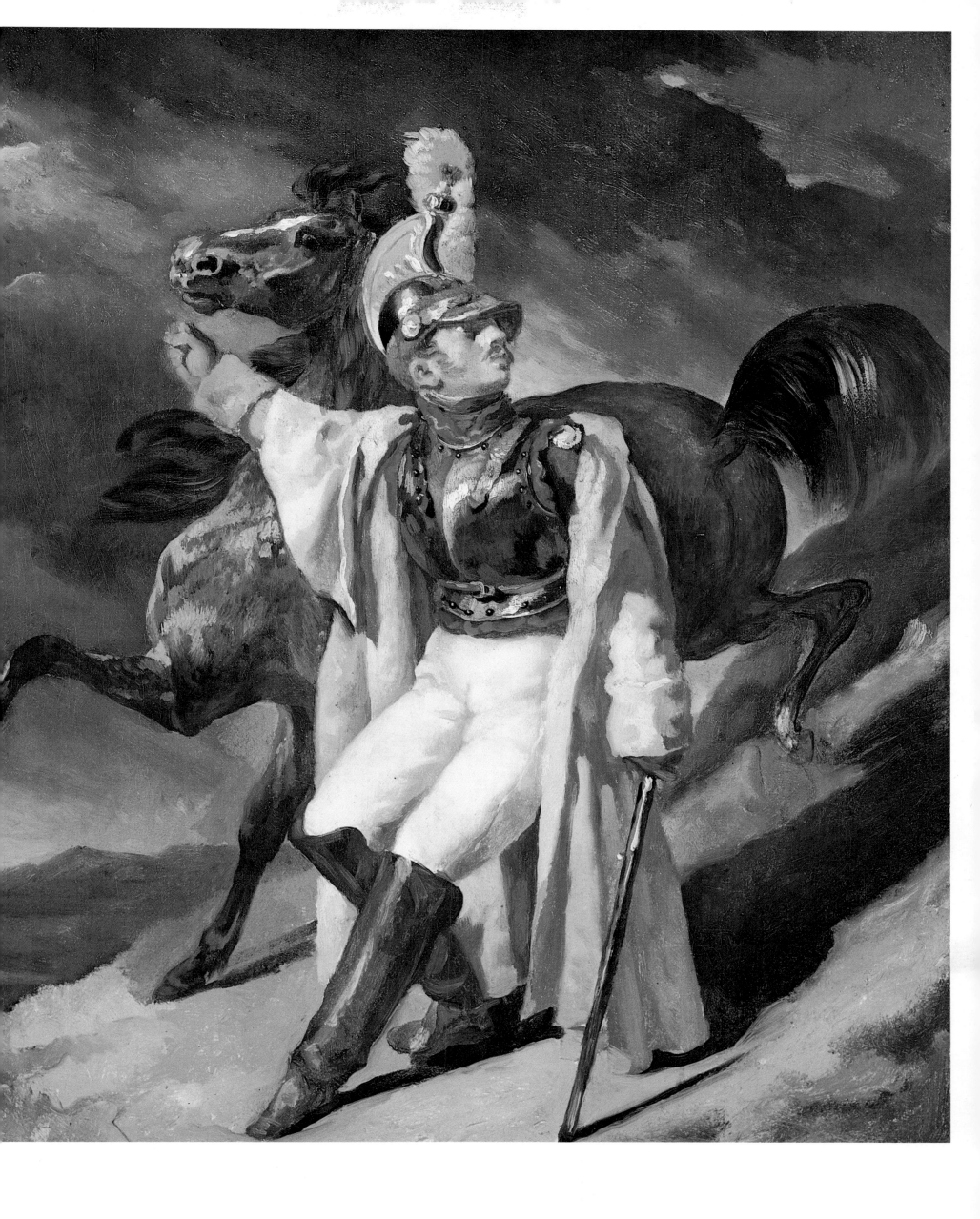

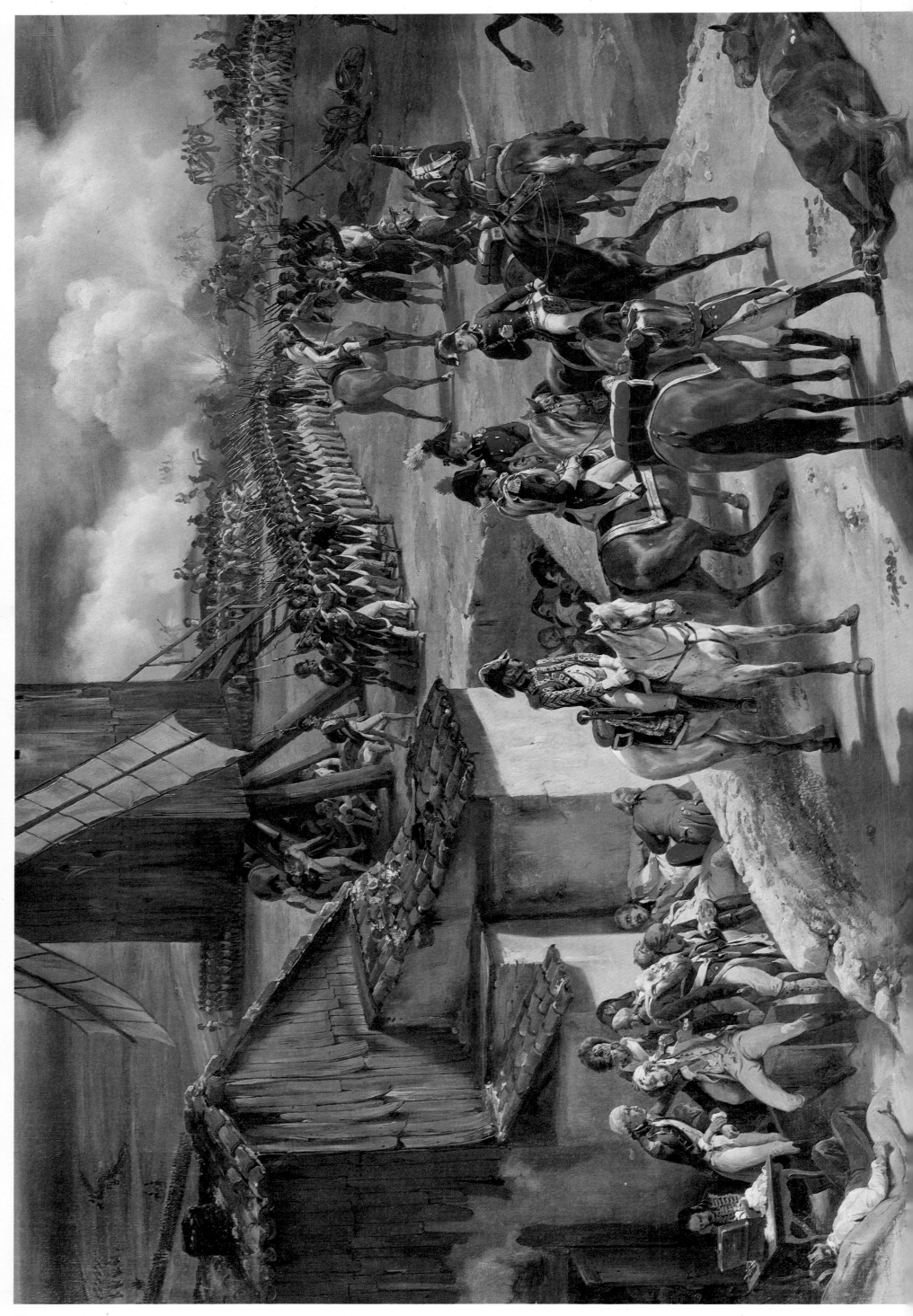

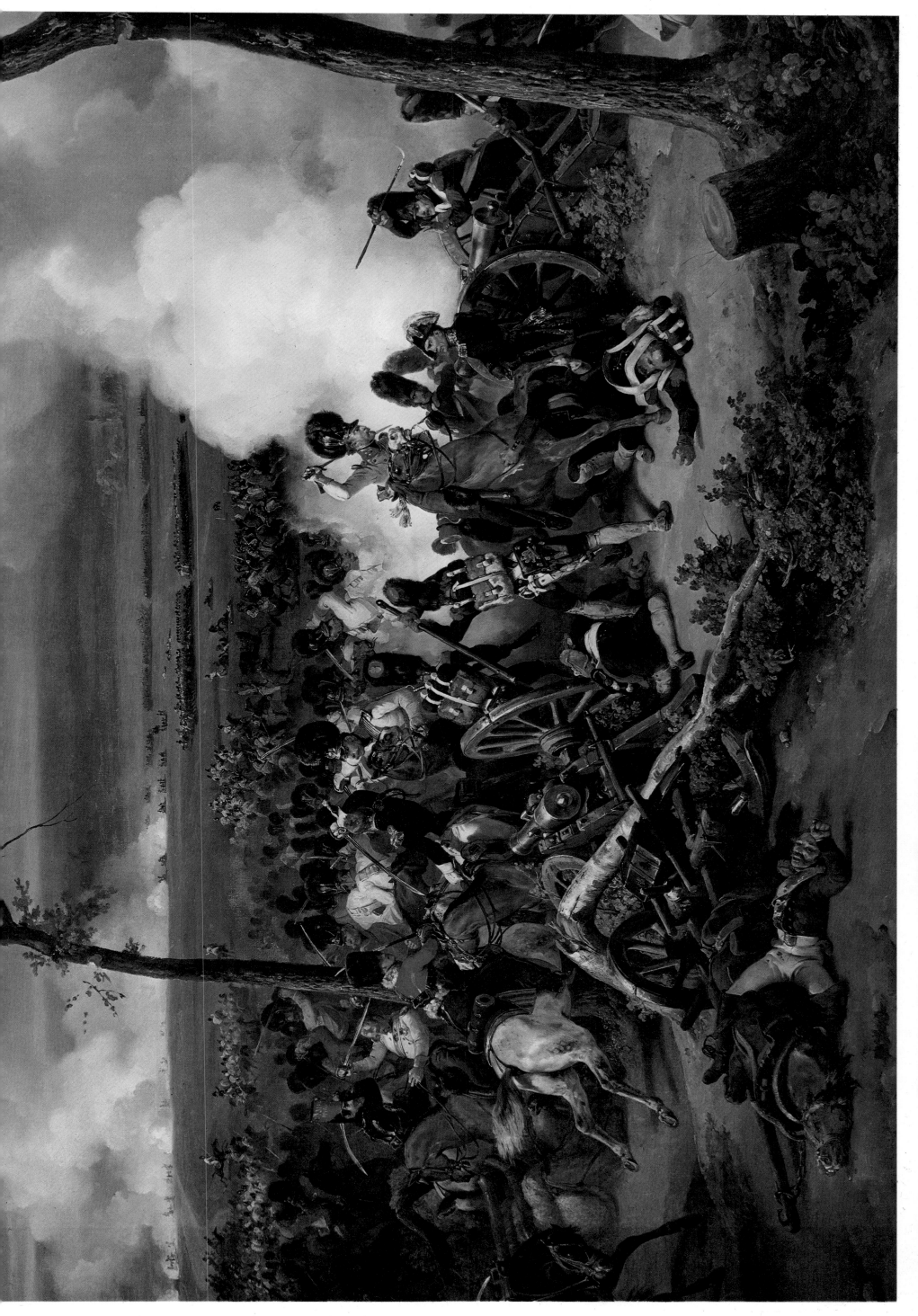

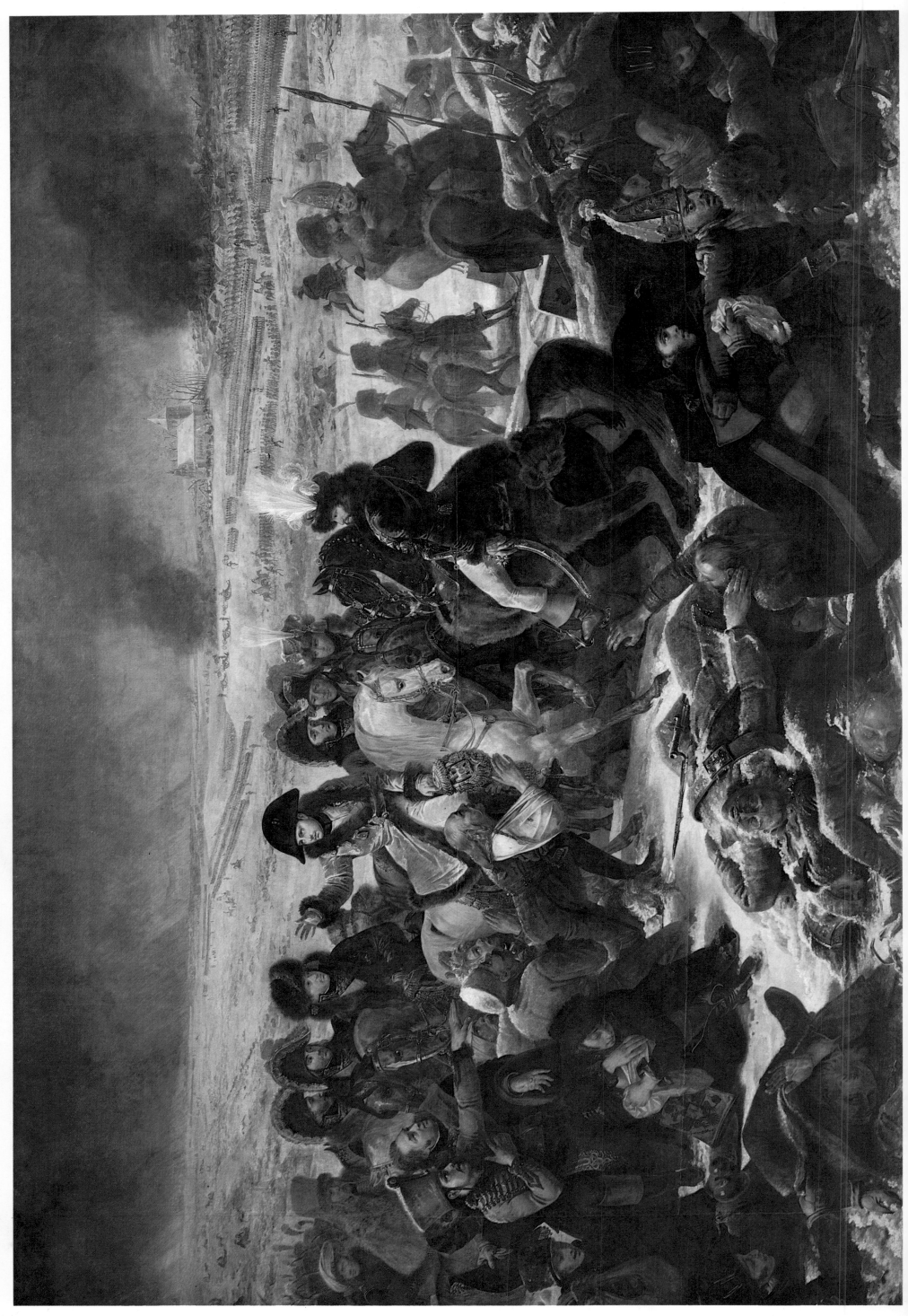

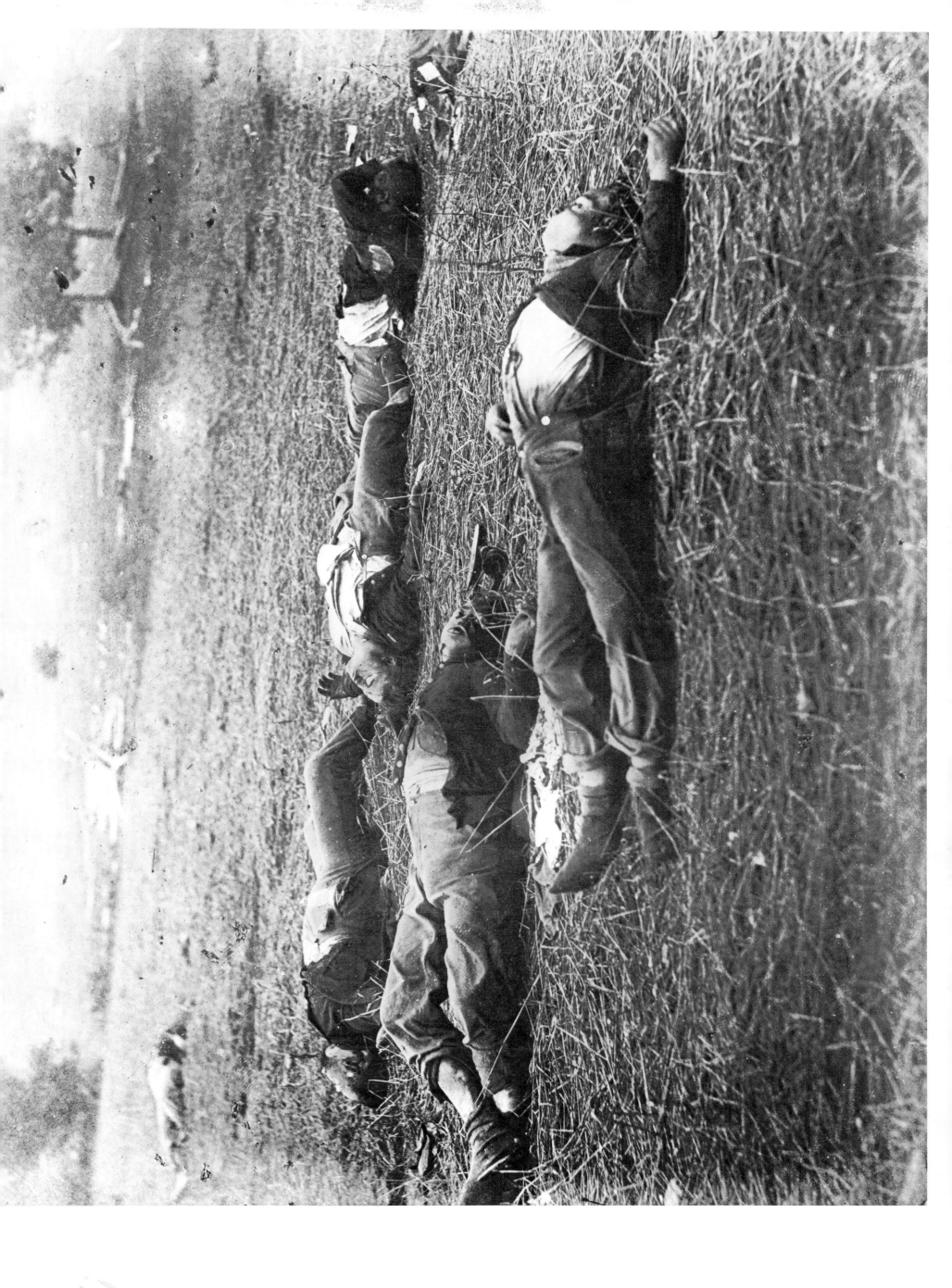

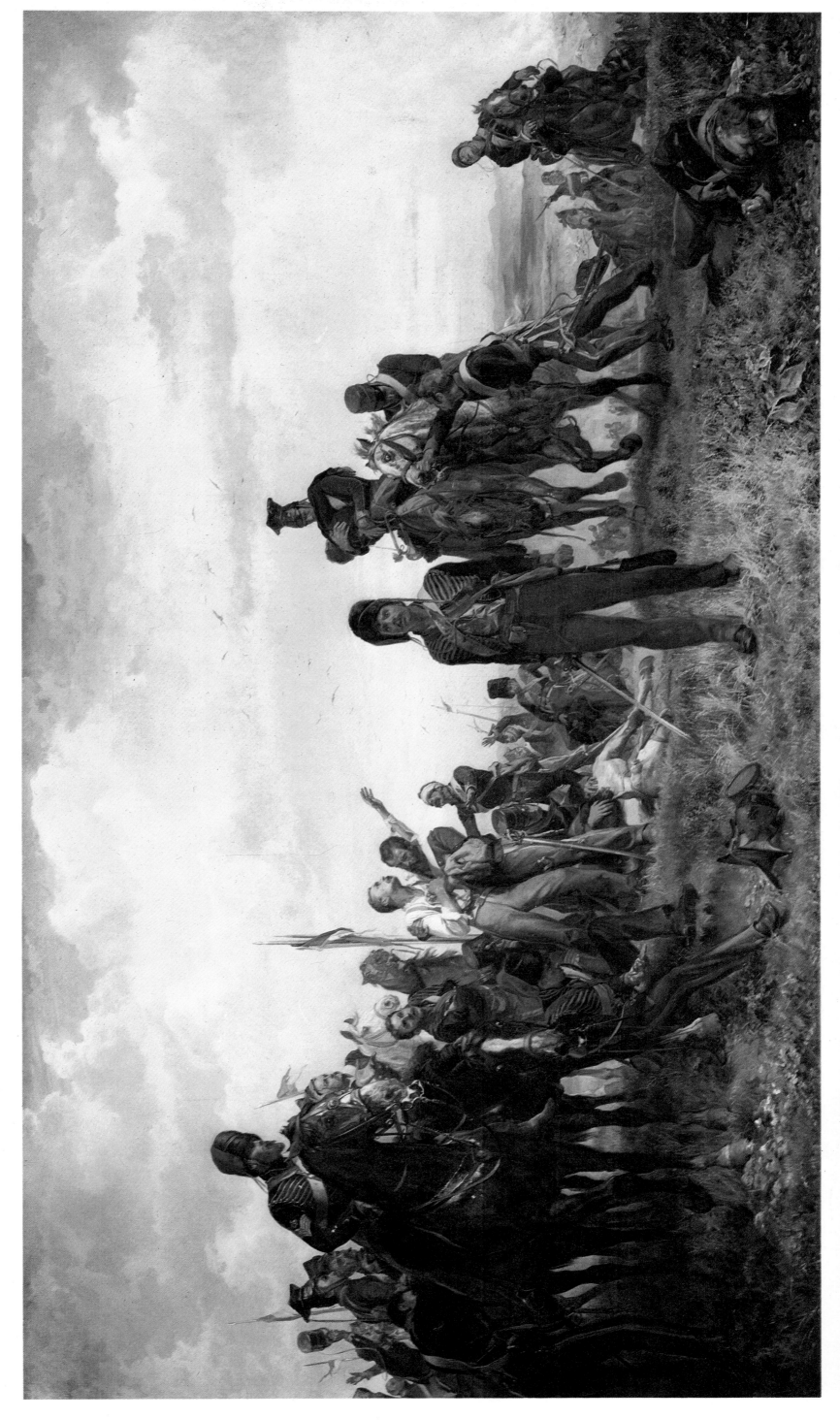

49

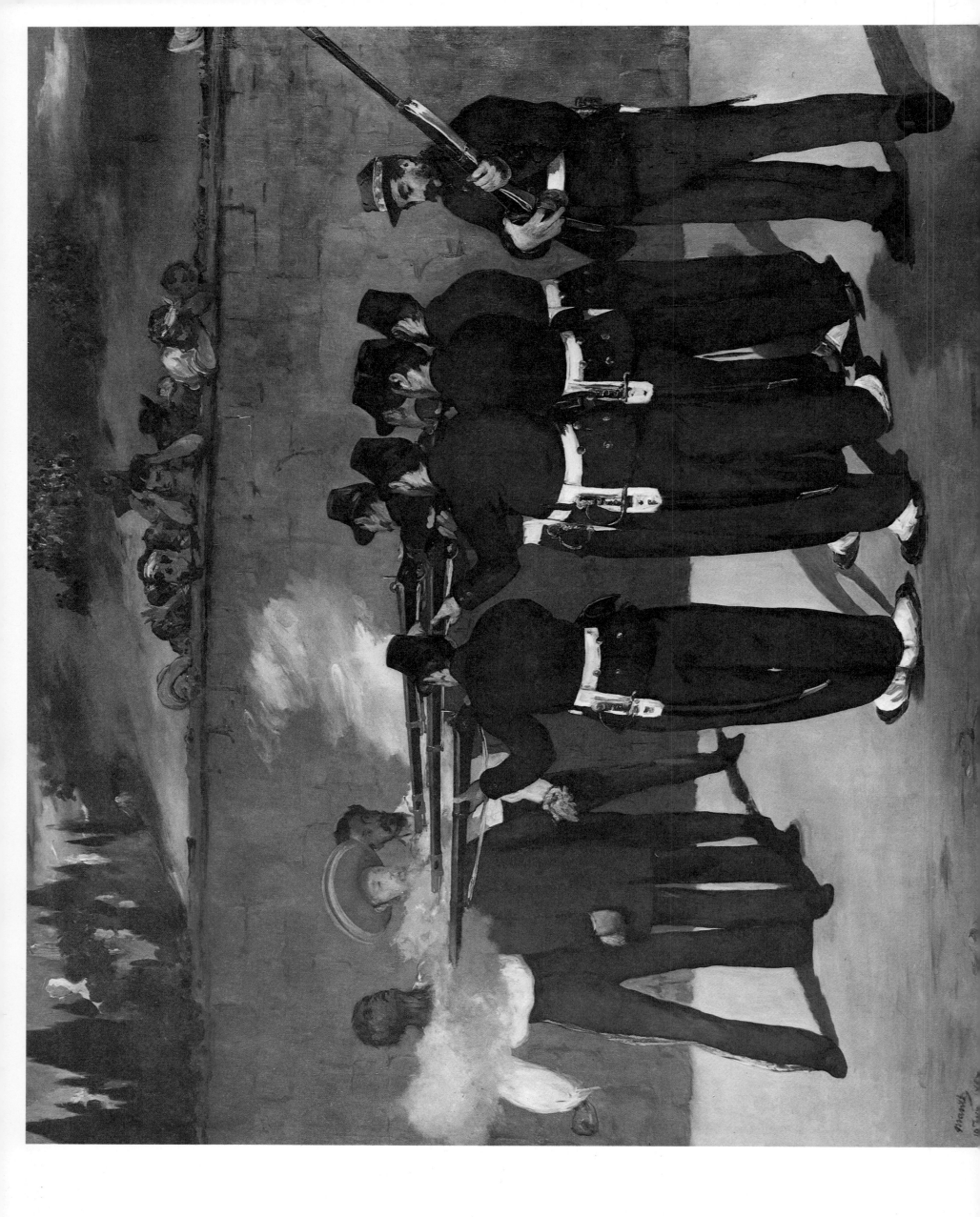

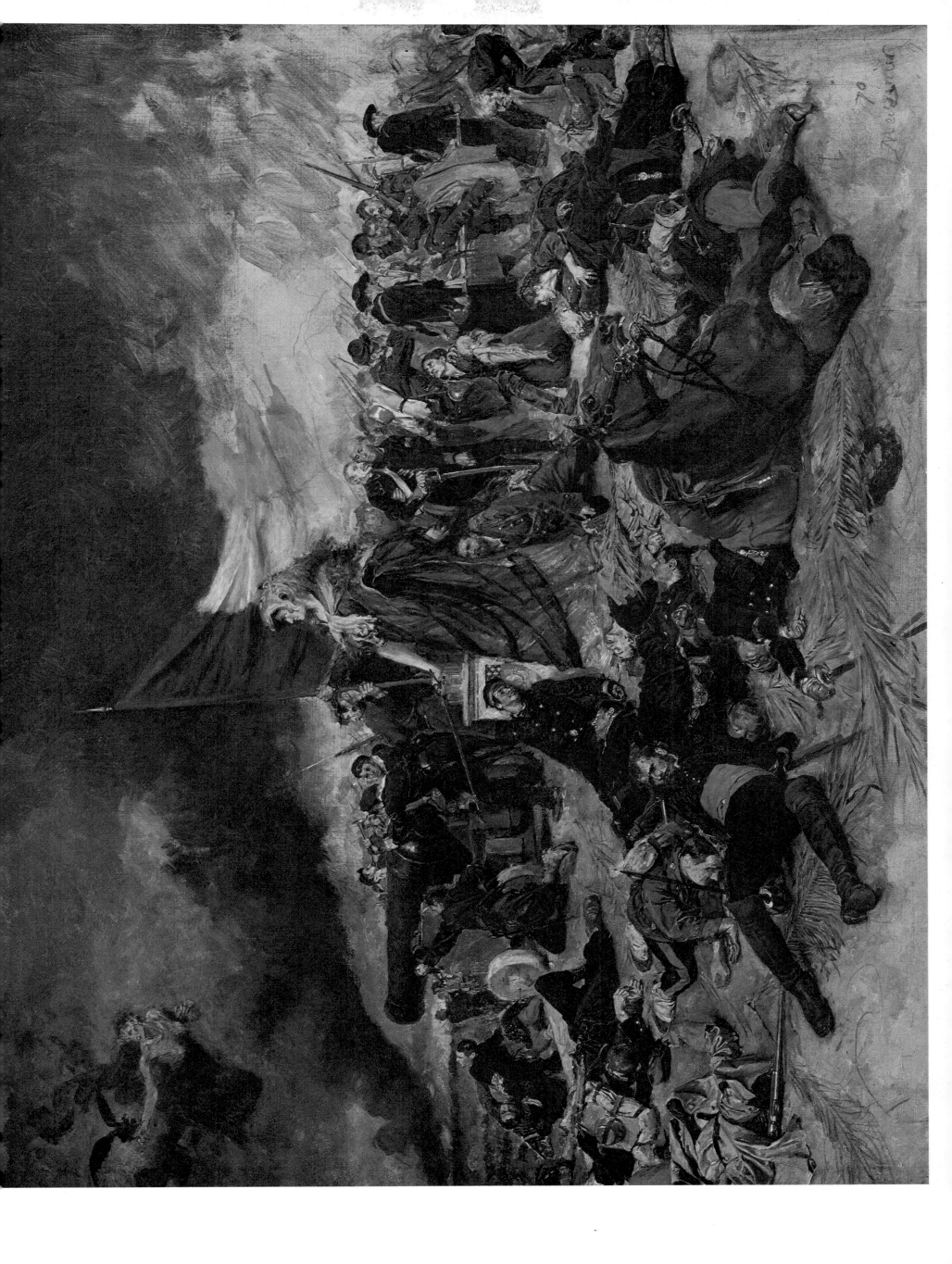

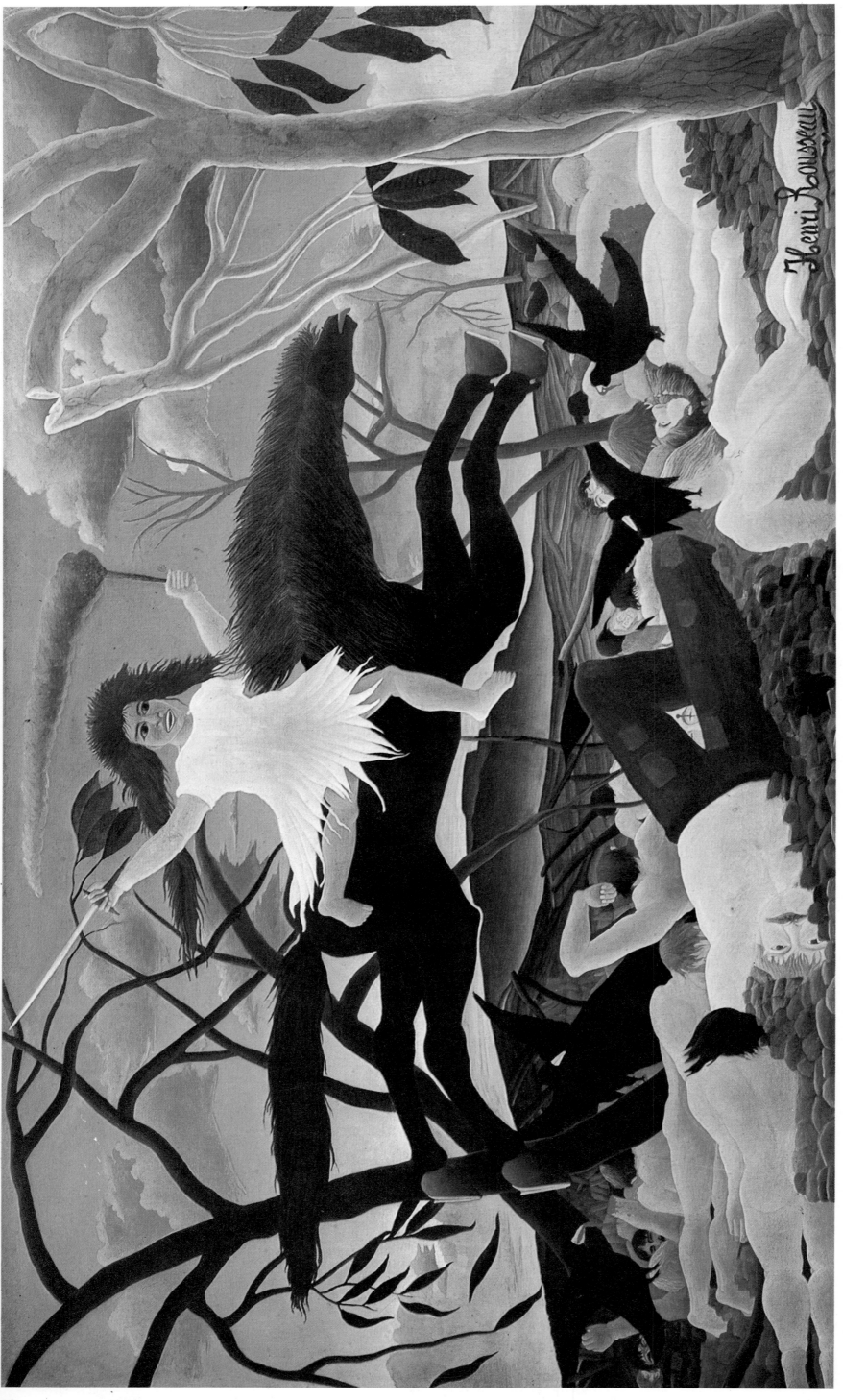

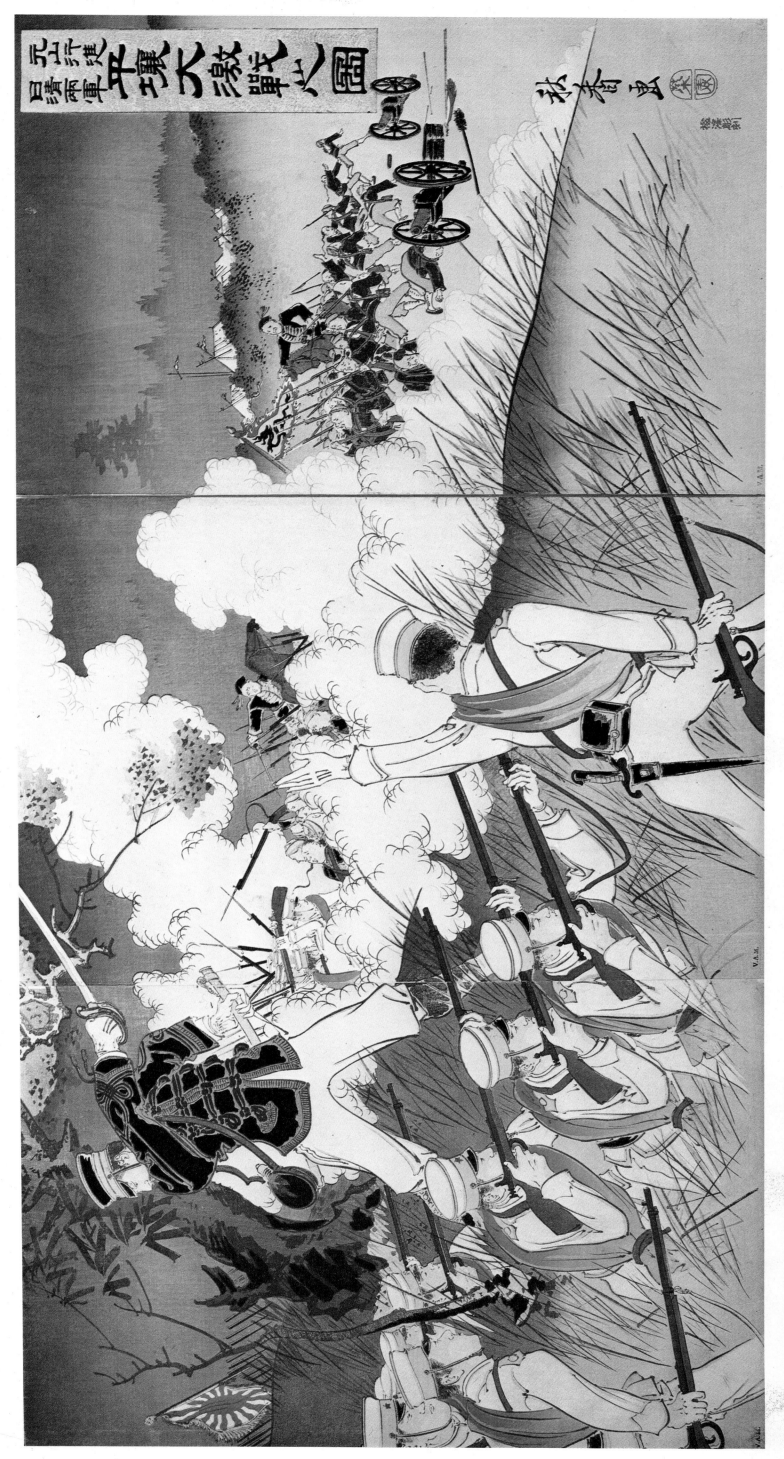

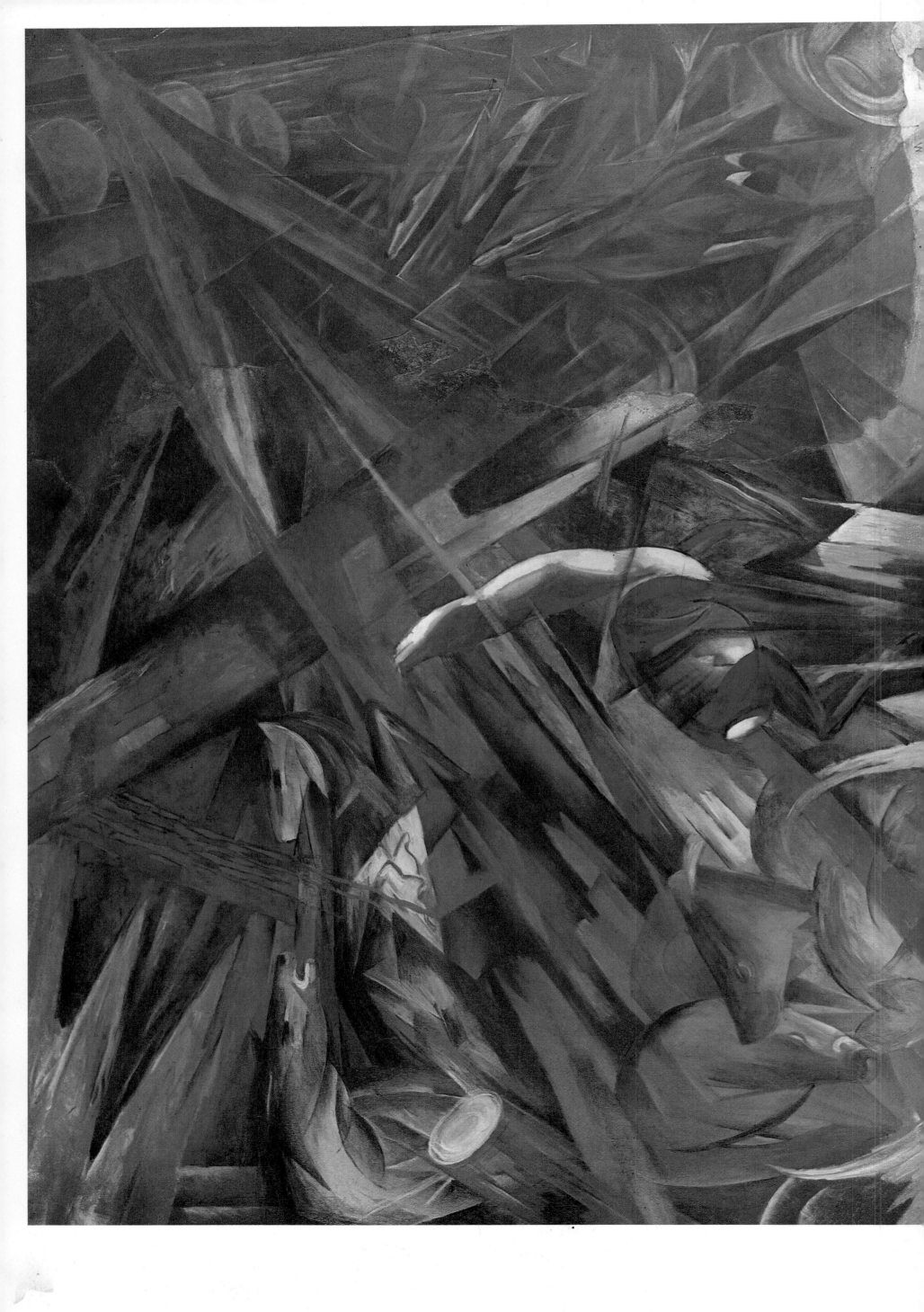

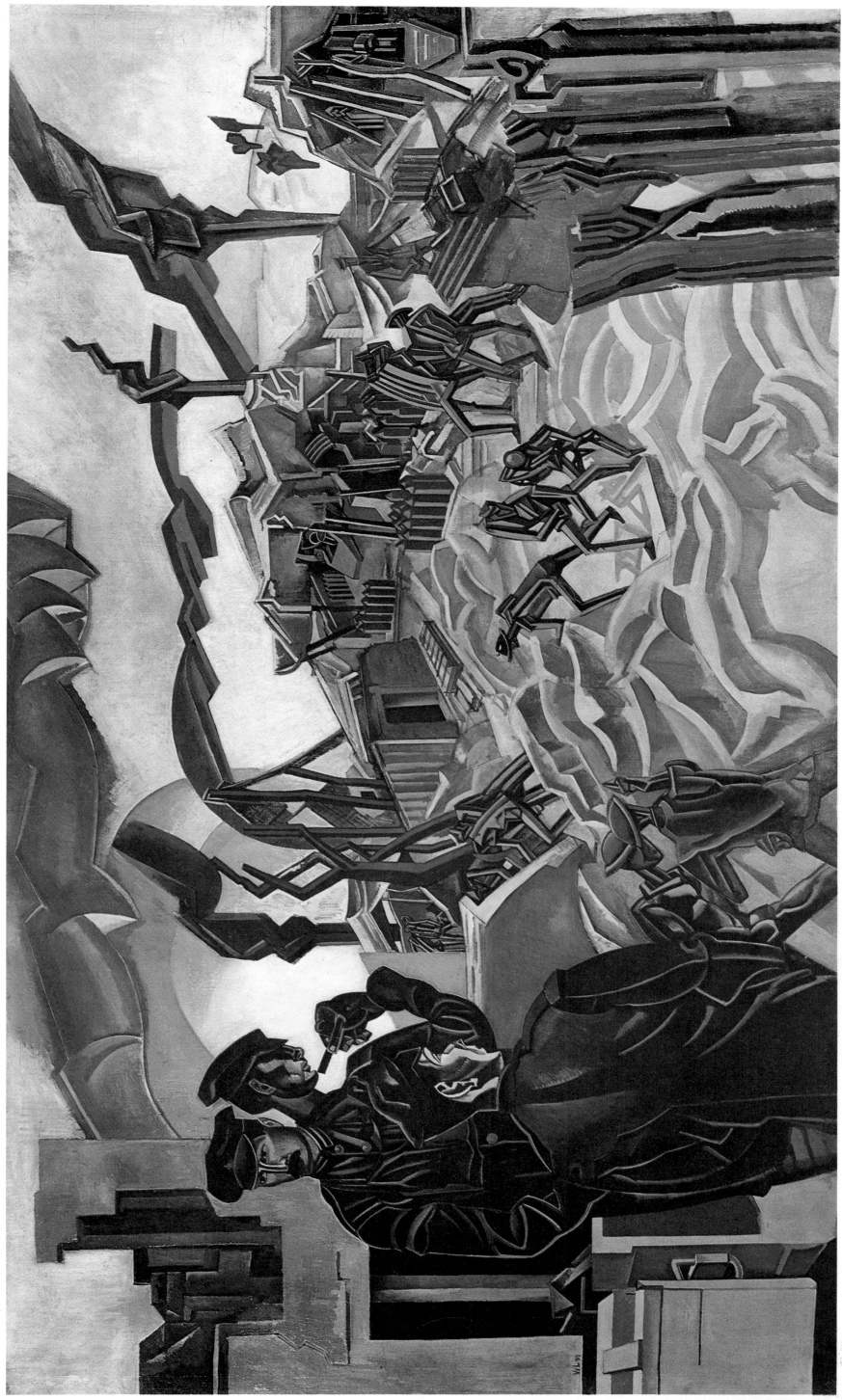

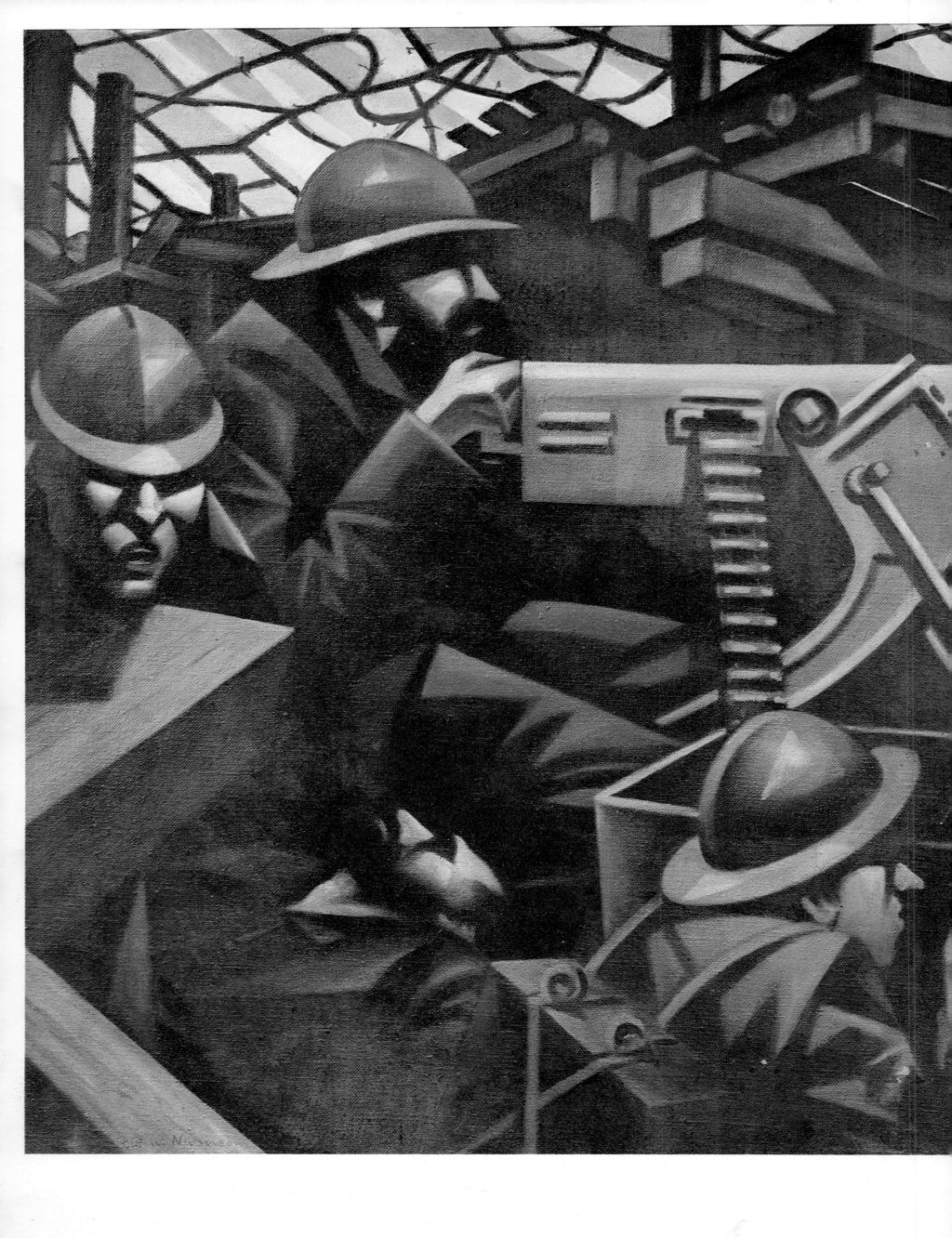

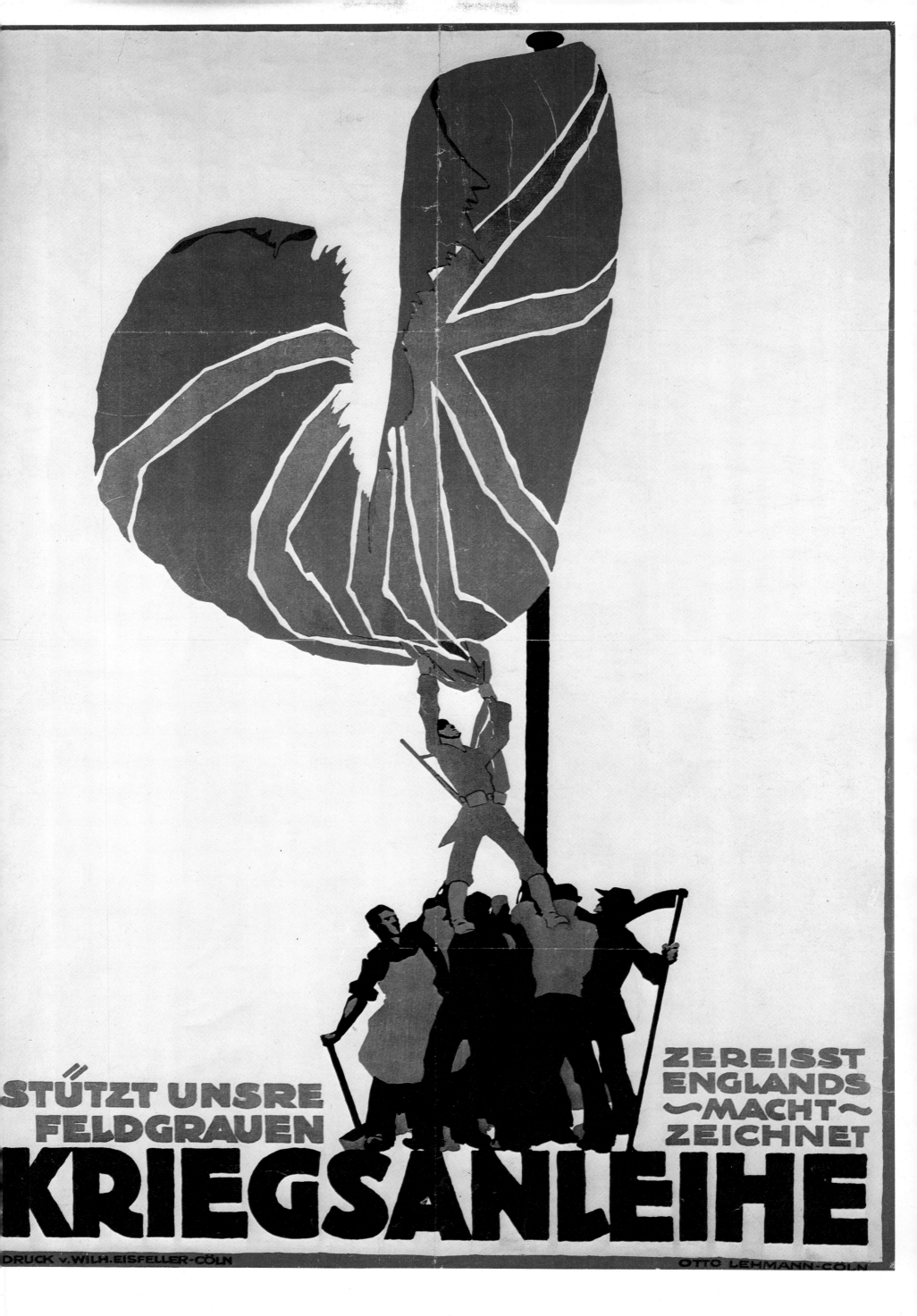

STÜTZT UNSRE FELDGRAUEN

ZEREISST ENGLANDS ~MACHT~ ZEICHNET

KRIEGSANLEIHE

DRUCK v. WILH. EISFELLER-CÖLN

OTTO LEHMANN-CÖLN

57

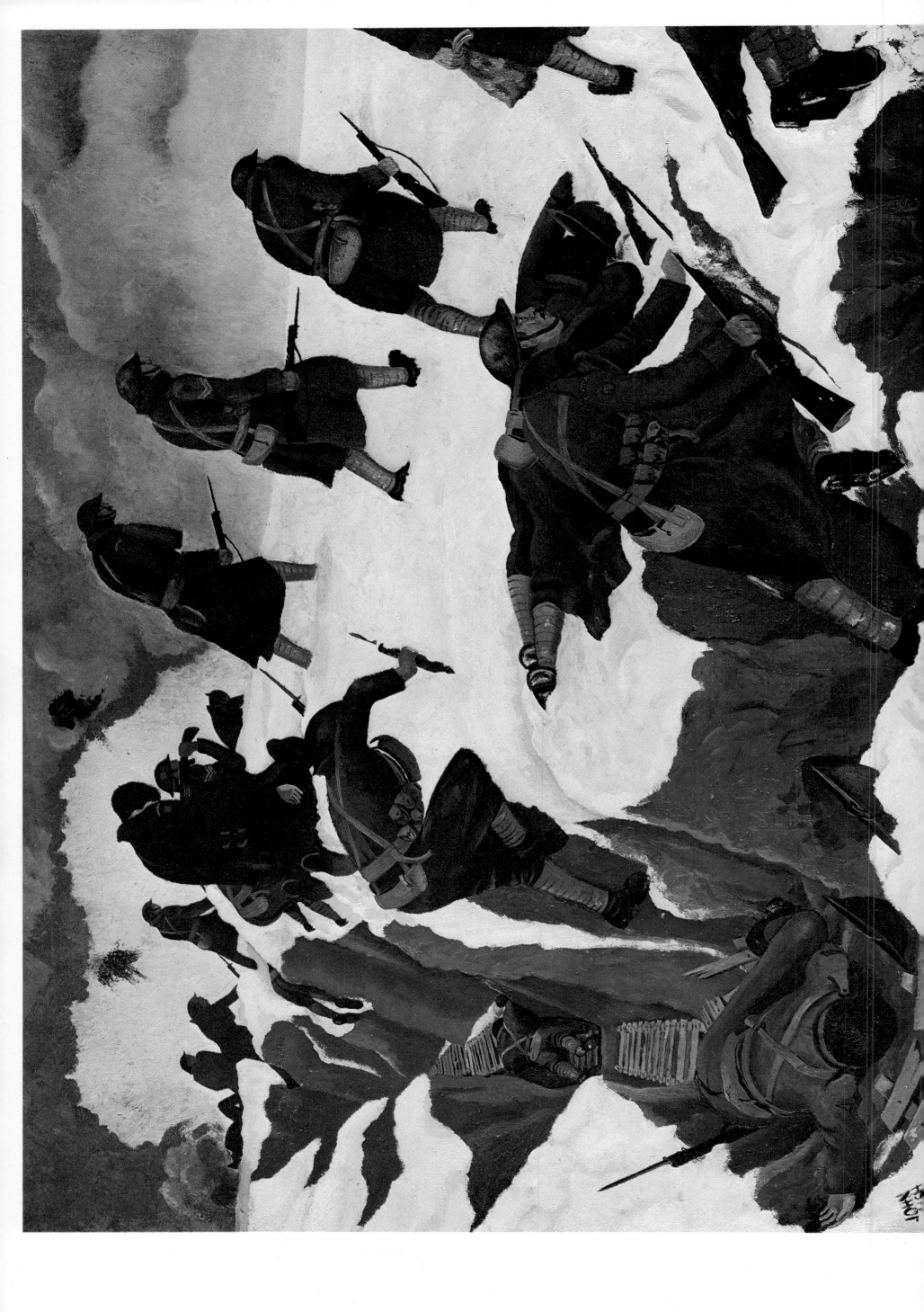

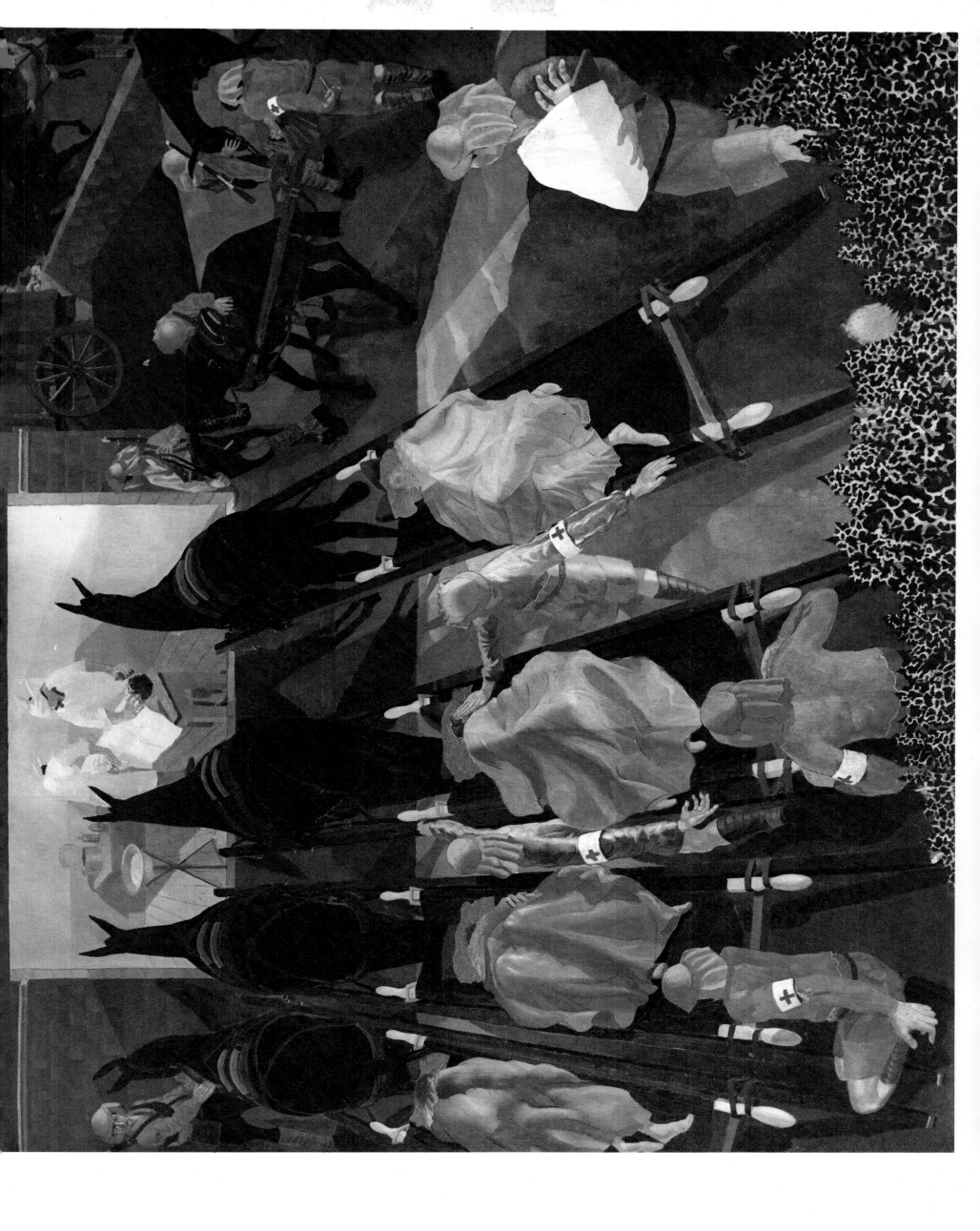

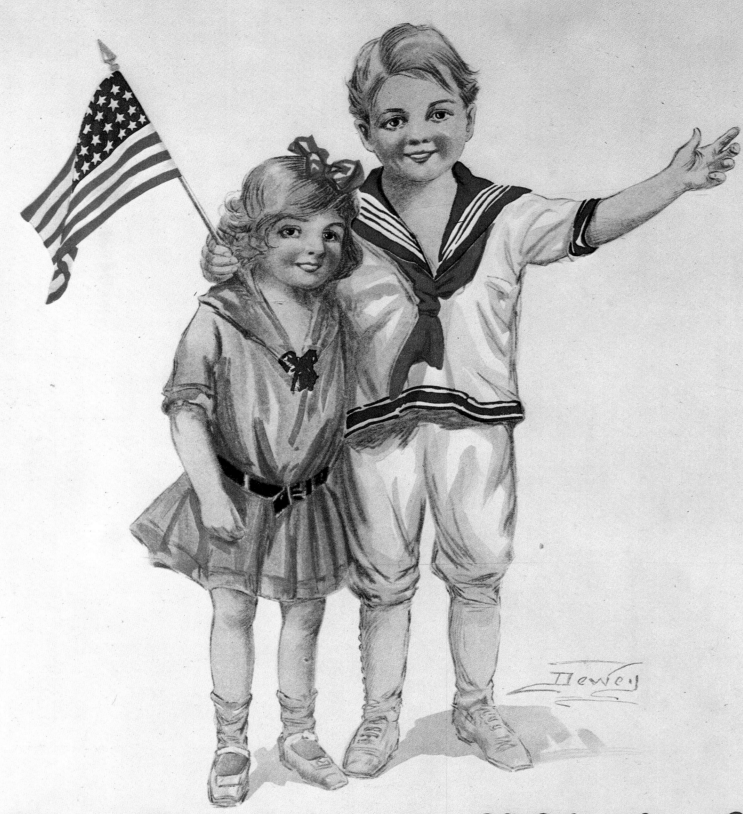

Our Daddy is fighting
at the Front for You—
Back him up— Buy a
United States Gov't Bond of the
2nd LIBERTY LOAN
of 1917

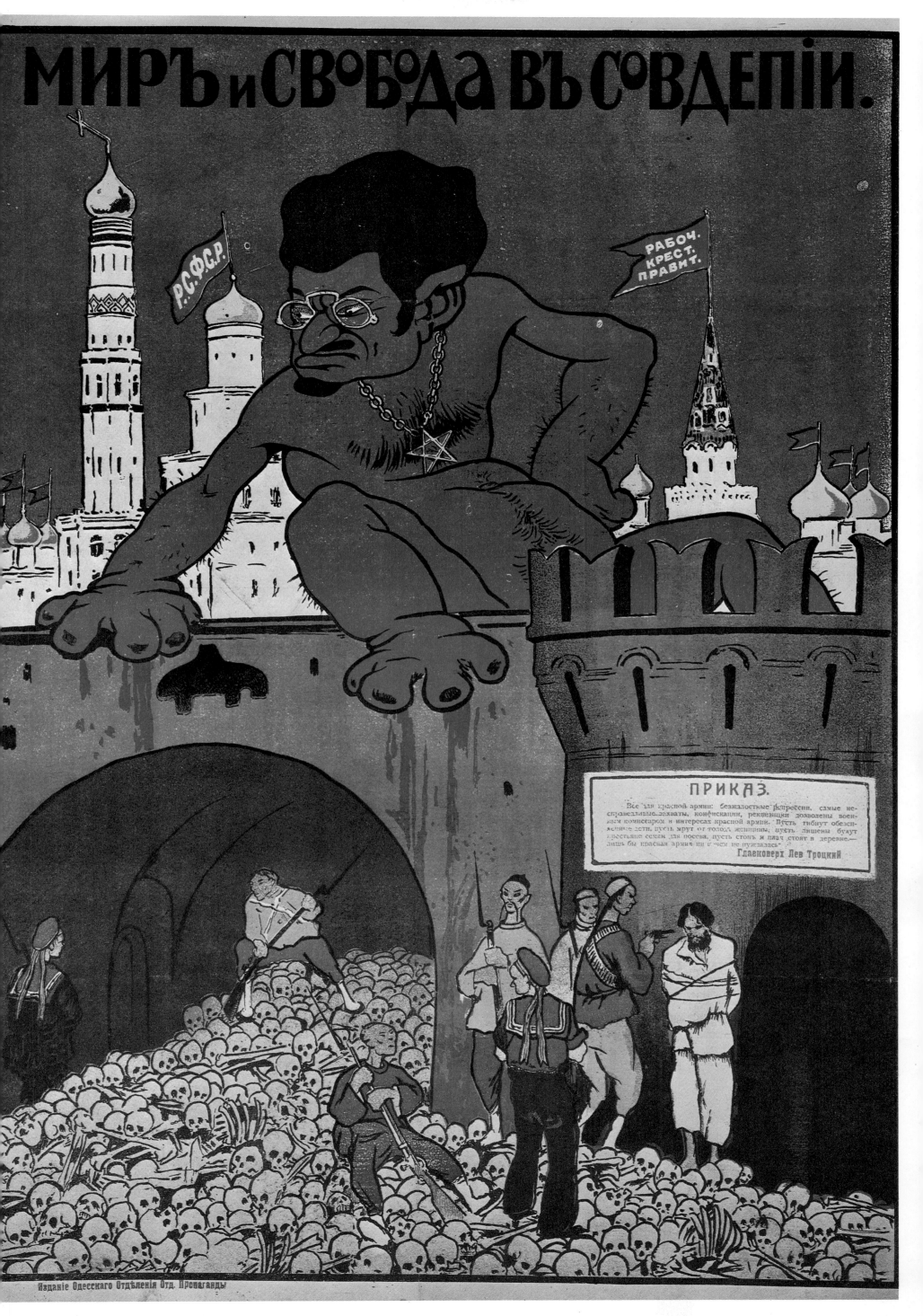

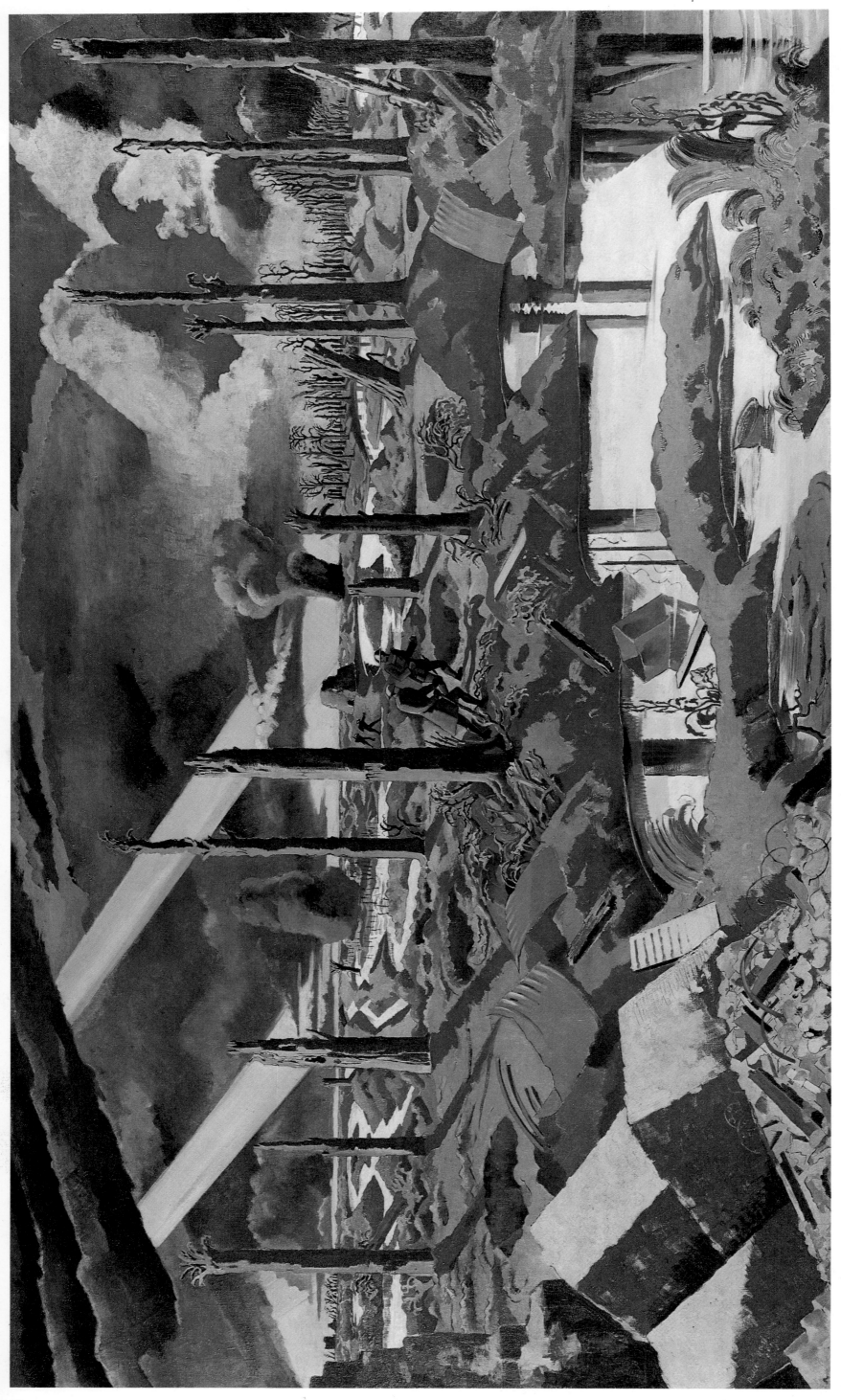

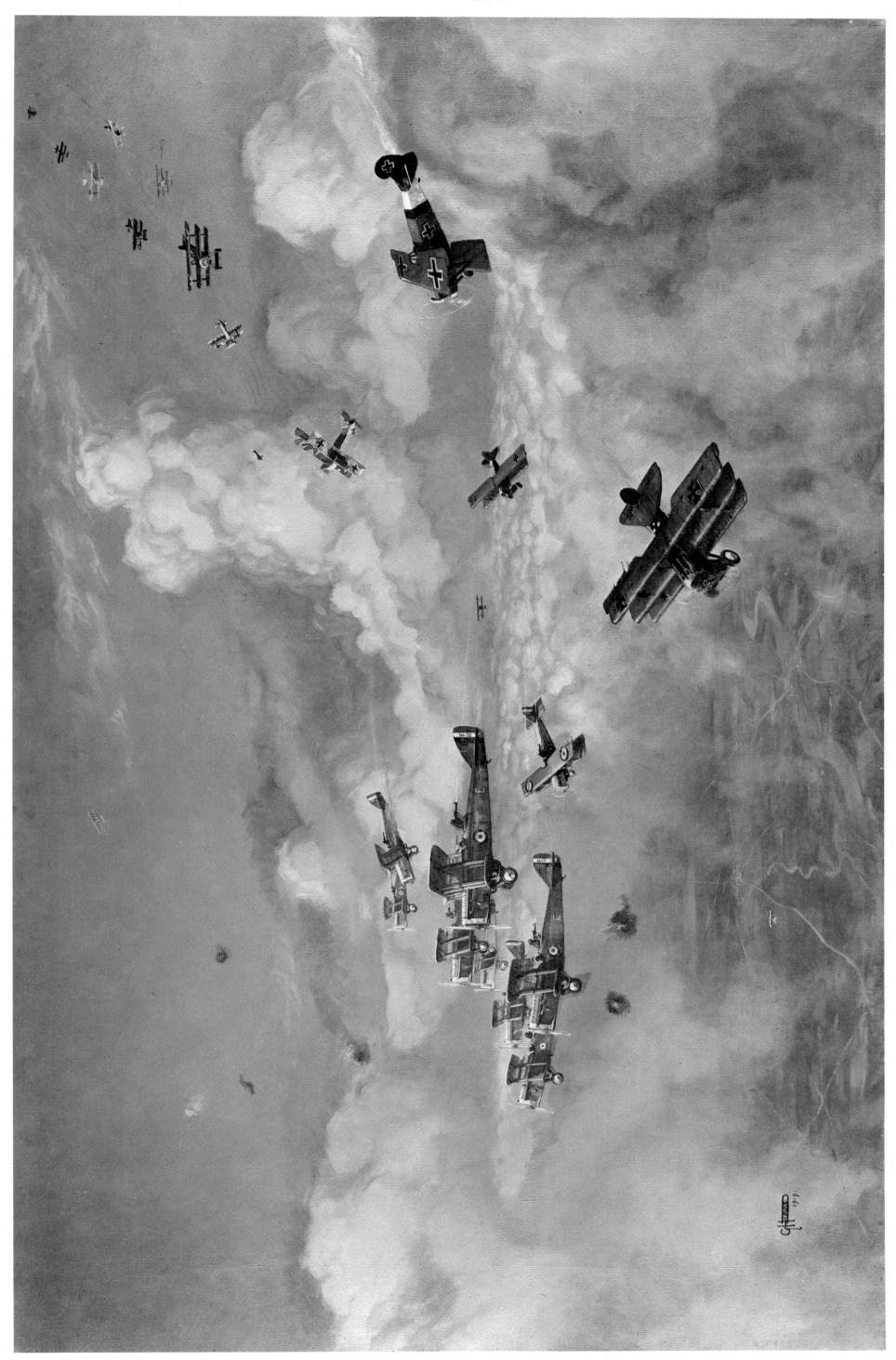

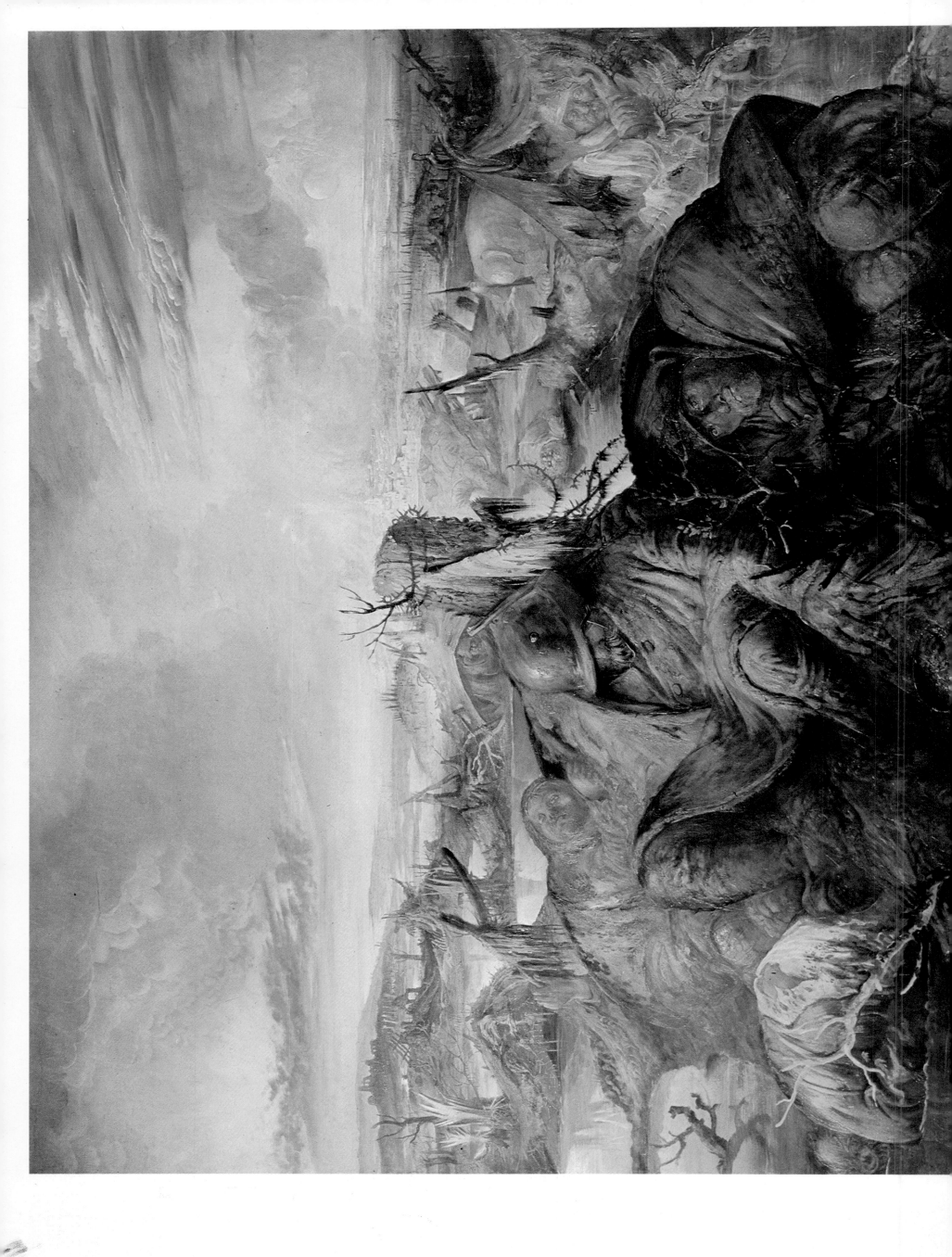

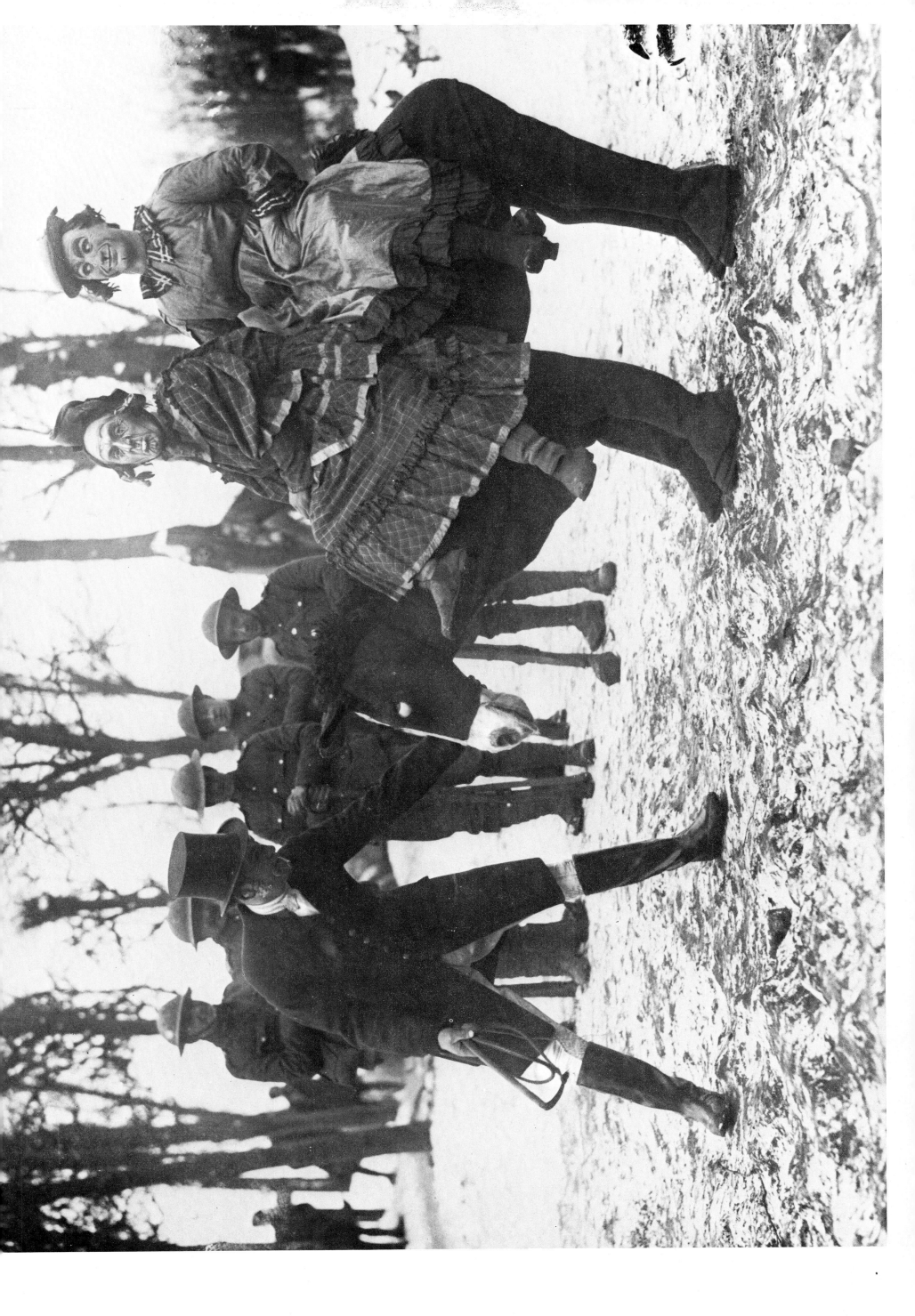

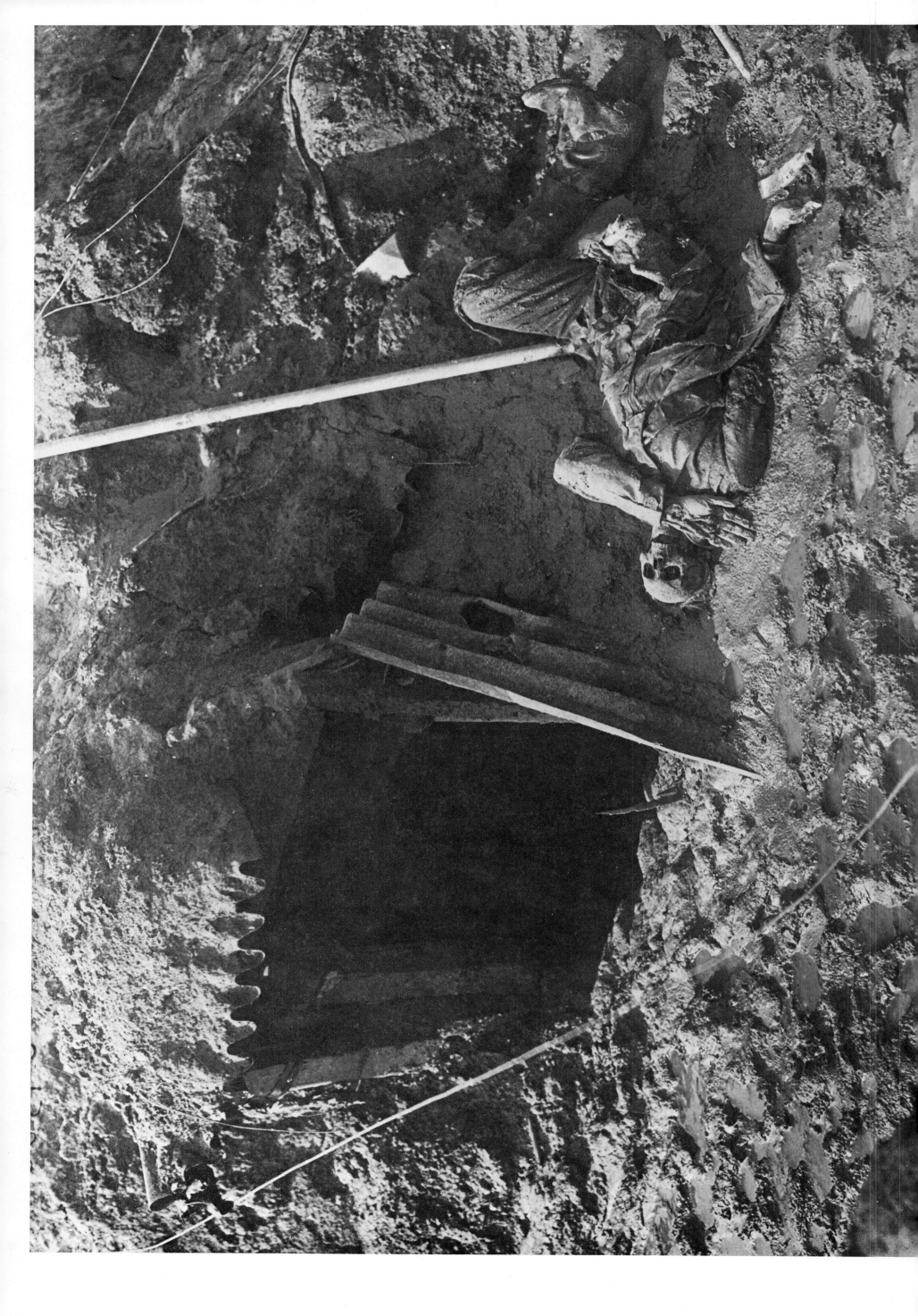

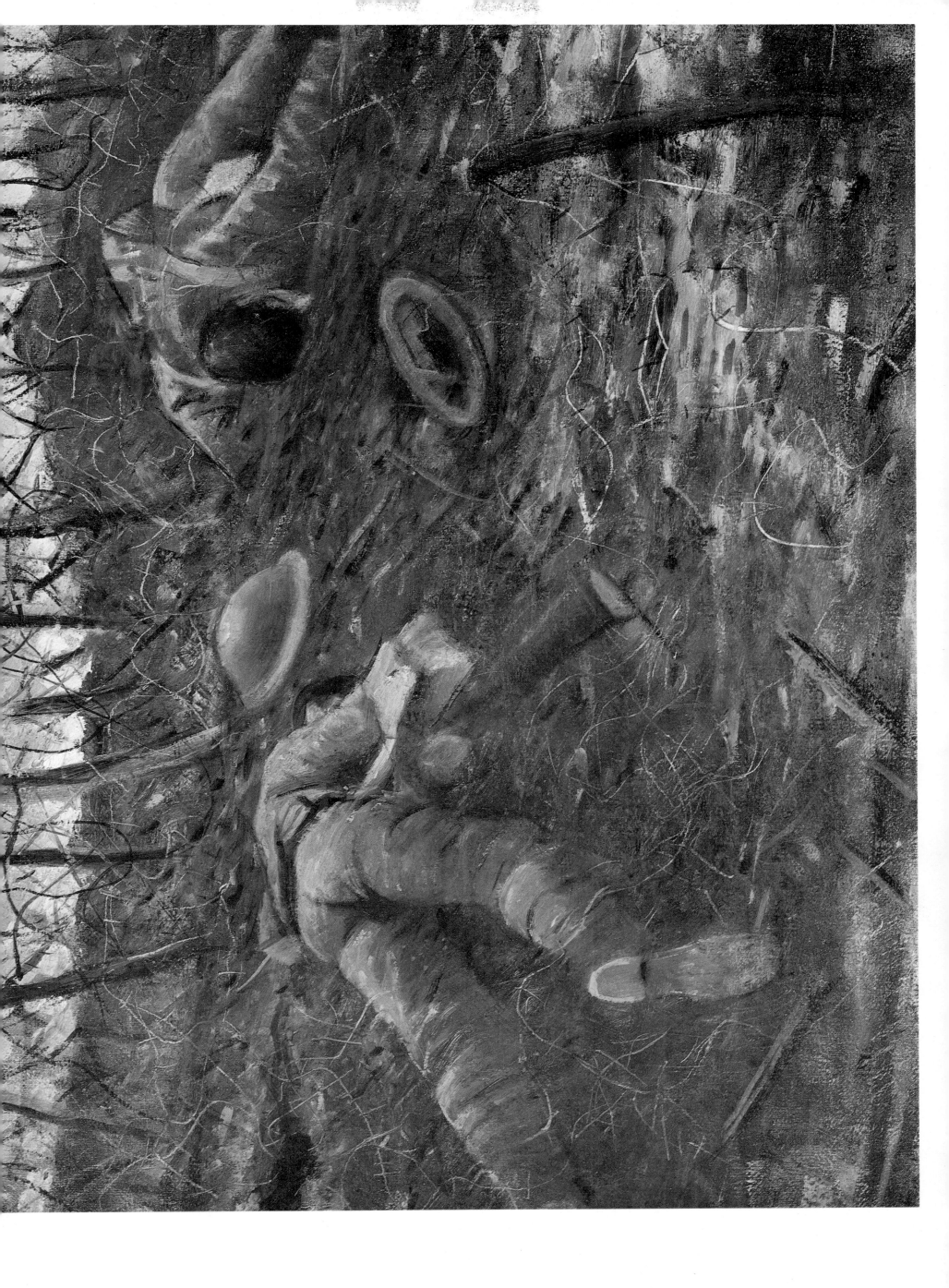

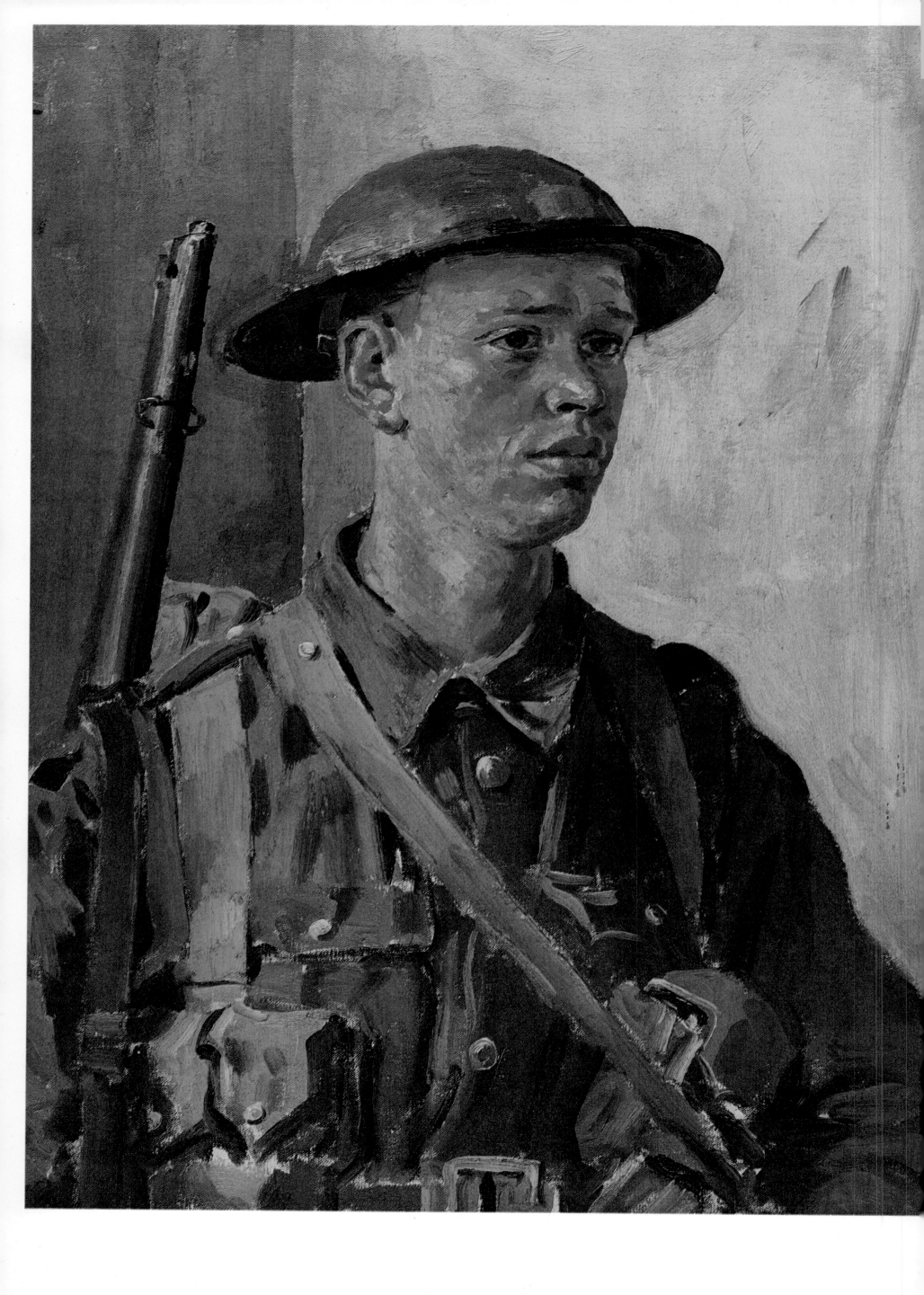

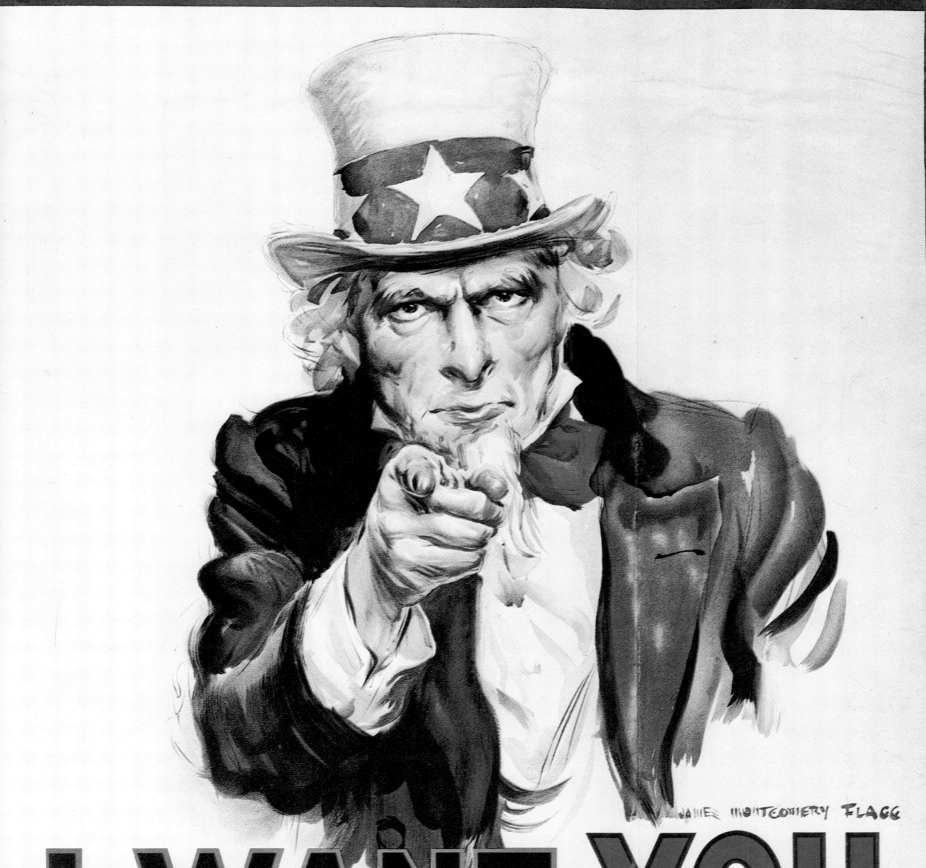

I WANT YOU
FOR U.S.ARMY
NEAREST RECRUITING STATION

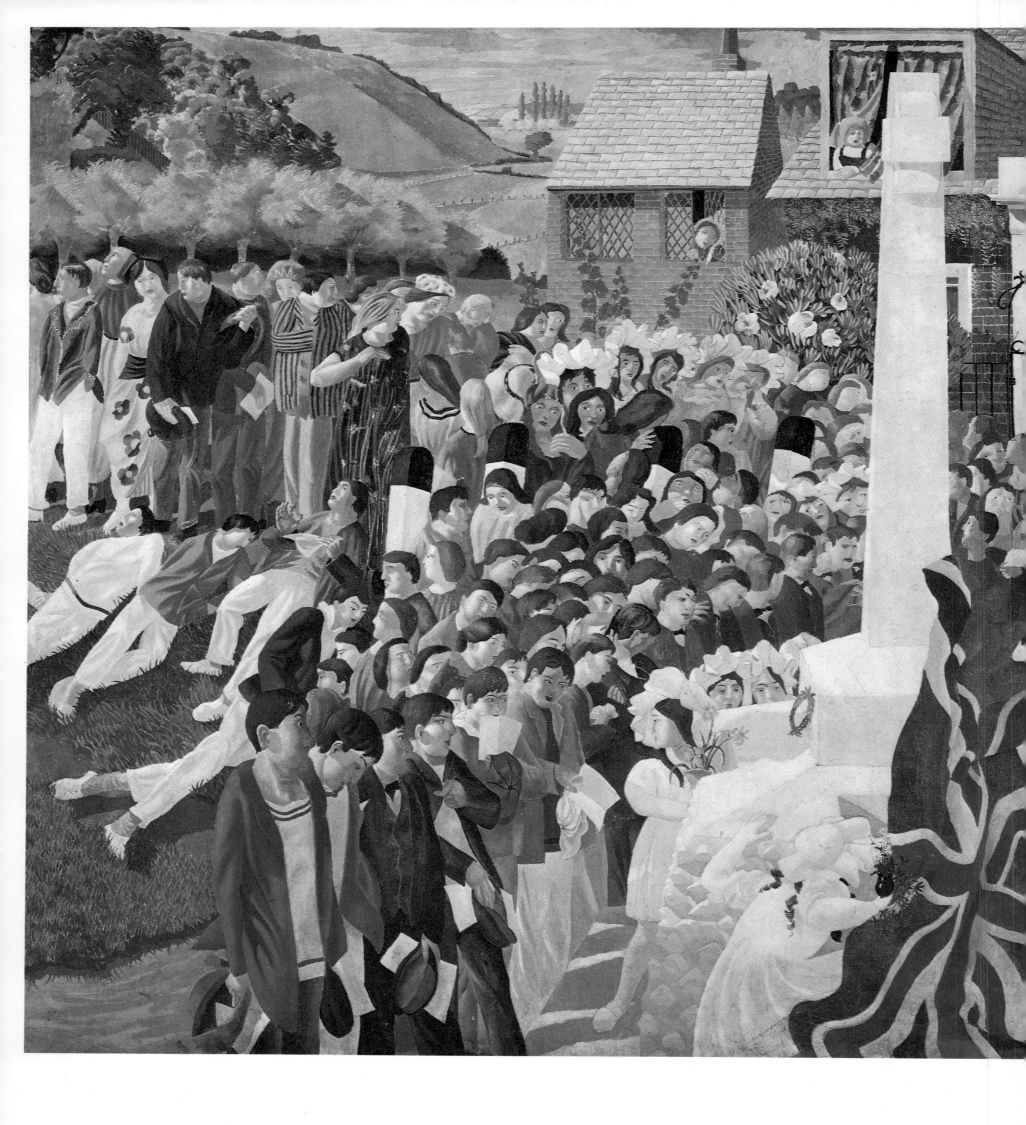

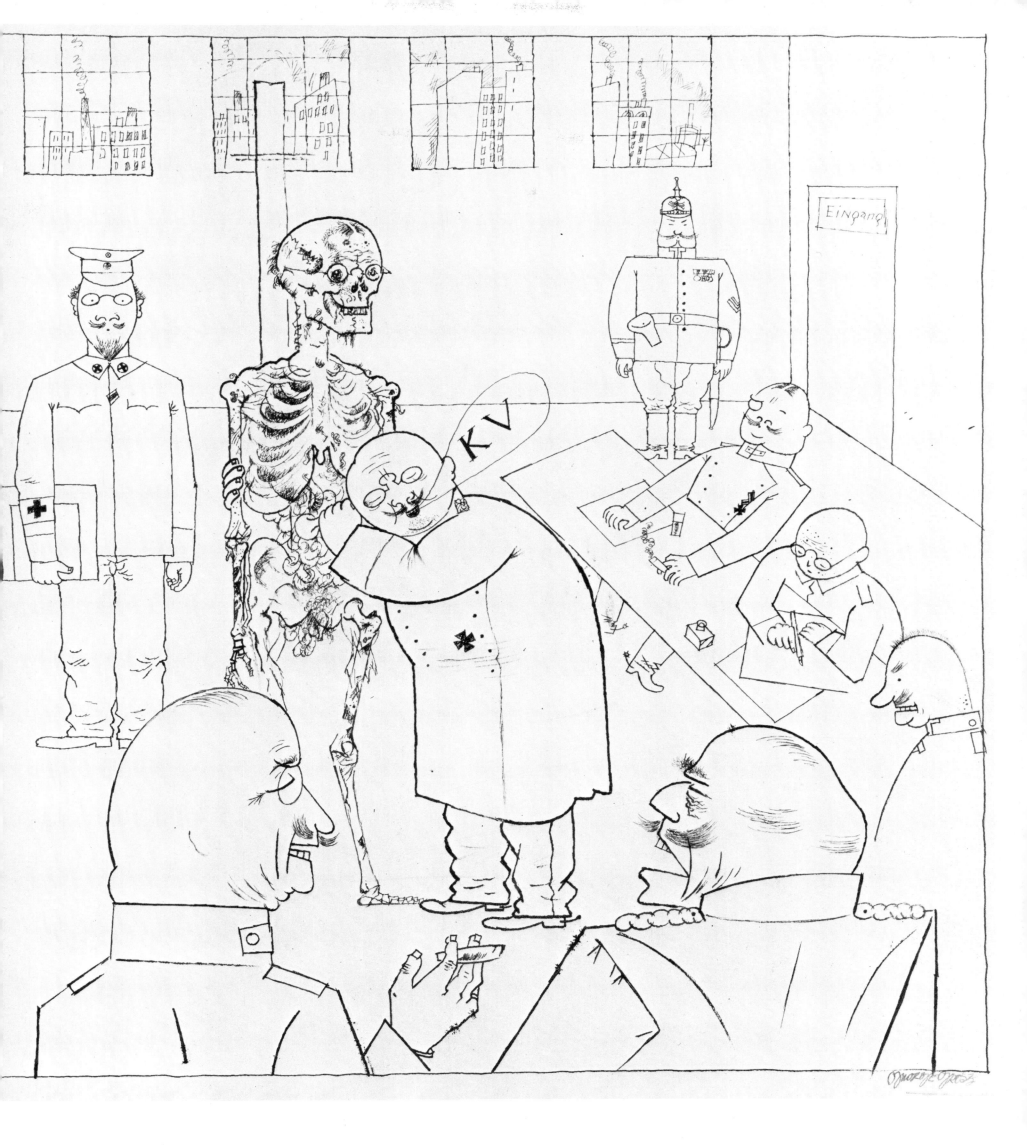

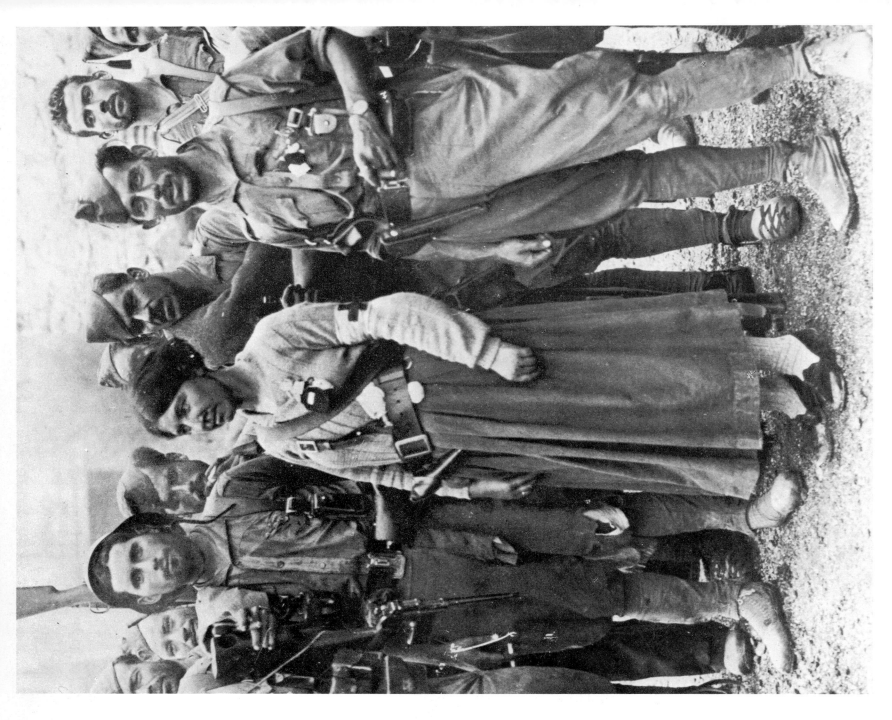

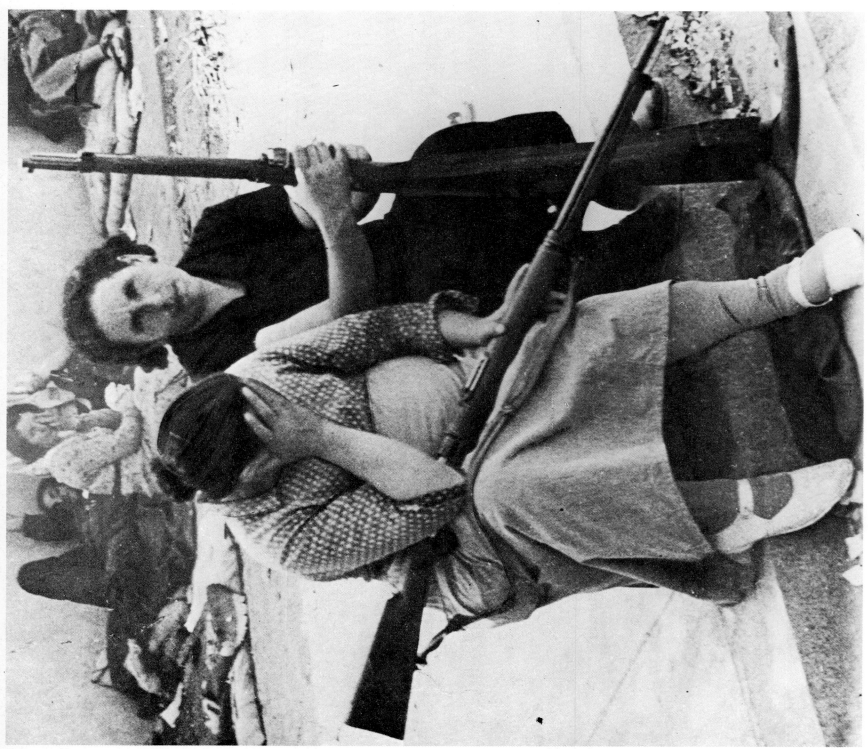

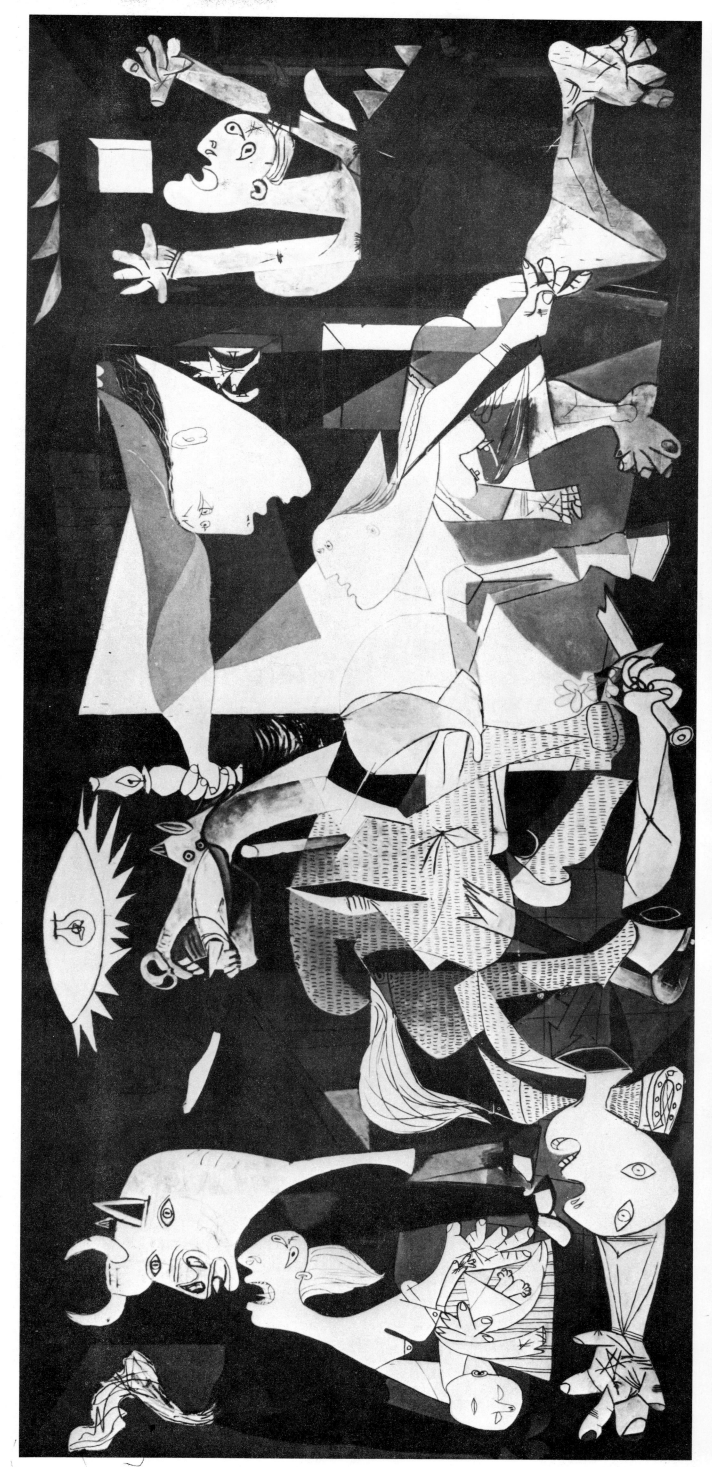

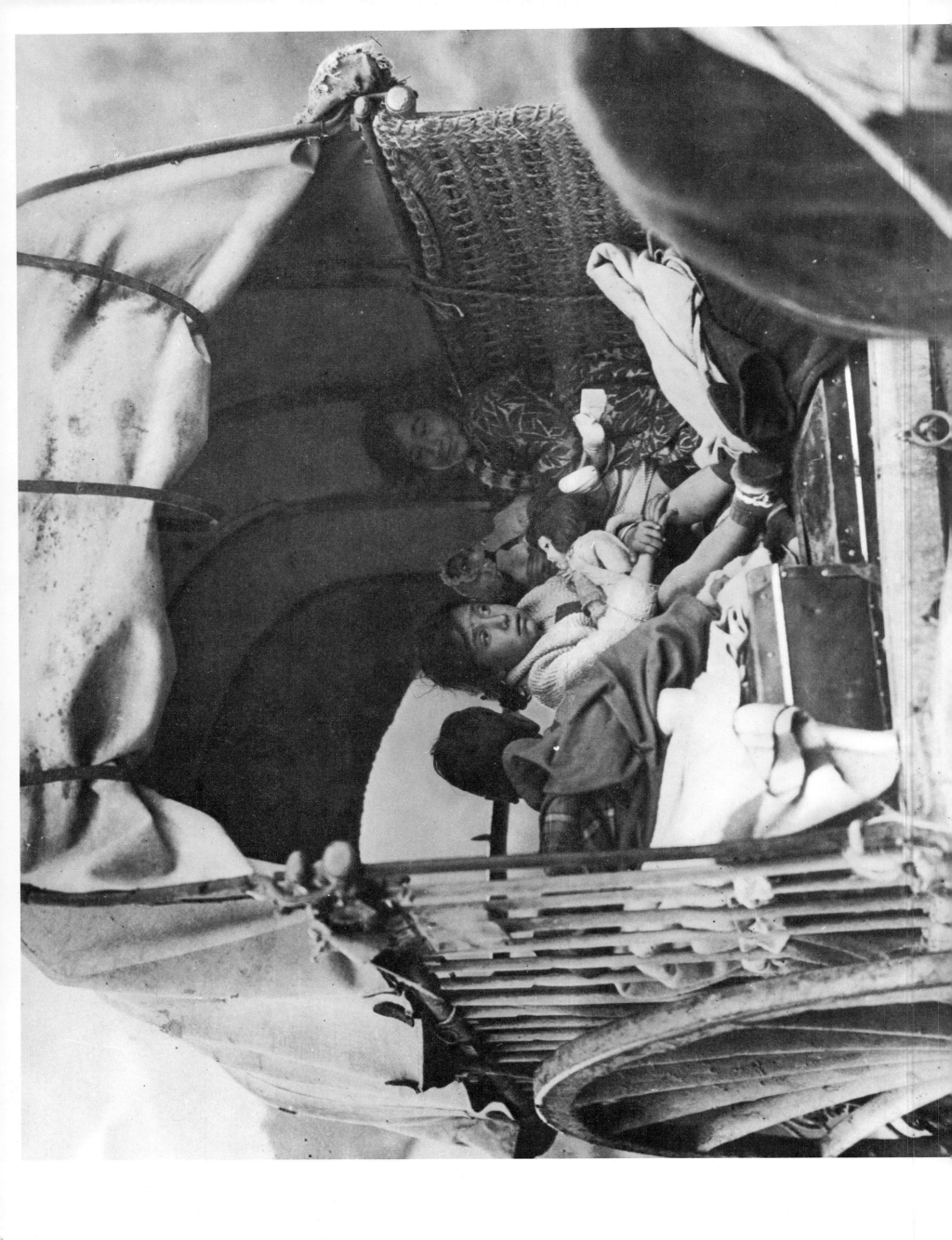

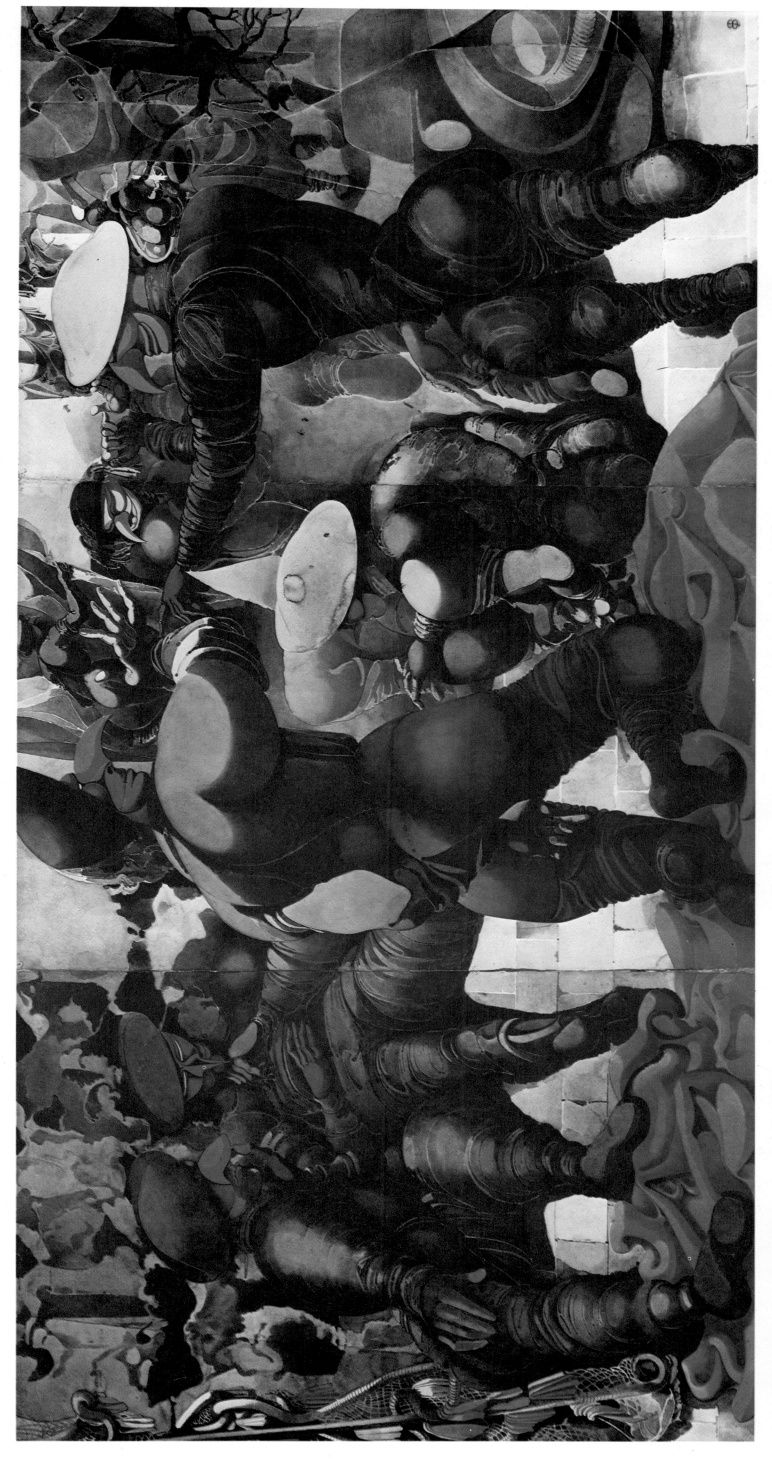

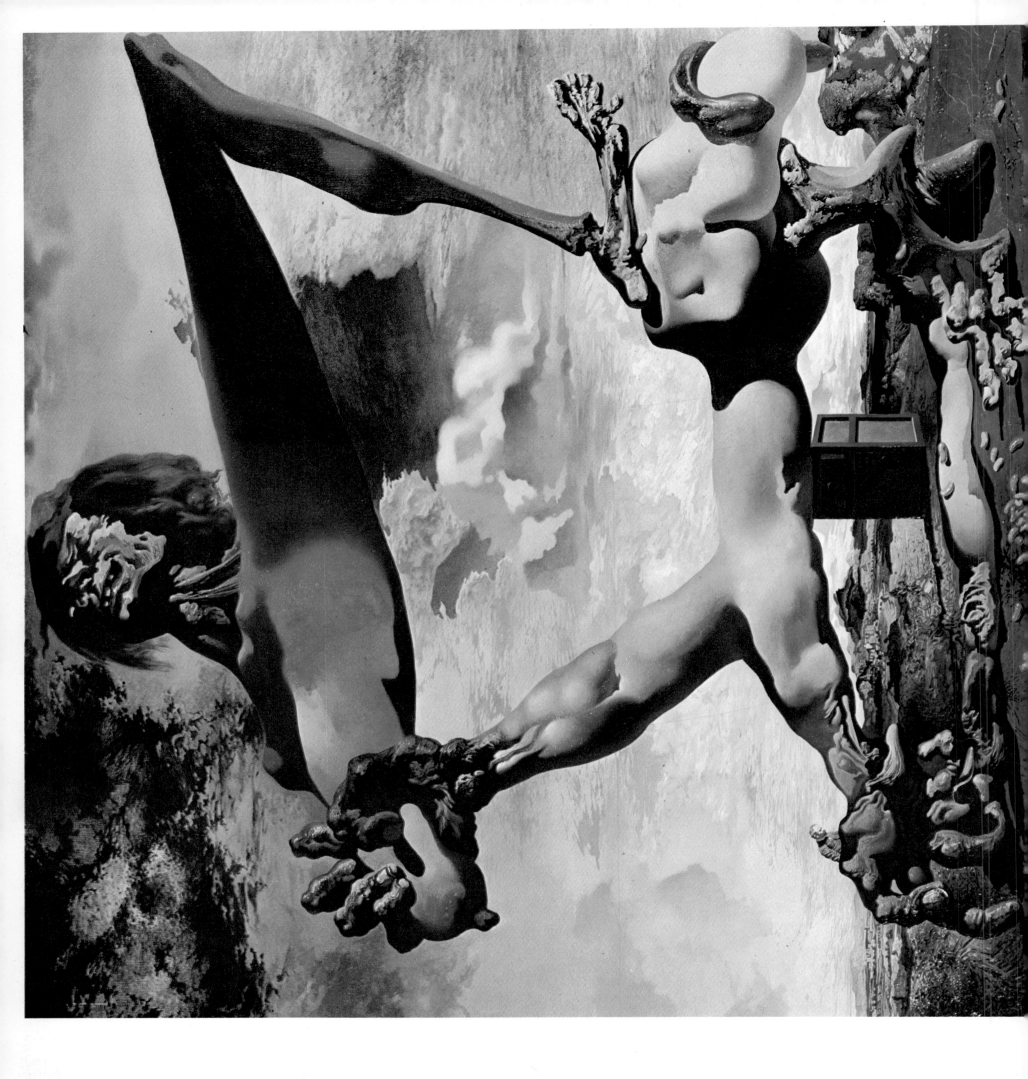

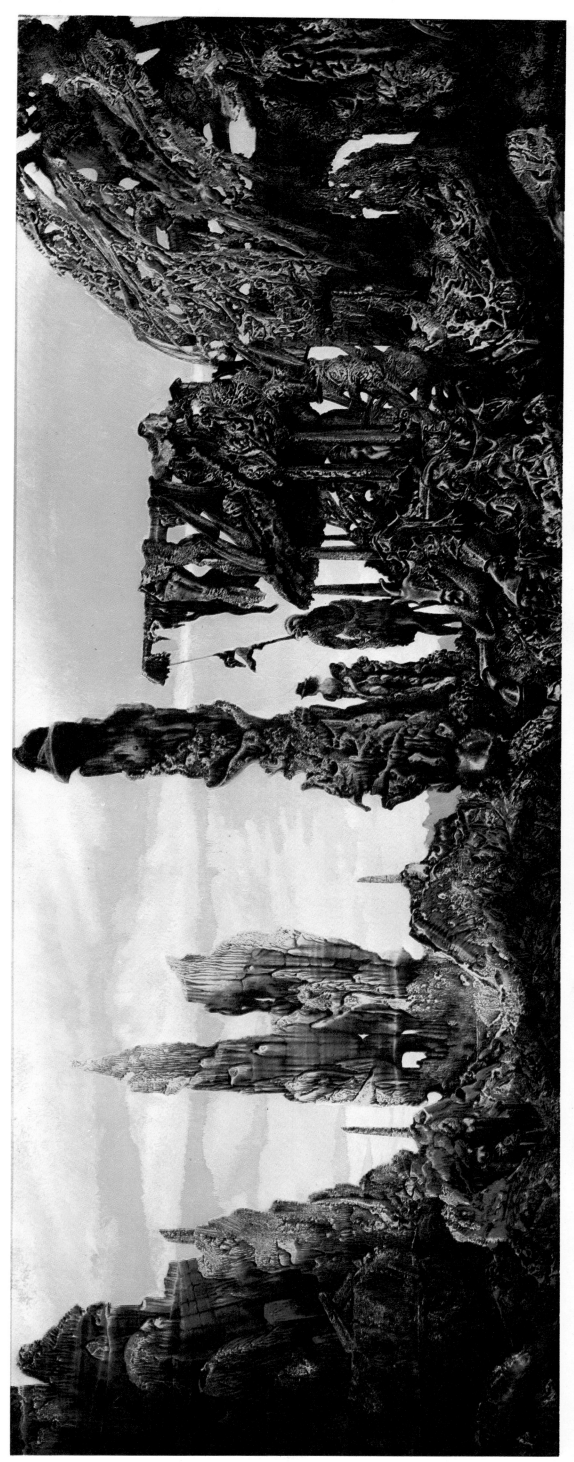

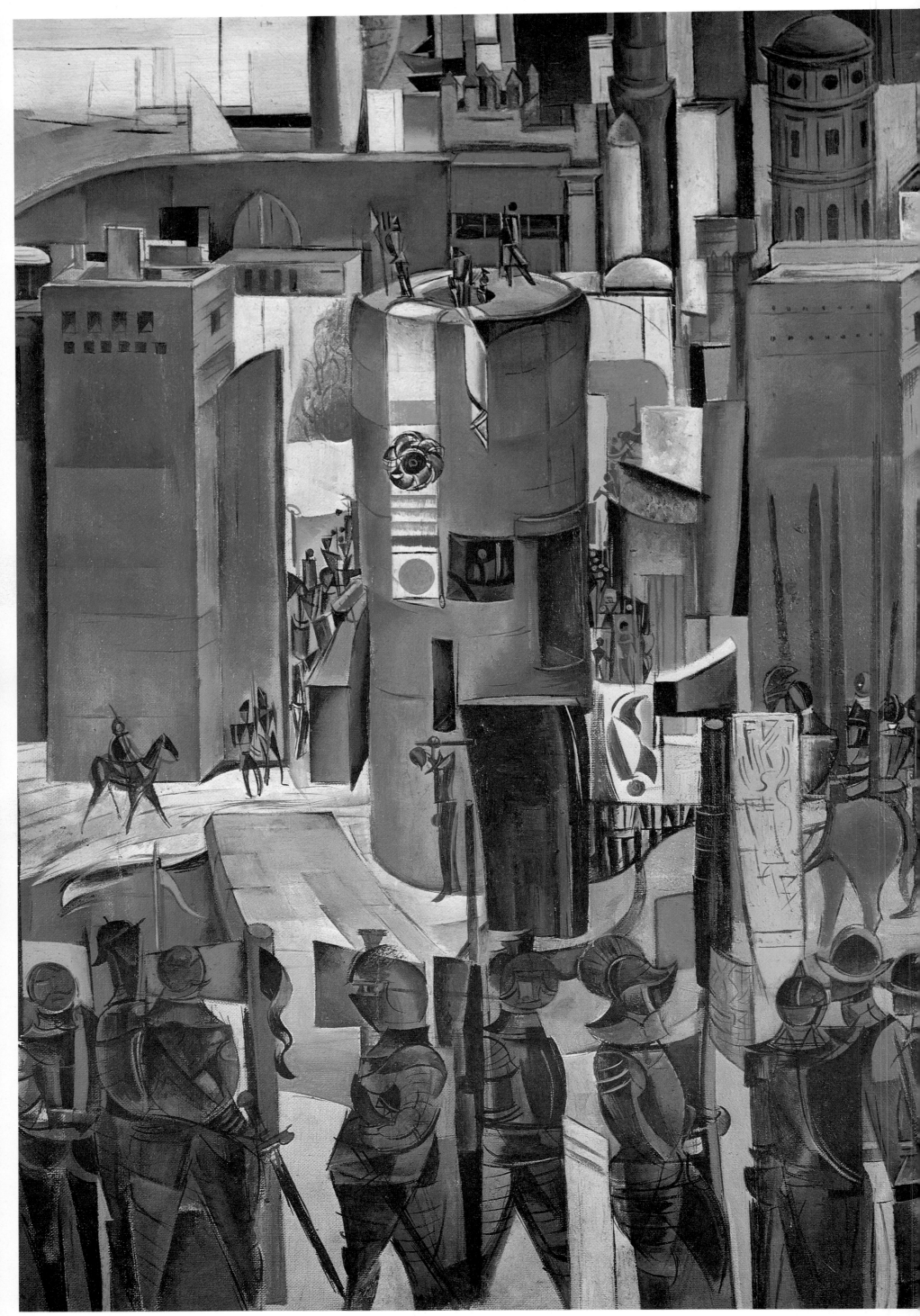

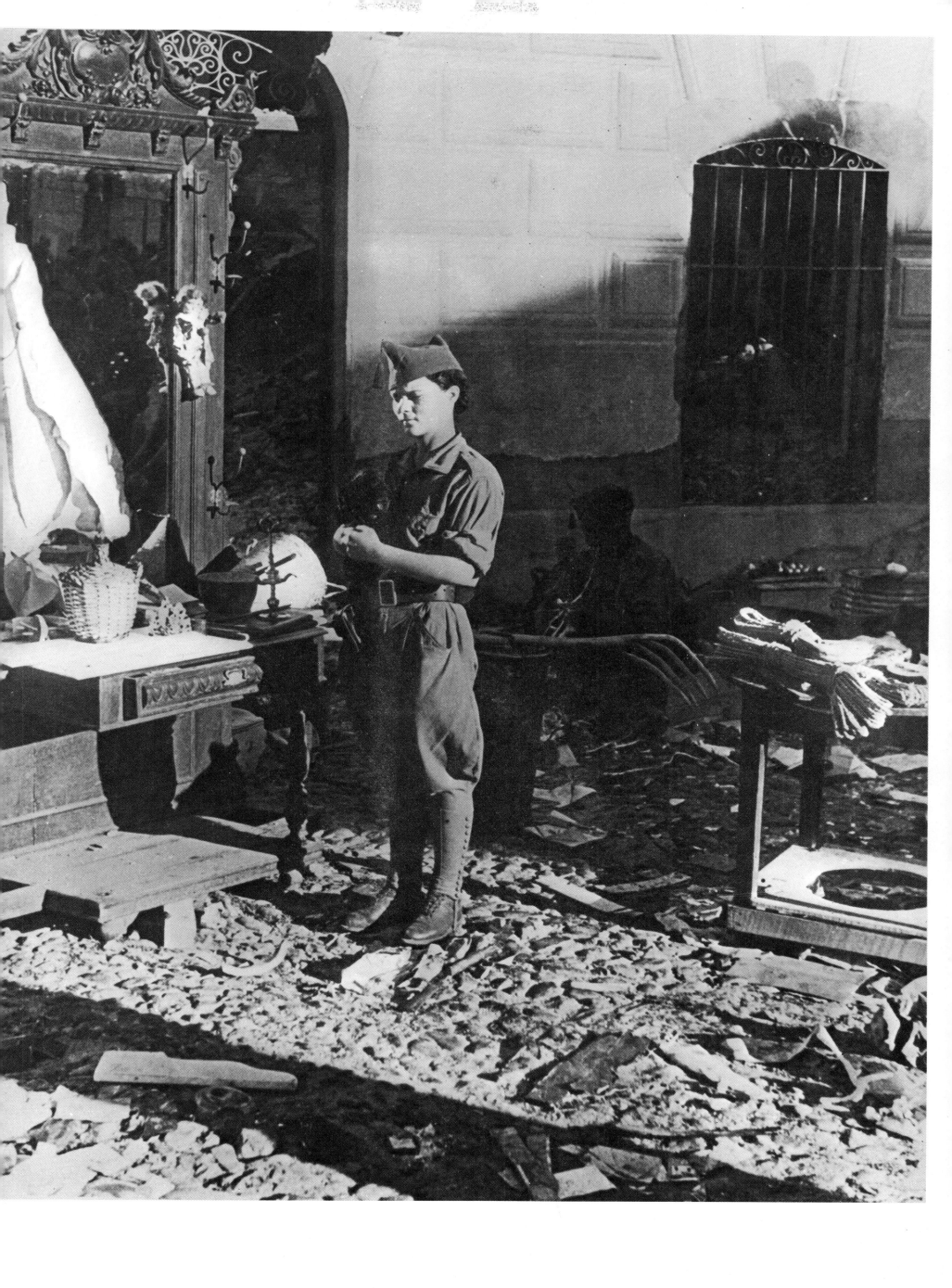

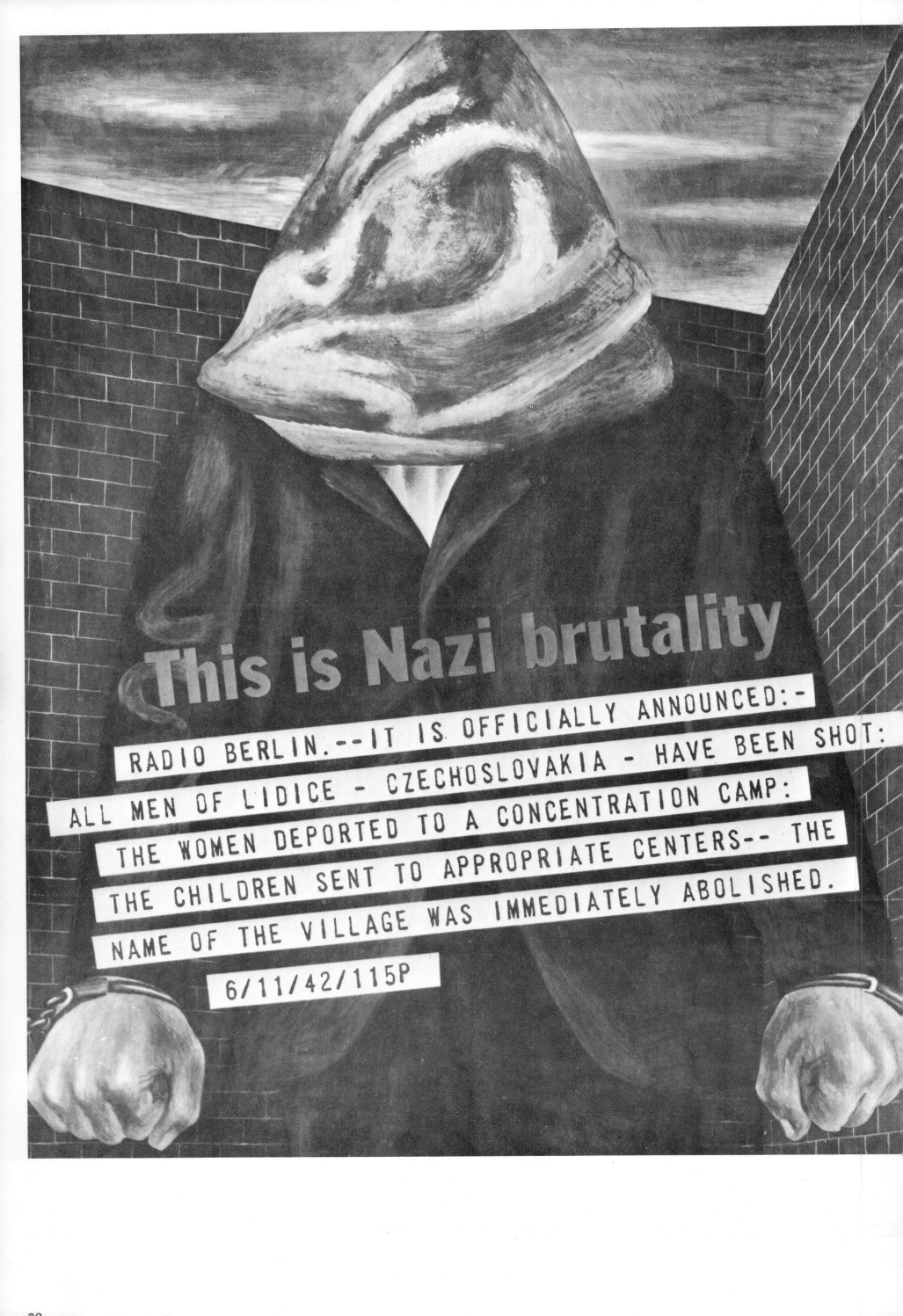

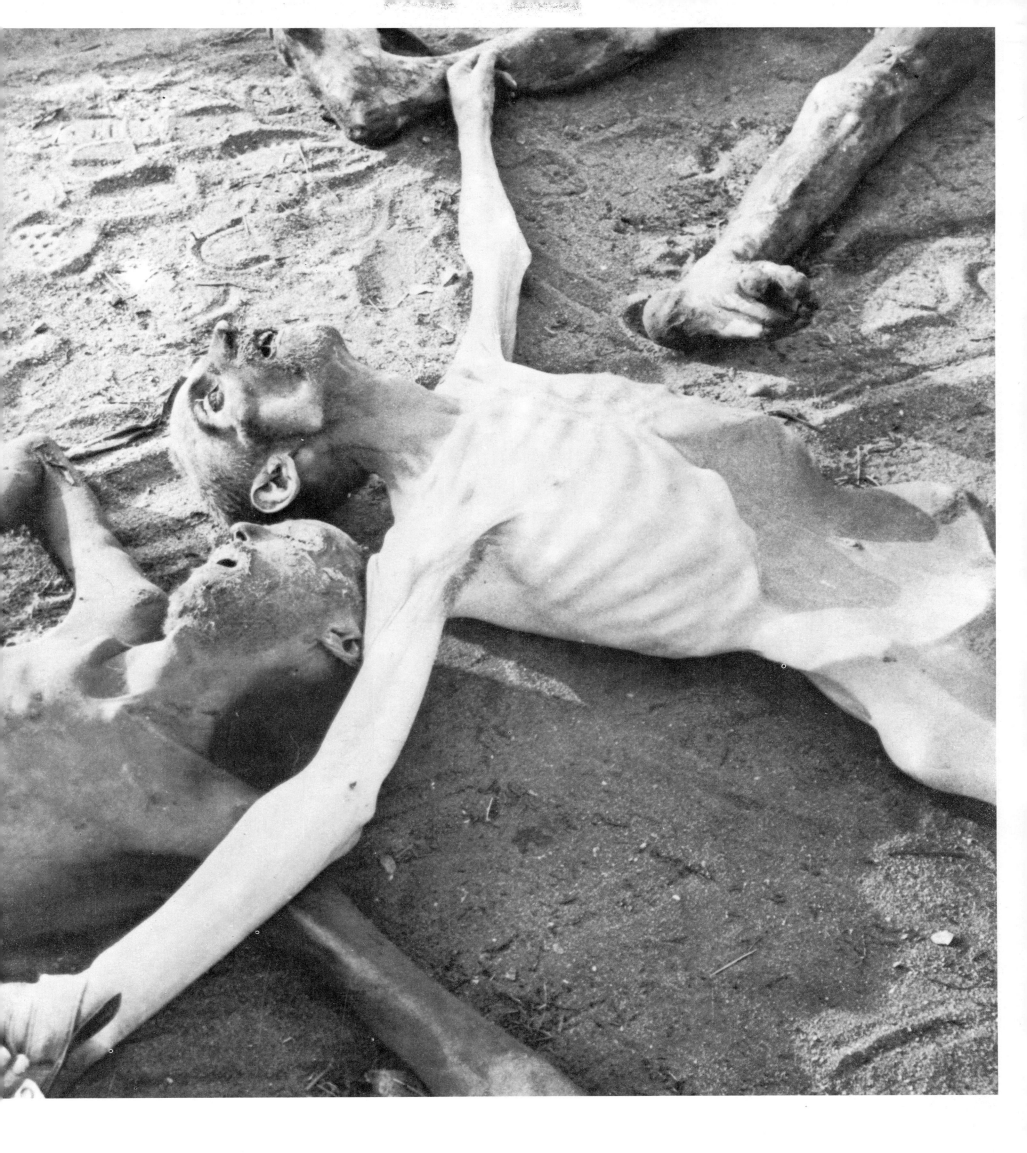

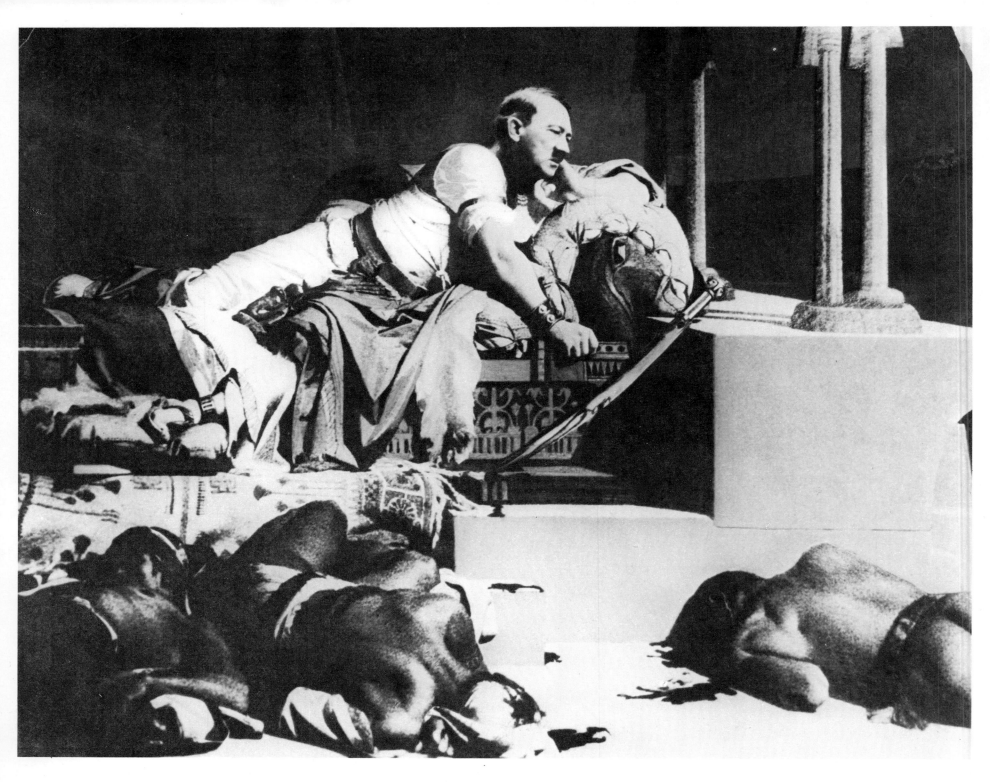

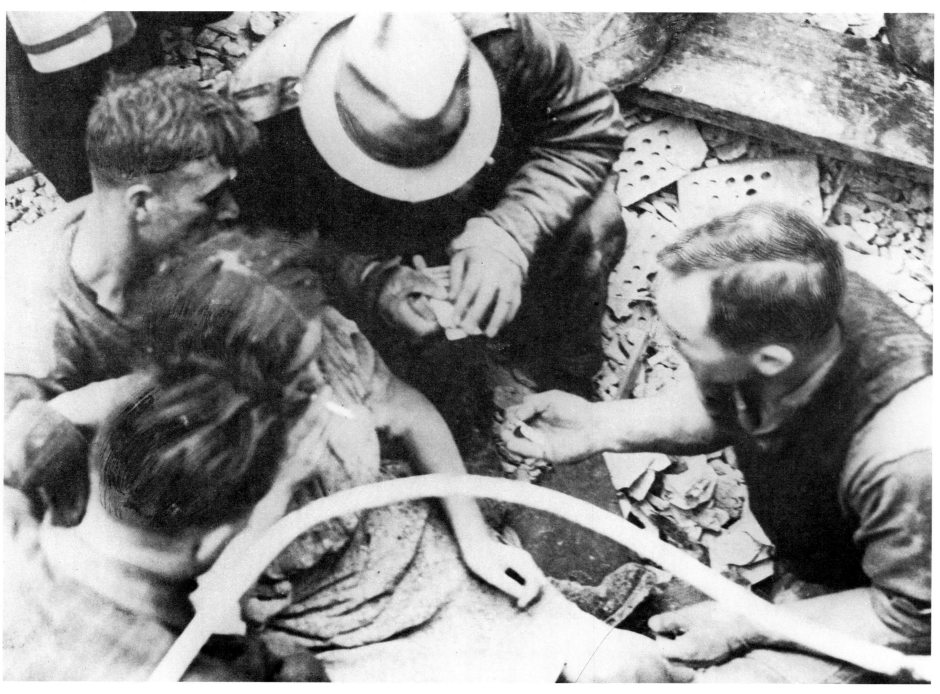

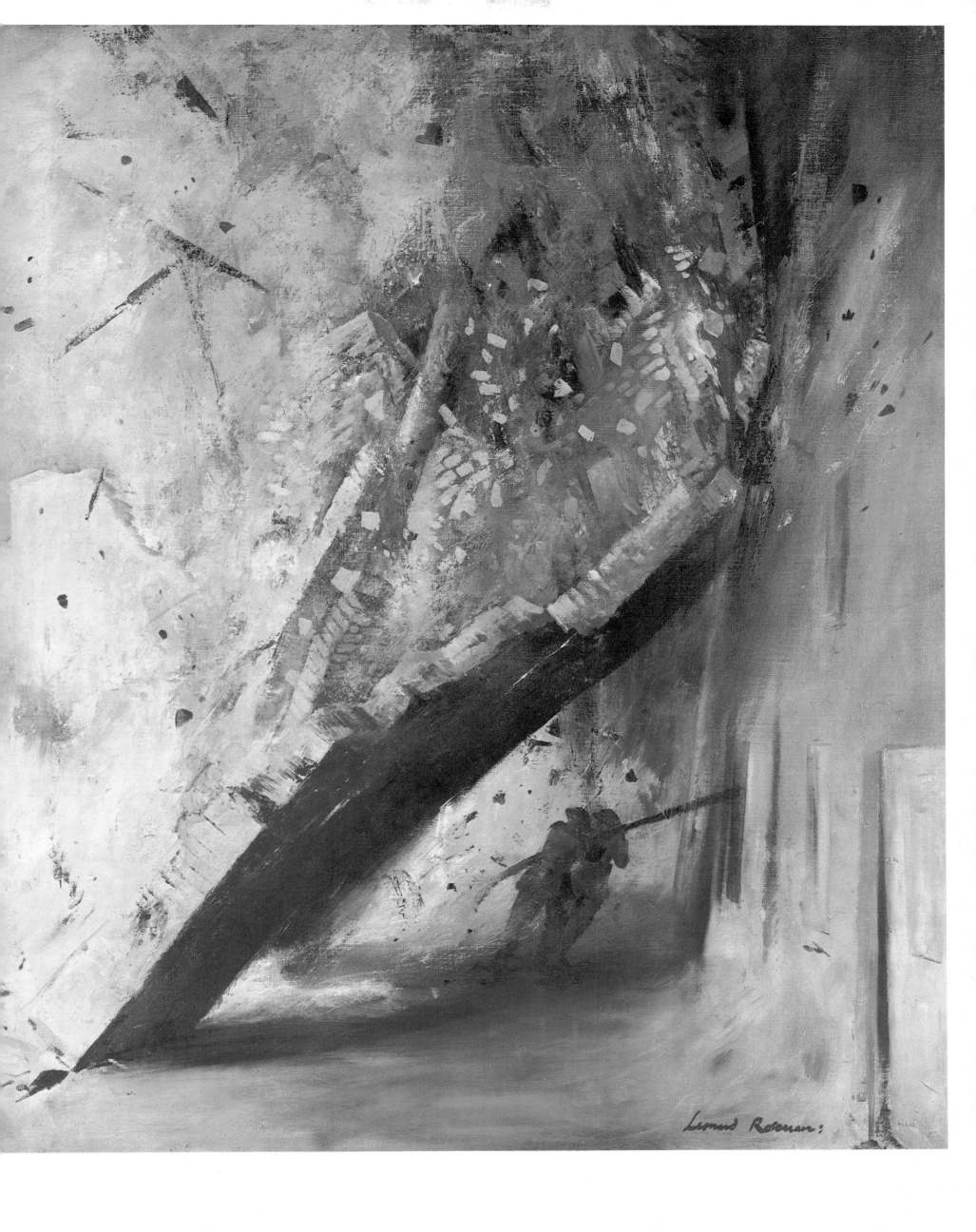

Leonard Rosoman:

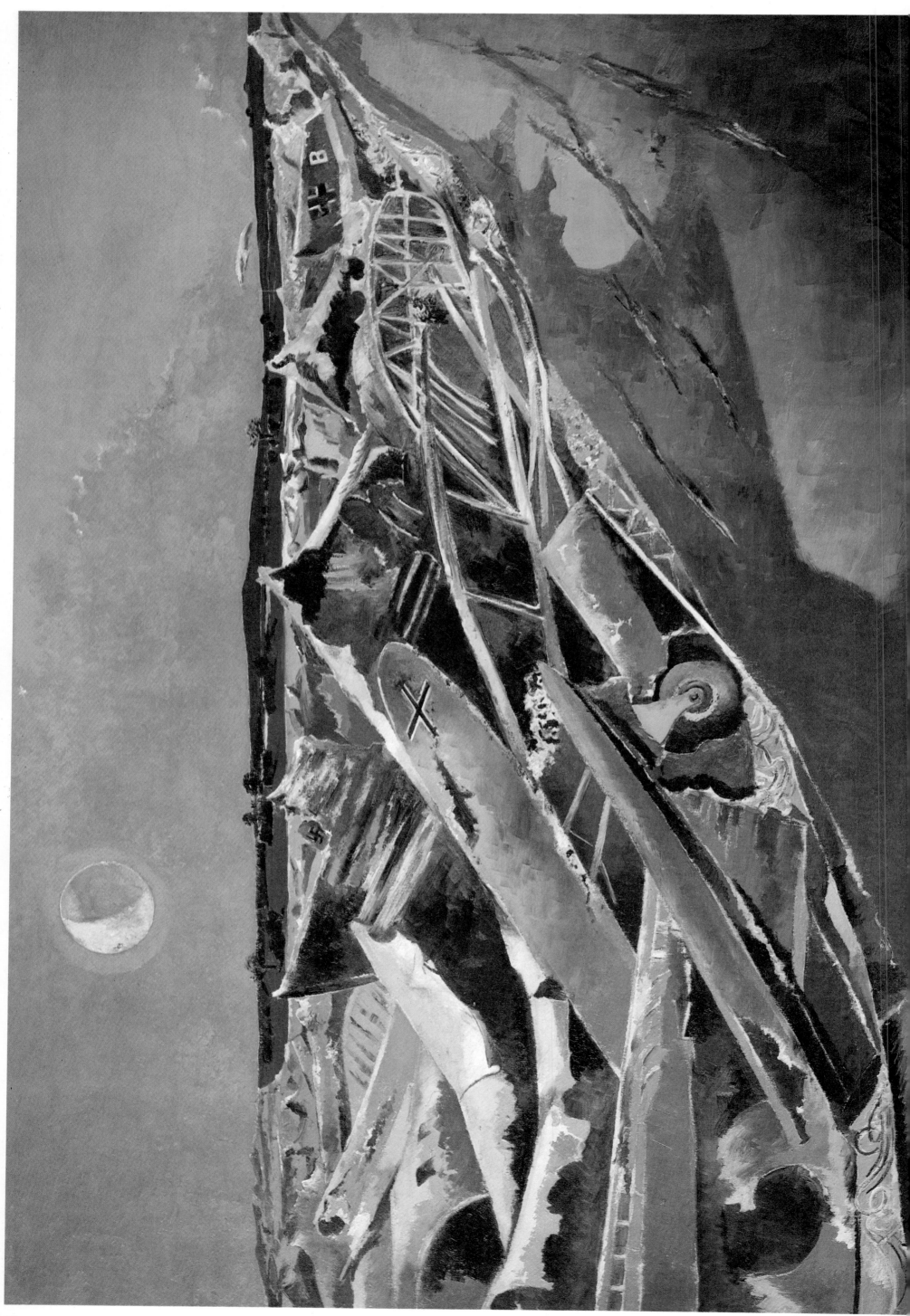

84

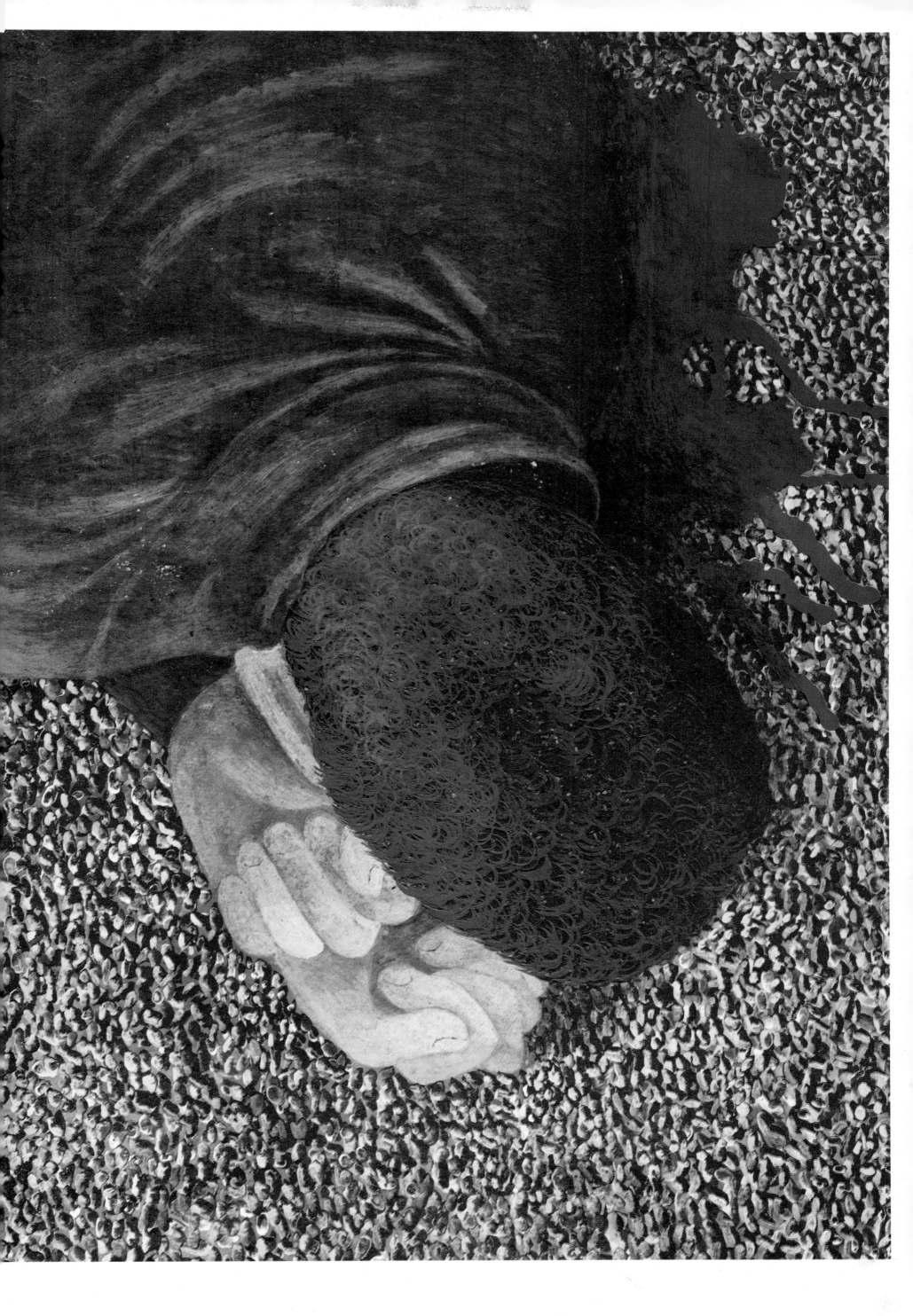

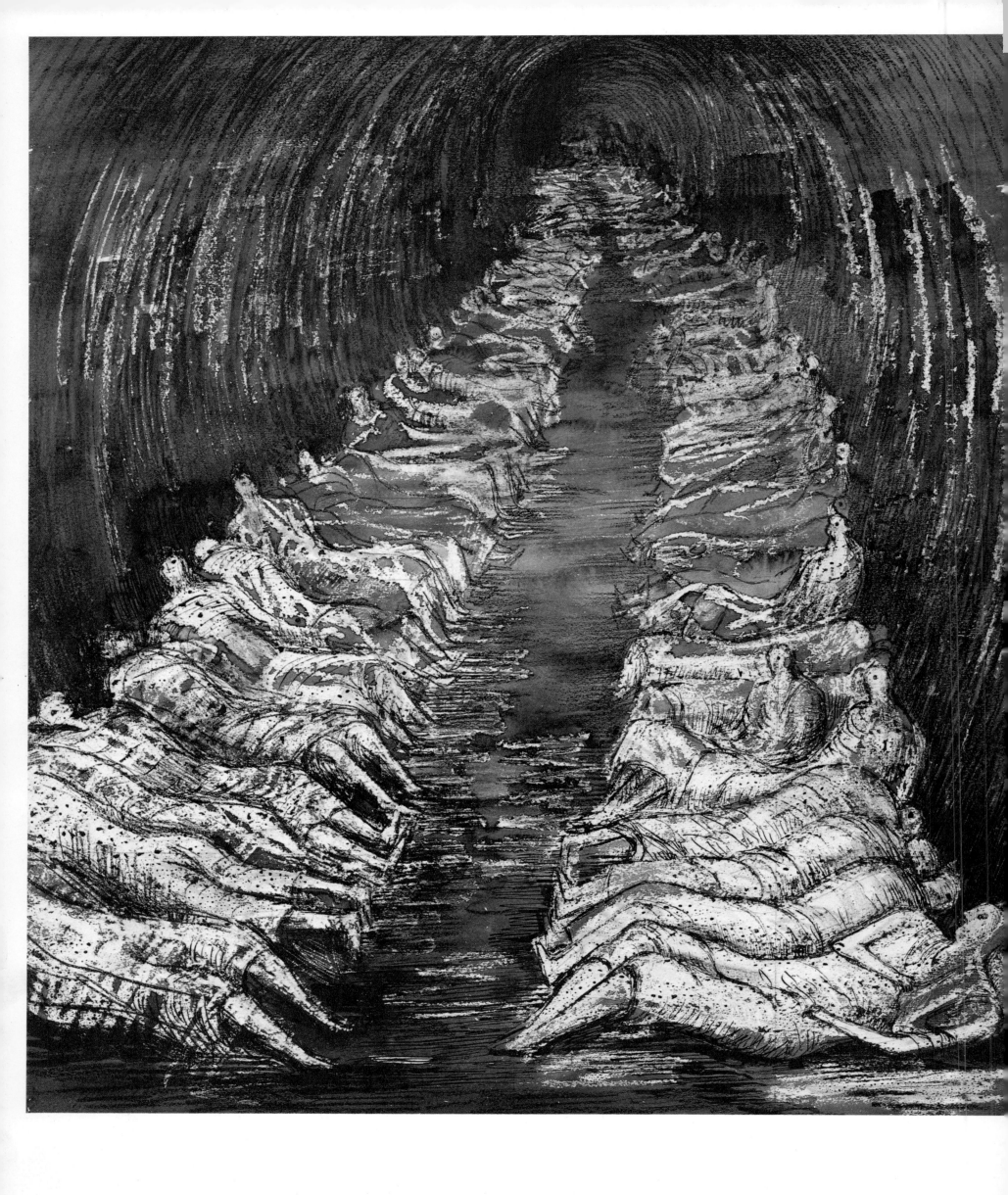

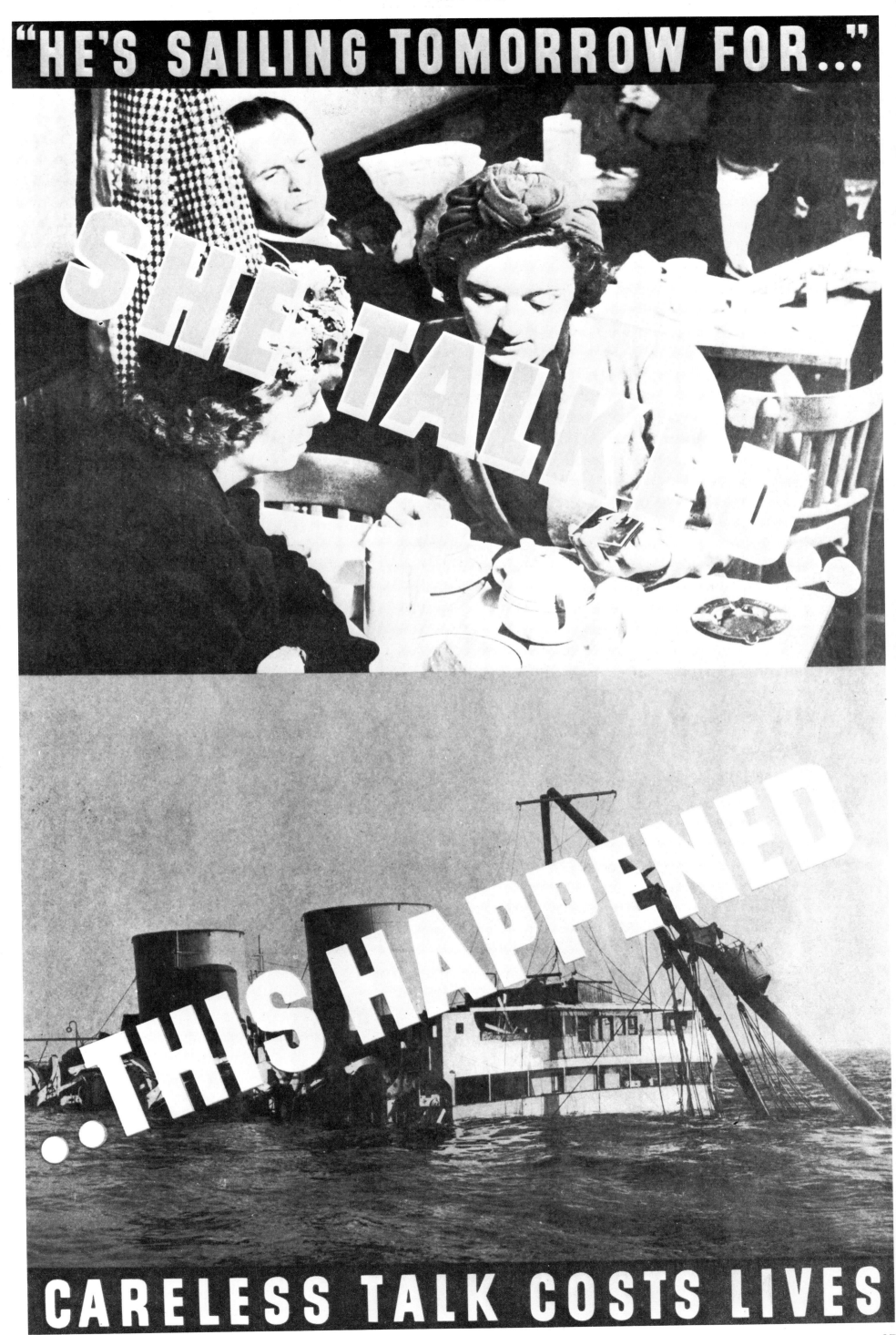

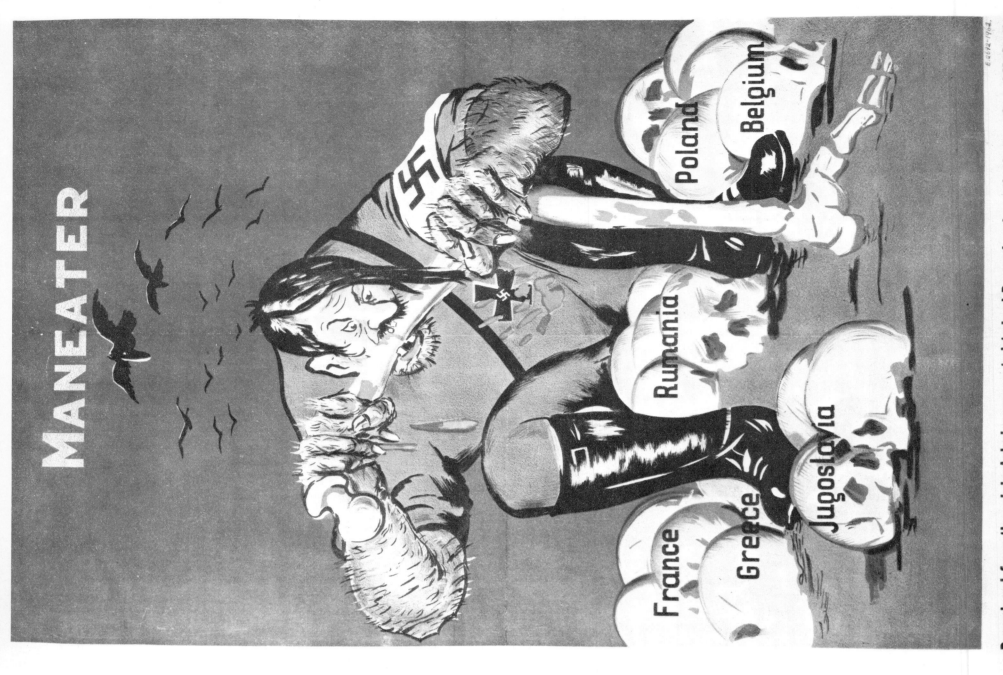

MANEATER

Poland

Belgium

Rumania

Jugoslavia

France

Greece

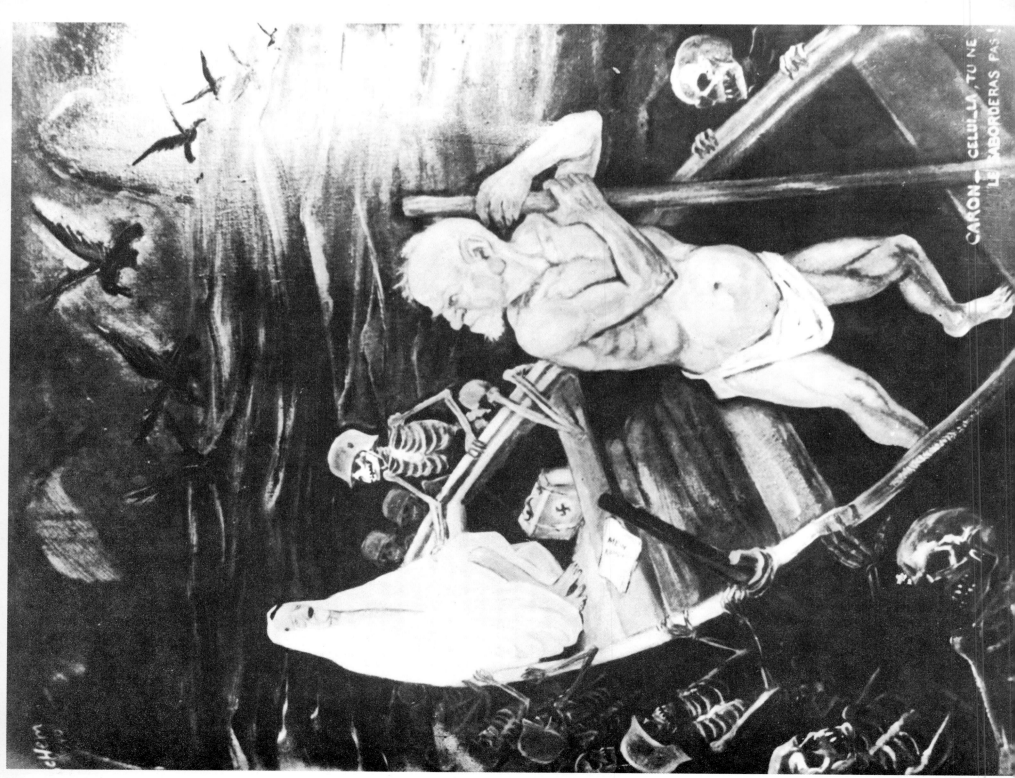

CARON— CELULA TU NE
LE SABORDERAS PAS !

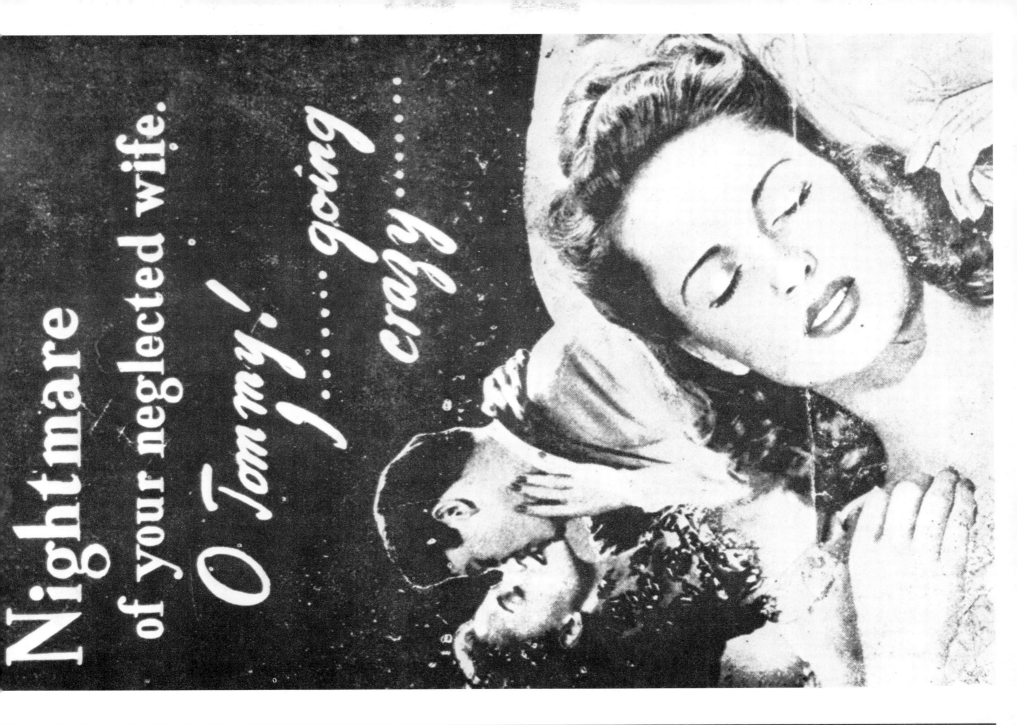

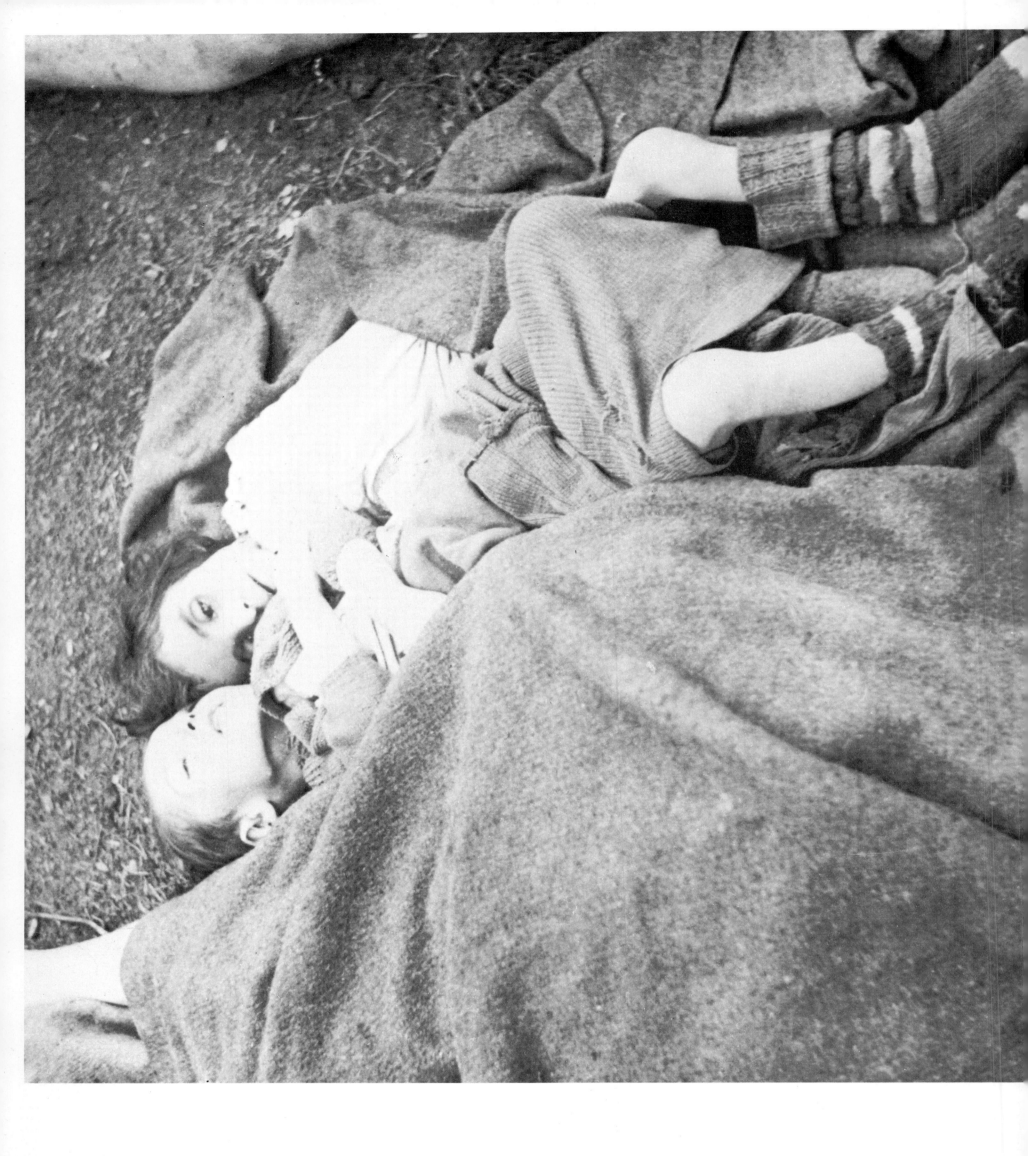

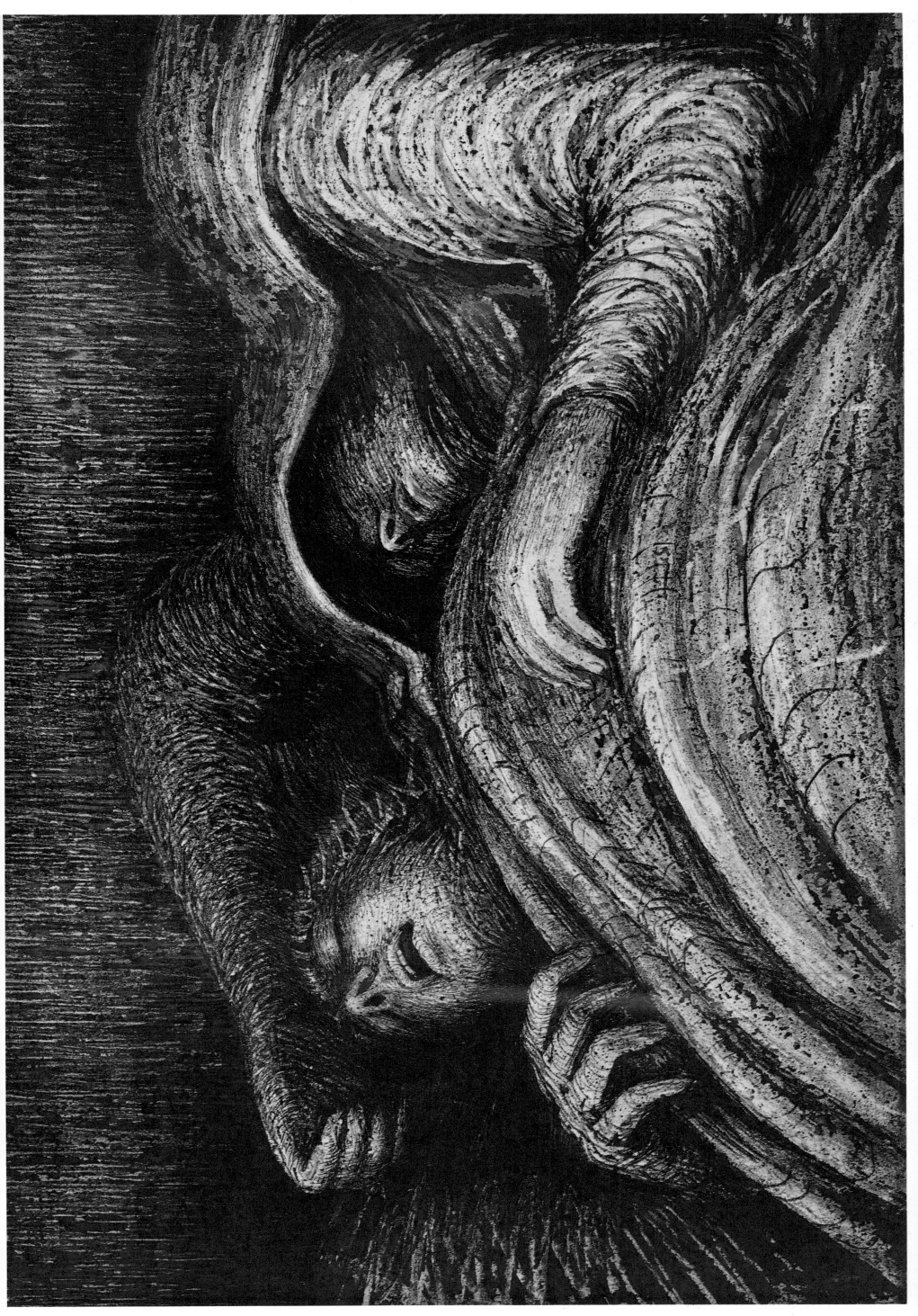

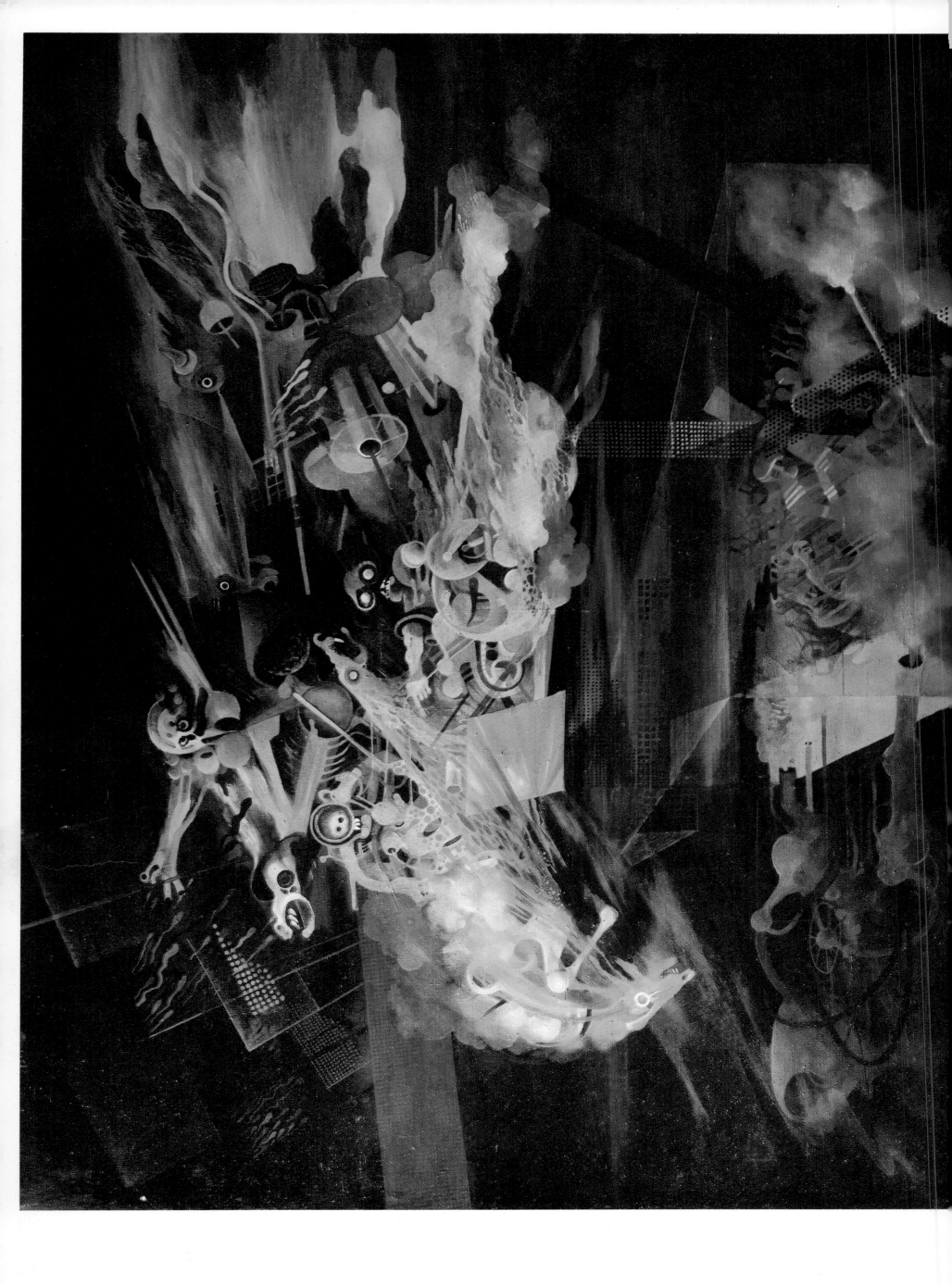

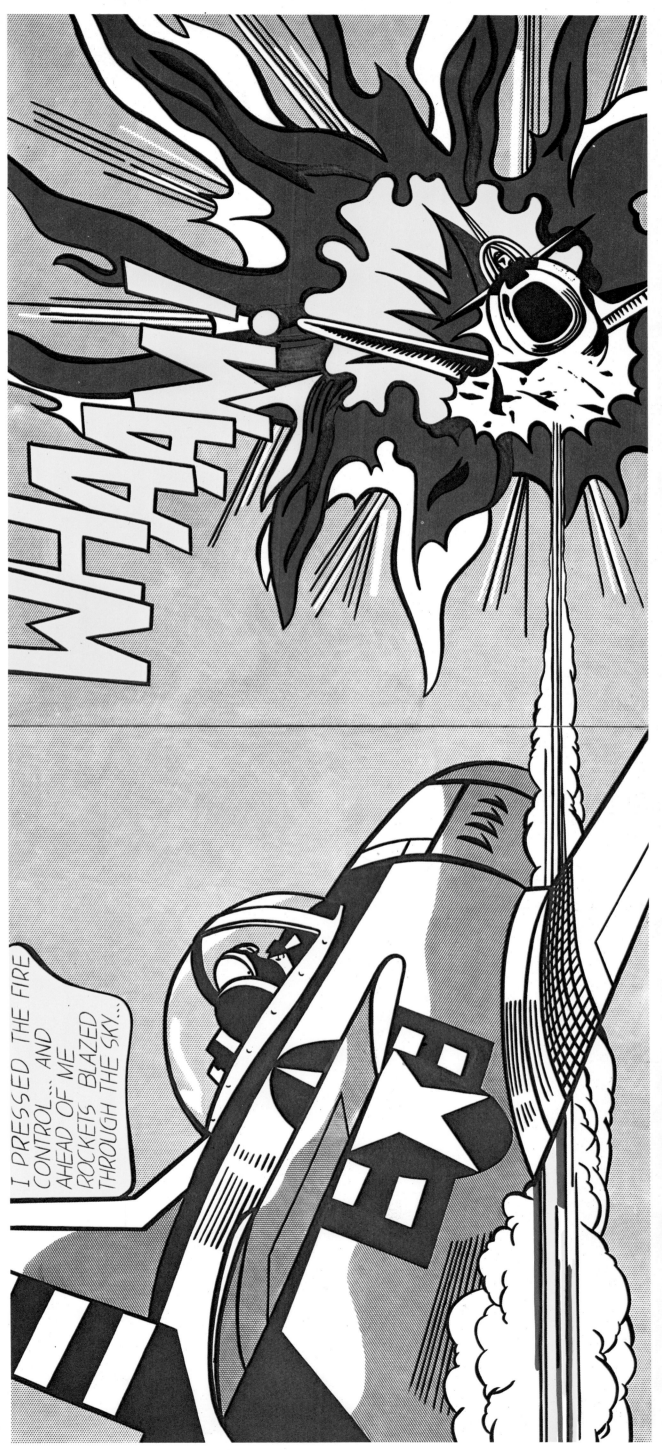

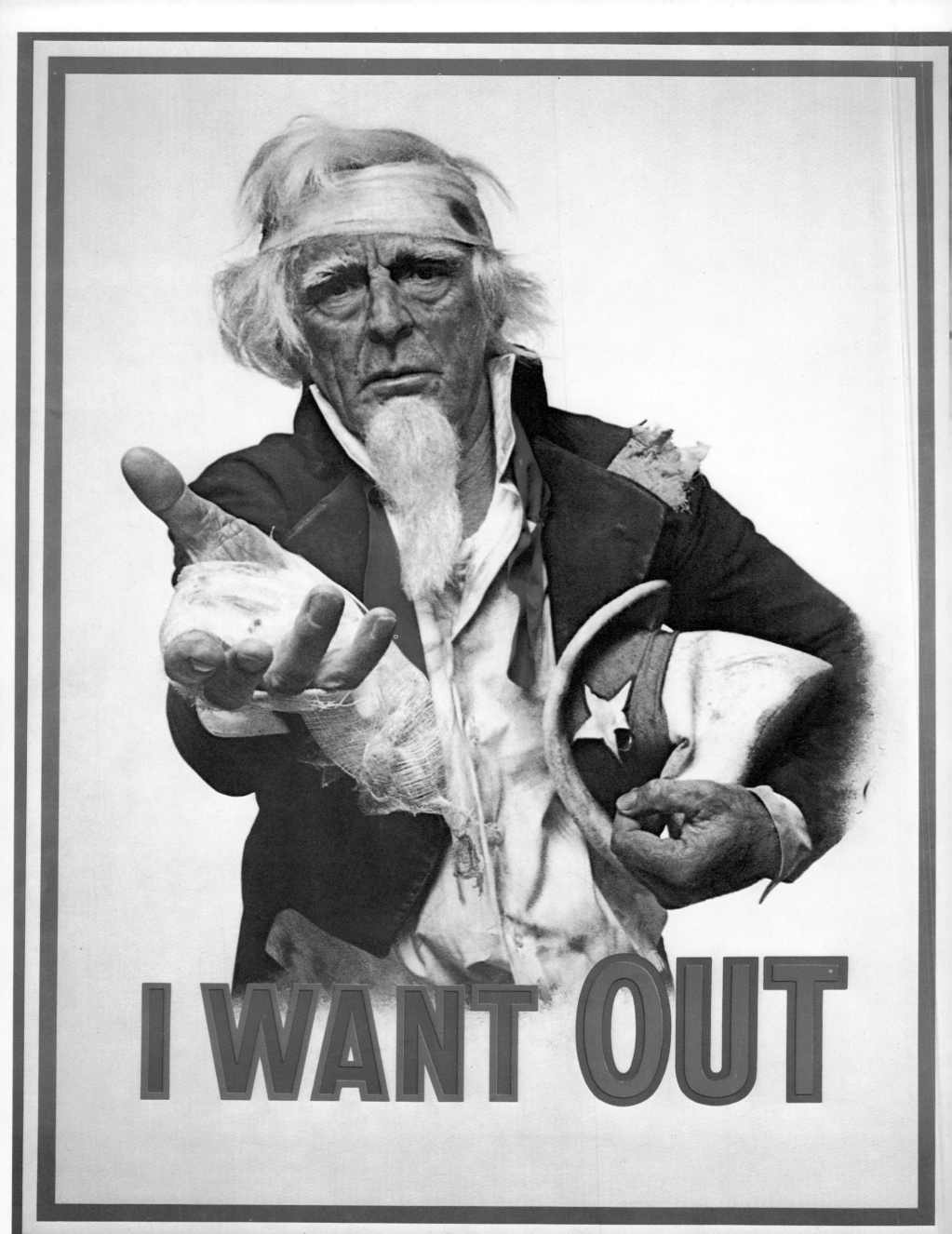